THE FLOWERS OF PROVENCE

JAMIE BECK

THE

FLOWERS

OF

PROVENCE

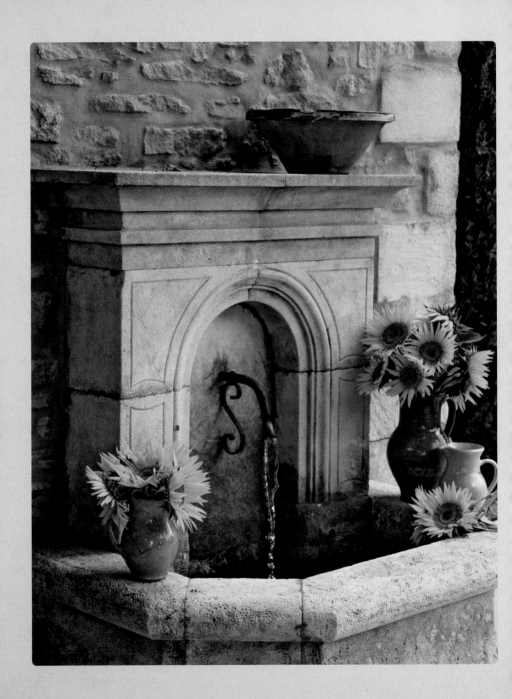

THE

FLOWERS

OF

PROVENCE

JAMIE BECK

SIMON ELEMENT

NEW YORK • LONDON • TORONTO • SYDNEY • NEW DELHI

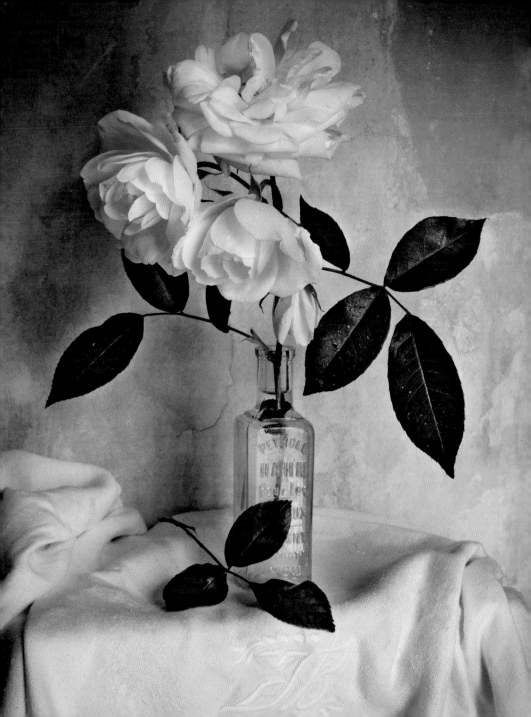

SIMON
ELEMENT

An Imprint of Simon & Schuster, Inc.
1230 Avenue of the Americas
New York, NY 10020

First Simon Element hardcover edition October 2023

SIMON ELEMENT and colophon are trademarks of Simon & Schuster, Inc.

For information about special discounts for bulk purchases, please contact
Simon & Schuster Special Sales at 1-866-506-1949 or business@simonandschuster.com.

The Simon & Schuster Speakers Bureau can bring authors to your live event.
For more information or to book an event, contact the Simon & Schuster Speakers Bureau
at 1-866-248-3049 or visit our website at www.simonspeakers.com.

Cover and book design by Natasshia Neary
Illustrations by Natasshia Neary

Manufactured in China

1 3 5 7 9 10 8 6 4 2

Library of Congress Cataloging-in-Publication Data has been applied for.

ISBN 978-1-6680-2069-2

in loving memory of

my grandmother,

who lives on in the eternity of flowers

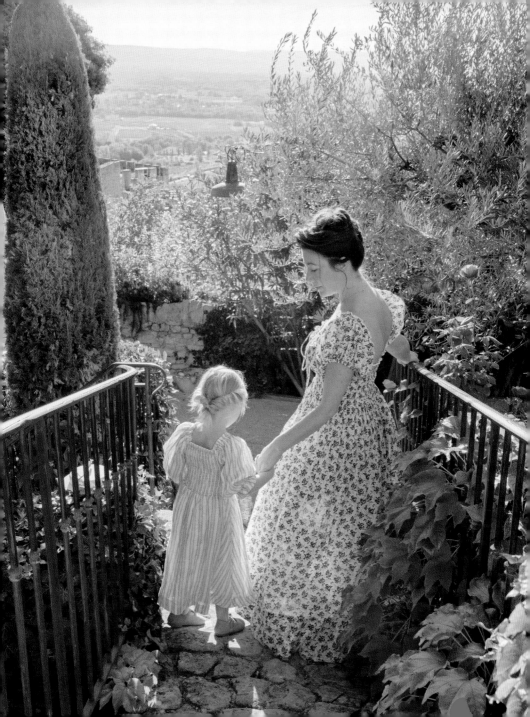

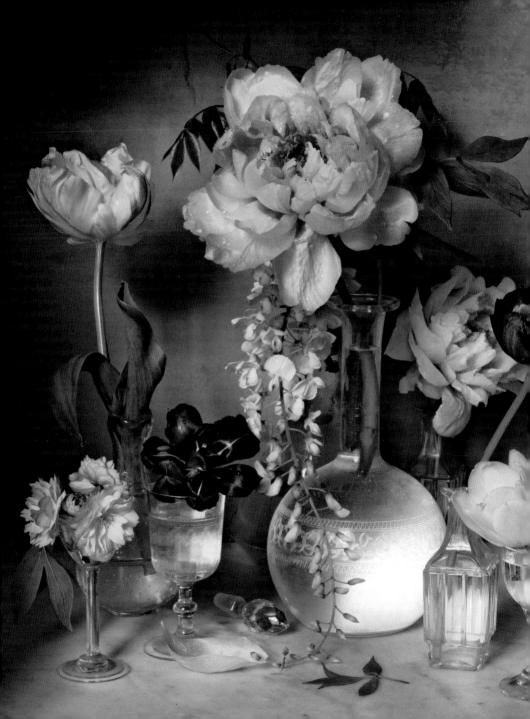

CONTENTS

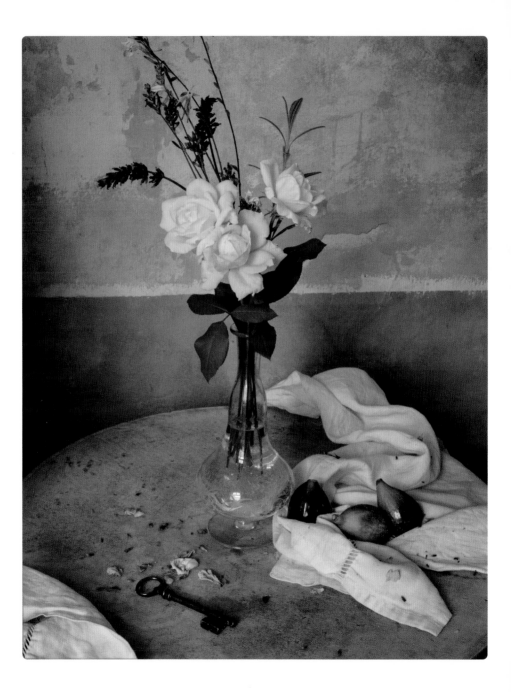

FOREWORD

I first discovered Jamie Beck through a mutual flower friend and have been completely obsessed ever since. Her work has the ability to transport you into another world; it's like falling down the most beautiful rabbit hole and getting lost in an entirely different time.

Like Jamie, my own journey with flowers began at an early age in my great-grandmother's garden, and I've since devoted my life to making other people's lives more beautiful with flowers. I started Floret after delivering a simple jar of sweet peas and witnessing the power a humble bouquet can have to stir deep emotion, leaving me forever changed. Flowers continue to remind me every day that even the smallest things have the power to alter your whole perspective.

The Flowers of Provence is filled with stories and images that will leave you longing to go outside and, as Jamie says, "watch the ballet of nature unfold." Her photography so uniquely captures the ethereal quality of flowers and the beauty of the Provence region, making you feel as though you're experiencing each season and spellbinding location alongside her, all while calling to mind the wonder that exists all around you, wherever you might call home.

I encourage you to let yourself be swept up in the overwhelming beauty found within these pages and to walk away inspired to discover the magic of nature through flowers in your own life—and to pass that inspiration along to others.

—Erin Benzakein, founder of Floret

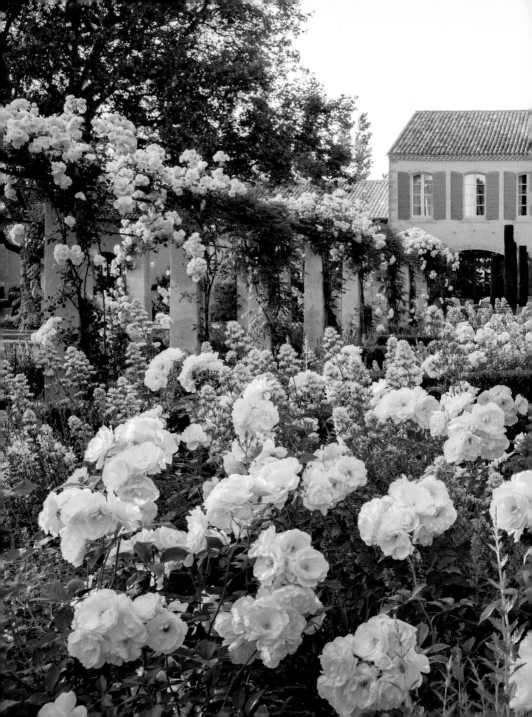

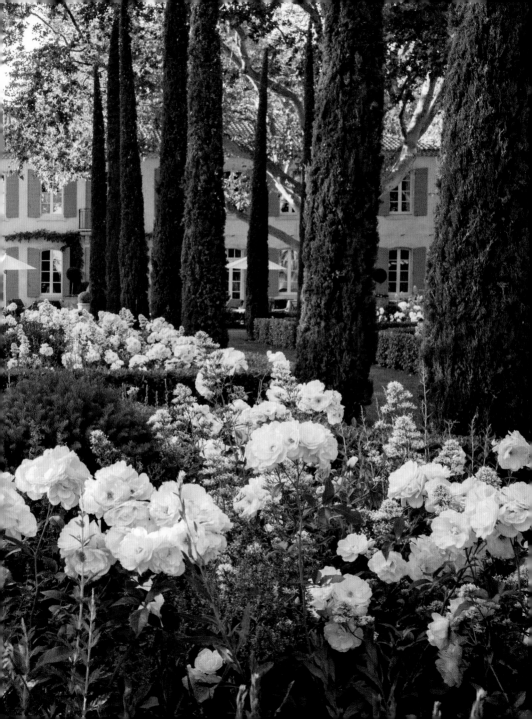

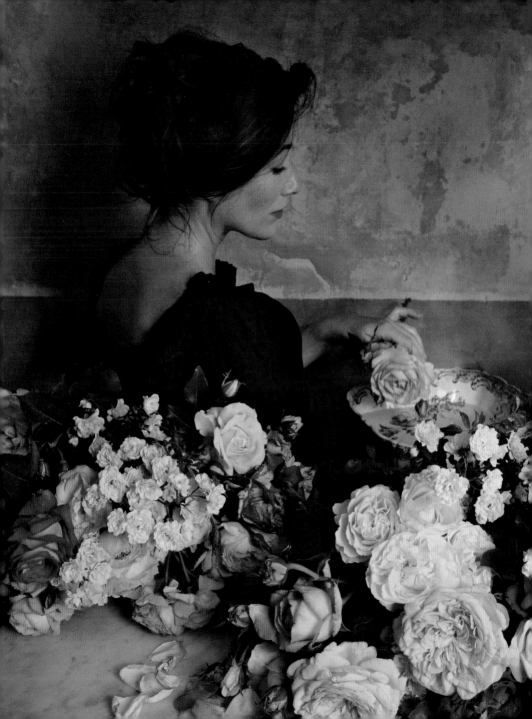

INTRODUCTION

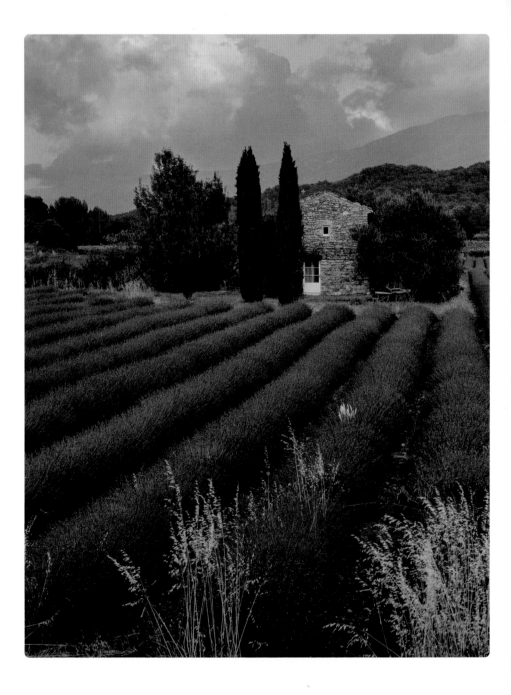

M y photography studio in Provence sits within an *hôtel particulier* in the Luberon mountains, halfway between the Alps and the Mediterranean Sea. When I moved here from Manhattan in 2016, it felt as if my whole world cracked open. Like Alice in Wonderland, I slipped down a proverbial rabbit hole and landed in a dreamscape of ancient stone streets, chateaux-studded hilltops, and endless vistas of flowering earth. It was at that moment, when the first morning light raked over the valley of purple lavender, yellow sunflowers, and climbing roses that grew outside my open windows, that I came to know this land as a living, breathing Garden of Eden.

My love affair with flowers dates all the way back to childhood. My grandmother had a garden at her home in North Texas, and when I was growing up, we would spend our days immersed in its natural splendors. Together, we watched caterpillars turn to butterflies from the confines of a mason jar and licked nectar from the wild honeysuckle that flowered on her fence line. If I close my eyes, I can still remember its sweet floral taste on my tongue. On sunny afternoons, I would play in my own imaginary world, picking up the puffy pink blossoms that had fallen from her trees and pressing them to my cheeks like blush. Sadly, when I went away to college in New York City, I left all that behind. I forgot about the natural world entirely until I moved to Provence many years later.

During my first summer in France, I sat in a field of sunlit lavender one late afternoon. As dusk descended and the moon rose, I watched the fragrant blooms bleed from purple to sunset pink to shimmering silver as the evening came to rest. The sheer beauty of that moment was both spiritual and surreal, a memory I will never forget. That same year, I stopped at a field of wildflowers while out on a long country walk. As I stood there, I began to see a whole micro-universe I had never noticed before. Everywhere I looked, butterflies fanned their wings next to ladybugs, red-and-black gendarmes, and dragonflies, while striped bees,

with bodies so rotund it baffled the mind how they stayed afloat, hovered drunkenly over a sea of perfumed flowers. I was so disconnected from that awe and awareness in my adult, career-focused life that coming here made me feel like a child again, lost in the daydreams of my grandmother's garden.

Today, I photograph the flowers of Provence to nurture that spirit of awakening. In the process of doing so, I've become much more attuned to the sensory world around me. With a deep breath in, I can smell the rosemary, thyme, oregano, and fennel that grow wild on sun-kissed hills. For thousands of years, these same hills have been laced with grapevines and orchards producing figs, almonds, lemons, and pomegranates. In many ways, Provence is one big, magnificent garden. Cultivated since prehistoric times, it has been a crossroads for everyone from the Ligurians to the Greeks and the Celts, and today, Roman ruins, medieval castles, Romanesque chapels, and crumbling châteaux are testaments to the many hands that have shaped this fabled land. Generations of farmers still tend to their fields, and secret gardens sit behind the high walls of centuries-old *bastides*.

As a photographer, I find nothing more pleasing than the wild, austere aesthetic of south-eastern France, with its flowering fields, perfumed markets, and patchwork textures of stone and earth. The searing sun and mighty mistrals make this place a land of extremes, and yet the craggy cliffs and rocky hills contain no shortage of gifts. In Provence's forests and valleys, mushrooms, berries, truffles, and wildflowers reveal themselves to those who know where to look.

Today, flowers are as much a part of the culture in Provence as the daily bread, local honey, rosé wine, and stone architecture. Every small village has its own flower shop, and the florist is as important as the local butcher and neighborhood baker. In that sense, flowers in France are like food—not a mere luxury but an essential part of life.

The village of Apt, where I live, lies in the light-filled Luberon Natural Regional Park within France's Vaucluse region. It's a charming village and home to one of the oldest and most visited markets in all of Provence. Since the sixteenth century—and, some argue, long before that—local farmers and growers have been bringing the fruits of their labors to

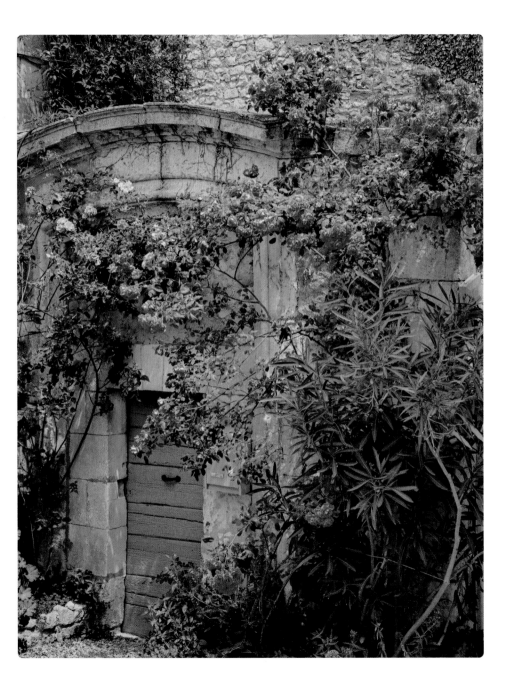

town in a buzzing, open-air exchange every Saturday. Everyone who comes has something to offer, from the vegetable vendors to the cheesemongers to the growers selling flowers clipped fresh from their farms. On my weekly visits to the market, I've met many wonderful people who have dedicated their lives to the Provençal terroir. There's a woman named Violette who comes every Saturday. Her table is an ever-changing display of local produce, from colorful peppers and tomatoes to squash and zucchini. My favorite of all are her seasonal bouquets, each of which is lovingly grown and tied up with string, be it irises in spring, cosmos in summer, or zinnias in autumn. Violette smiles when she sees me returning for her flowers, knowing that most likely they will be memorialized in my photographic work. We have a mutual admiration for each other, though it's not always a blissful friendship. For instance, there are days when she refuses to sell her bouquets, for they are simply "too beautiful to sell," a maddening yet inspiring aspect of French culture, knowing that not everything has a price, and certainly not beauty.

Markets aside, I'm convinced that one of the best ways to get to know the many flowers of Provence is by traveling through the countryside, be it on foot, in a car, or on the seat of a bike. Over the years, some of the most surprising discoveries have revealed themselves in a quiet farm field or a sleepy medieval village just beyond the crest of a hill.

I encountered my first Provençal sunflowers while driving to the ancient coastal city of Arles. On the horizon, fields of gold glowed under the sun, beckoning me to stop. Dry earth cracked beneath my feet as I walked through the maze of towering stalks. The humming of bees drowned out every other sound as the sunflowers' heads, large as dinner plates, shone like the sun itself in the white of daylight. It was hard not to think of Vincent van Gogh in a place like this. After all, it wasn't far from here, in his Yellow House in Arles, where he painted some of his most famous floral canvases. Lifting my face to the sun, I soaked in its warmth before continuing my journey.

Every morning, I head outdoors inspired by moments like these. In the process, I've become a forager, taking part in the historic French pastime of bringing nature into my home.

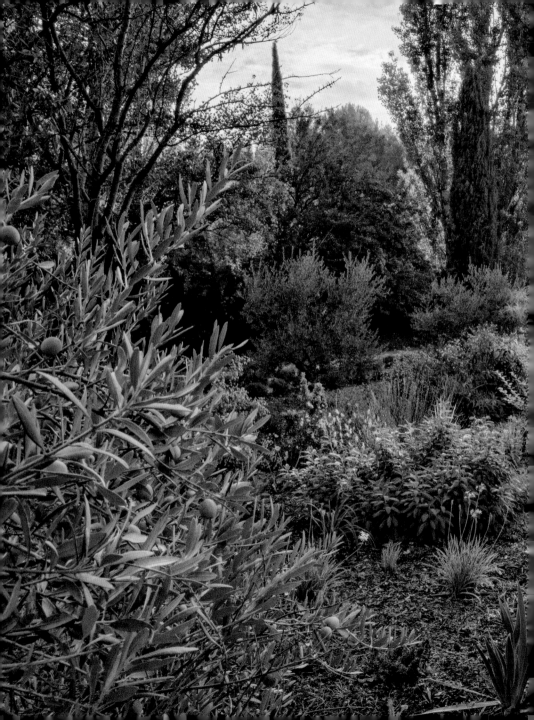

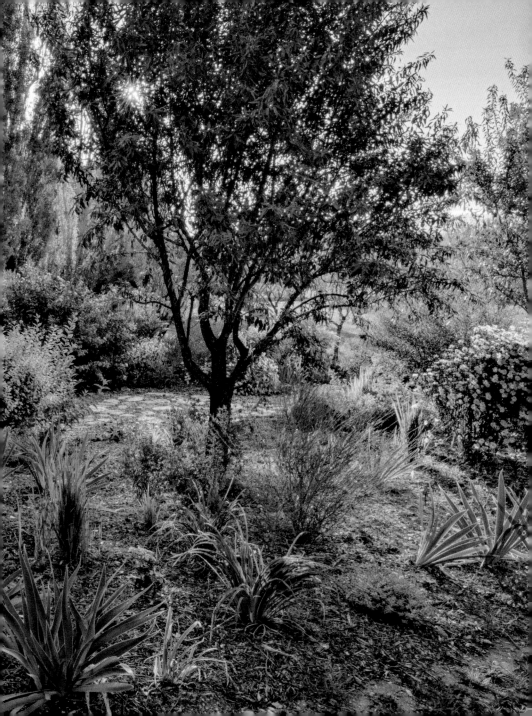

The very first flower I ever foraged for my studio was an iris I passed while out on a Sunday stroll. Bending down, I took the blossom in my hand and marveled at its exotic silhouette. There's something otherworldly, almost sea creature–like about the iris, with her ruffled beard and waxy skin. Bringing it to my nose, I inhaled the seductive scent, a perfume that could be described as the early morning dew of springtime in Provence. To this day, I'm still drawn to the iris's beguiling form, the surprising places I find her, the old-world tonalities she possesses, and the photogenic nature of her beauty. She is quieter than most flowers, but for those who come to appreciate her, she fuses to the soul.

To my delight, the endearing ritual of giving flowers is still a part of everyday life in Provence. It's such a simple gesture, and yet there's something so sweet, sincere, and humane about it. As the seasons change, so, too, do the flowers here, and the many reasons for giving them. Throughout human history, flowers have been given in sickness and in health, in joy and in sorrow, in friendship and in love. Sometimes, they're given "just because," and in France, cultural tradition alone can be reason enough. Every week, my village florist and the market-day flower vendors stay busy helping customers make their floral selections before wrapping them up with colorful paper, ribbons, and bows.

I can still vividly remember cutting roses back in my grandmother's North Texas garden in the early morning light under her guiding hand and presenting the small bouquets to my teachers at school. The gifts brought smiles to their faces and mine and left a lasting impression on my heart. Here in Provence, the tradition continues with my daughter, Eloise. On her final day of *maternelle*, or preschool, we sent small bouquets of chamomile to the teacher and her aides, not just as a thank-you but as a sign of the peace and restfulness we hoped the end of the school year would bring.

Often, I find myself thinking about what it is that makes flowers so universally appealing. Beauty, diversity, and symbolism aside, I believe there's a morsel of magic at play. Every day, I strive to conjure that magic in my studio. There's a quietness to this craft and an intimacy that comes from working with something so fragile and fleeting. Because of this, I partake in the

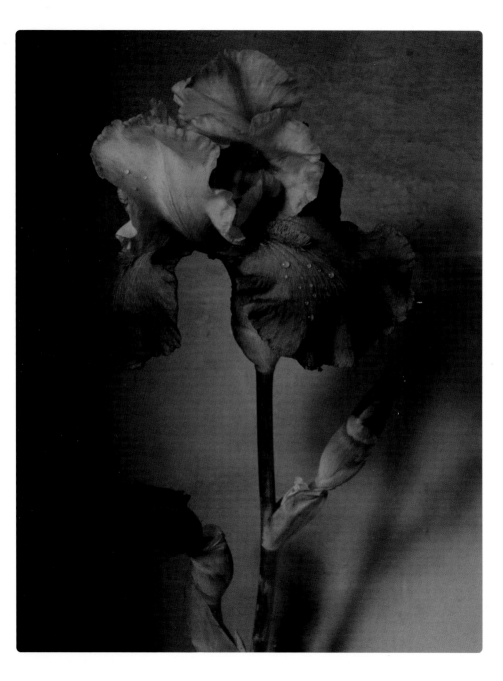

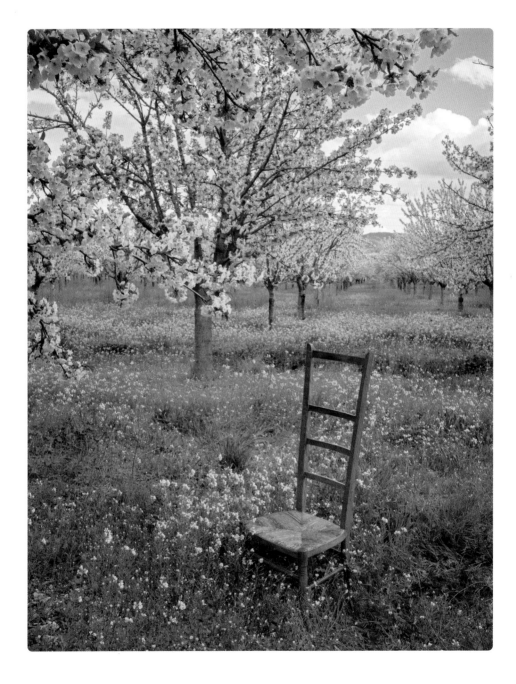

process tenderly. Maybe cutting a flower and bringing it into your home is no different a sacrifice than slaughtering an animal for a meal; either way, it's deserving of respect and gratitude, as is anything in life that takes time and energy to grow.

These days, it's dizzying to think of all the things I wish to create. It reminds me of the quote by the French painter Claude Monet, who once said, "Every day I discover more and more beautiful things. It's enough to drive one mad. I have such a desire to do everything, my head is bursting with it."

During lockdown in France, I channeled that sentiment with an Instagram series called #IsolationCreation, for which I created a new photograph every day for sixty days. Each morning as the sun climbed over my village, I foraged for fruits and flowers to incorporate into my still lifes. Like Henri Matisse and Paul Cézanne, who lived here before me, I became engrossed in light, shadow, color, and composition, from the spacing of a petal to the texture of a stem. In the confines of my studio, I slipped into an isolated world of intimacy with flowers.

Flowers became a source of salvation and creative expression beyond anything I could have imagined during the pandemic. It's amazing how much one can appreciate a flower when it's all one has to hold. In a moment of darkness, #IsolationCreation showed me that creativity is endless, and so, too, are the ways that flowers make us feel. The curve of a tulip, the suppleness of a rose, and the overwhelming perfume of a hyacinth in bloom became something altogether different through the lens of my camera. Best of all were the surprise guests that would find their way into my still lifes, be they a bright green caterpillar, a spotted ladybug, or a tiny French snail. My photographs are invitations to quite literally stop and smell the roses, to lean in and enjoy all that's good and beautiful in the world. Every picture is a love letter to Mother Earth, telling stories of a landscape touched by sun and scent.

Of all the teachers I've had in my life, Provence has taught me the most about how to live well. Perhaps the greatest gift she's given me yet is an acute awareness of life's beauty and brevity. Cut flowers, be they butterfly ranunculi or melon-colored roses, are a great metaphor for this, and keeping them around has taught me to better enjoy the present moment.

Today, I'm a firm believer that there is much we can learn by getting outdoors and watching the ballet of nature unfold. You don't need a garden to enjoy this in Provence, as a long walk through the countryside offers its own gifts. Over the years, my explorations have taken me across this varied landscape, where I've encountered private sanctuaries and storied gardeners whose hands are stained from the earth and marred from its thorns. Being an American in Provence isn't without its challenges, and while my French is limited, I've come to learn a whole new language of flowers. I might not be able to speak the words of *les fleurs* from the tongue in French, but through my photographs, I can communicate in a visual language that we all understand. To make friends with a Frenchman is a challenge, as any foreigner will attest, but being fluent in this visual floral vernacular has led me to many local growers and the glorious gardens that they keep. In the process of photographing their flowers and telling their stories in my studio, new and unexpected friendships have blossomed from the soil.

One morning I walked with Martial Florent through his garden at the foot of Gordes. Martial comes from a family of winemakers, and his studied persona stems from a deep, generational wisdom passed down over time and terroir. "I tried wine, and it wasn't for me, but I knew I wanted my hands in the earth," he told me as the sun rose over the garden. Roaming through the passageways, I admired the old plants from his grandfather's province, like gladioli, strawberry trees, and Mexican orange blossoms. A sweet and heady scent preceded our arrival at a leafy bush blooming with roses. Grabbing the Japanese shears from the holster on his belt, he took a stem in hand and showed me how he prunes under the first two leaves, always leaving a bit of stem exposed to ensure new growth.

For many months, I had heard about the very esteemed, very aloof rose grower Benoît Hochart, whose roses grace the entryway of five-star hotels, cultural centers of Provence, and even royal weddings. It took me years to find him, and even then he refused to meet me until a mutual friend gifted me a bouquet of his roses, which I passionately photographed for a week. When they shared my work with him, he finally agreed to meet in person. As we walked through his rose garden, it looked as if a rainbow had dropped from the sky and

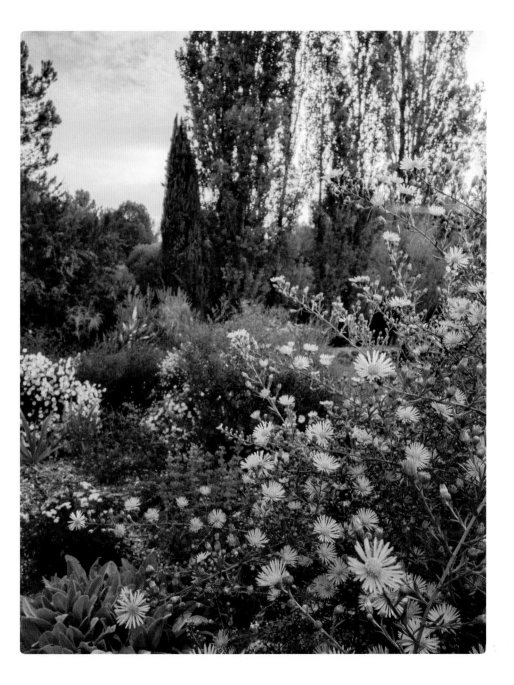

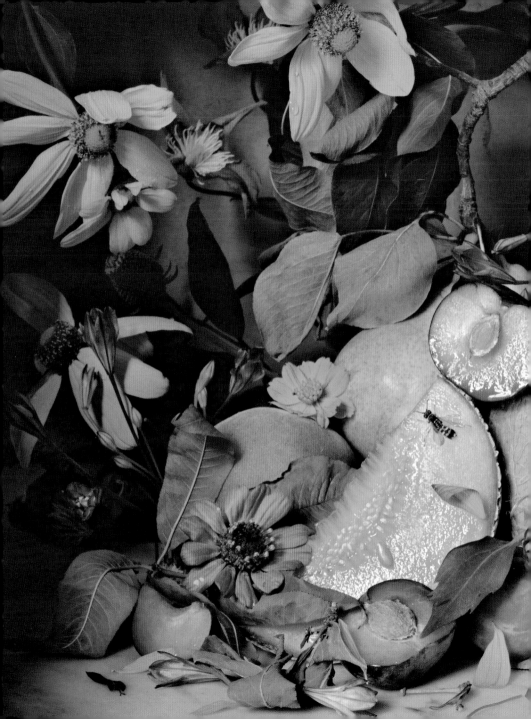

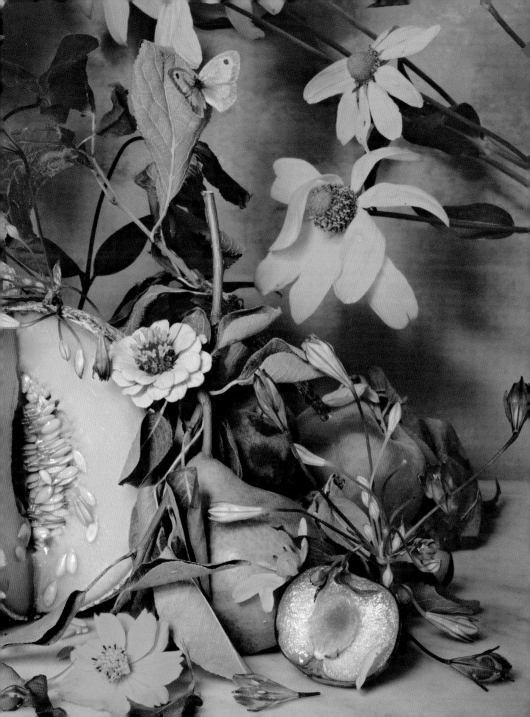

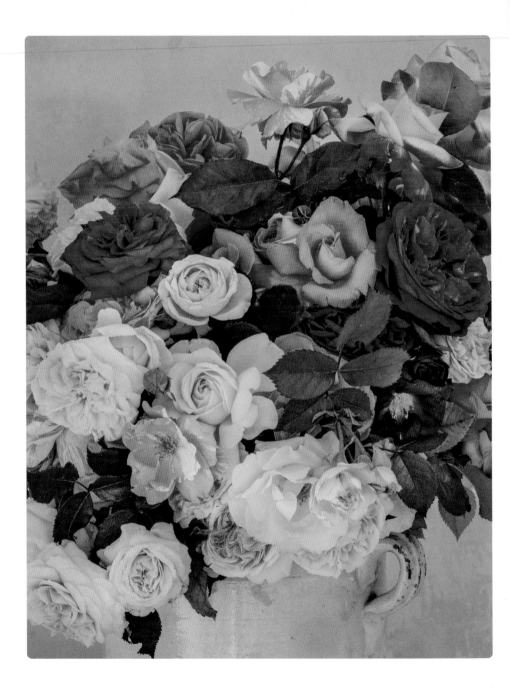

onto the bushes before us. I listened as he lovingly introduced each flower varietal by name, like his own beloved children. Growing up in a strict household, Benoît told me, he found comfort in the softness and elegance of this classic flower. It was only later, however, while working with Paul Croix, a rose specialist who created varieties in St. Étienne in the Loire, that he caught "rose fever," or "*le virus du rose*": "I found through the rose the question of mastering the beauty, grace, and elegance I longed for."

Up until this moment, I had seen many roses in my life, though never had I experienced any quite like the Sweet Love, a creamy, peach-colored bloom with fairy-tale folds that reveal a perfectly spiraled center. Its scent was intoxicating, and so was its beauty; I came to find out that this was Benoît's favorite, too. Kneeling down, he carefully clipped the rose from its bush and handed it to me as a symbol of our new and budding friendship.

In the seven years since I moved to France, I've experienced exquisite beauty in these local gardens. In the process, I've also discovered storybook locales, like the Jardin Abbaye de Valsaintes, located not far from my village. Jean-Yves Meignen is the keeper of this eleventh-century abbey's enchanting gardens, which are home to over five hundred varieties of roses, alongside jasmine, poppies, and an edibles garden they use for their on-site restaurant. As we walked through the sanctuary one day, he shared with me his belief that gardens should be loved, not constrained. In order to thrive, they need imagination, variety, and freedom. To walk in Jean-Yves's footsteps is to truly know *la vie en rose*. Visitors can glean a great deal from his wisdom, along with tips on natural gardening through his on-site workshops and segments on Radio France Bleu. My final question at the end of our morning walk together was, "Why roses?" His answer was simple: "I thought it would be nice for my friends."

Everything grown in Provence comes with multigenerational experience. With that, the farmers and growers who are caretakers of this land have come to notice a sizable shift in the climate. We as a global community might not be ready to collectively talk about climate change, but the farmers here do. In the immediate future, gardens will have to become more adaptable to extreme summer temperatures and harsh drought conditions. My sincerest hope is

that this book doesn't become an artifact of a land that once was a Garden of Eden but, rather, a reason to save her beauty for the generations to come.

Provence comprises three vegetation zones that create a plethora of microclimates, from the Mediterranean Sea in the south to the mountainous Alps to the north and the hills in between. Of all the garden climates in Provence, the ones that bloom just above the rocky, terraced terrain of Grasse might be the most well-known. Though originally home to the tannery industry in the twelfth century, the town's perfume heritage began during the Renaissance when fragrances were used to mask the undesirable scent of leather, particularly for ladies' gloves. Today, orange blossom, jasmine, and tuberose grow in thick carpets across the mountainous landscape, turning Grasse over the past few hundred years into the perfume capital of the world. In 2016, I was lucky enough to visit this terroir with the House of Chanel, where they harvest the famed *Rosa centifolia* for their Chanel N°5 perfume. When the car door opened at the foot of the fields, a fragrance came over me that was so intoxicating and intense that it felt like falling in love. Nothing will ever compare to the scent of those fields, with their trembling petals and powerful perfume. With the Mediterranean Sea air on my cheeks, I breathed deeply, eyes closed, never wanting to forget it.

Grasse may be the cradle of French perfumery, but roses abound throughout the region, blooming from bushes and branches, archways and arbors; they even frame shuttered windows and explode from the tops of cypress trees. In the center of my village, there's a quaint cobbled courtyard tucked behind a wrought iron gate near the local café. There in the corner, growing like a beanstalk to the top of a multistory, fairy-tale building, is a massive climbing rosebush with the prettiest yellow flowers.

More than ninety years ago, this flowering rosebush was planted by a young girl and her father. That young girl later became Madame Kremer, who went on to live in the same building until her death last year. There's something so special about the journey of this once small yet sentimental rosebush, which grew taller and taller over the course of one woman's life, scenting the walls and open windows of the place she called home. In my own garden, Eloise and

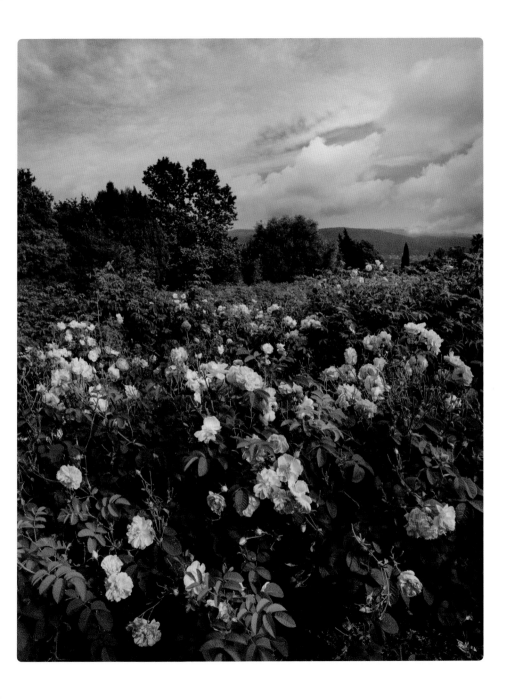

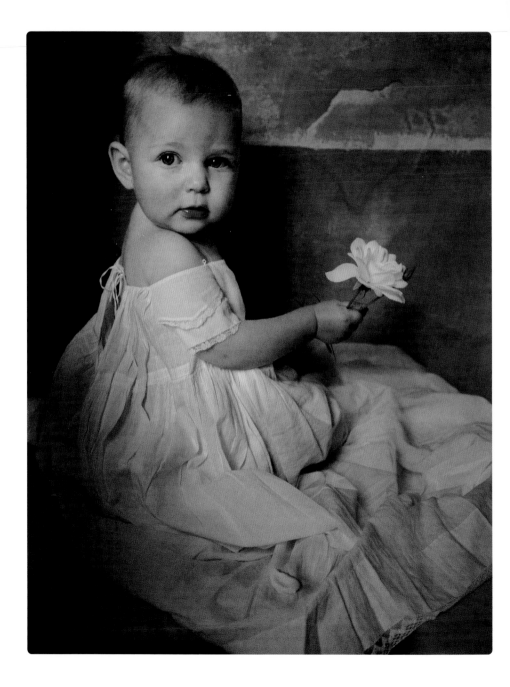

I have planted climbing roses as well. It delights me to think of the ways they'll keep growing after I'm gone. Perhaps one day, our roses will inspire the next generation to ponder the distant memory of a mother's unyielding love for her child. This is why roses are so special here; they climb not only through our physical spaces but through lifetimes and generations, touching everything and everyone in their path.

In Provence, the diversity of the flowers that grow across the landscape is rivaled only by the number of their everyday uses and applications. Indigo blooms, for example, are called the "blue gold of the Luberon" for their covetable pigment, which is used to dye clothing and linens. Plants such as valerian and sage are employed for medicinal purposes, and it's not uncommon to find homeopathic pharmacies here stocked with hundreds of varieties of medicinal plants, herbs, and flowers. Others are tied to religious holidays and spiritual traditions. Chrysanthemums, for one, are commonplace at French funerals and on All Saints' Day, as their ability to weather the winter frost has made them a symbol of immortality.

The Provençal are incredibly resourceful with their flowers. Apart from the bouquets, wreaths, and garlands that adorn local homes, flowers are often part of the everyday cuisine, from wild ground elder to stuffed squash blossoms and herbaceous honeys. Their intoxicating scents have been melted into soaps, candles, and oils of all kinds, while herbs such as lavender are used as room fresheners and bug repellant, especially in the home armoire.

These days, I like to think of myself as a student in Mother Nature's classroom. With every season, I study her shapes and changing light, wondering what gifts each dawn will bring. Spring is my personal favorite time of year. When the earth awakens from its winter slumber, locals forage the hillsides for wild asparagus and ramps. As the first flirtatious breezes signal the start of warmer days, pear trees burst with billowing flowers, and strawberries and artichokes appear like magic in the markets. Even the cheese here tastes more earthy and floral, as animals graze on spring's young grasses and wild herbs.

By May 1, petite bouquets of lily of the valley are for sale on every street corner and in flower shops across Provence to mark the start of France's annual May Day celebrations. The ancient

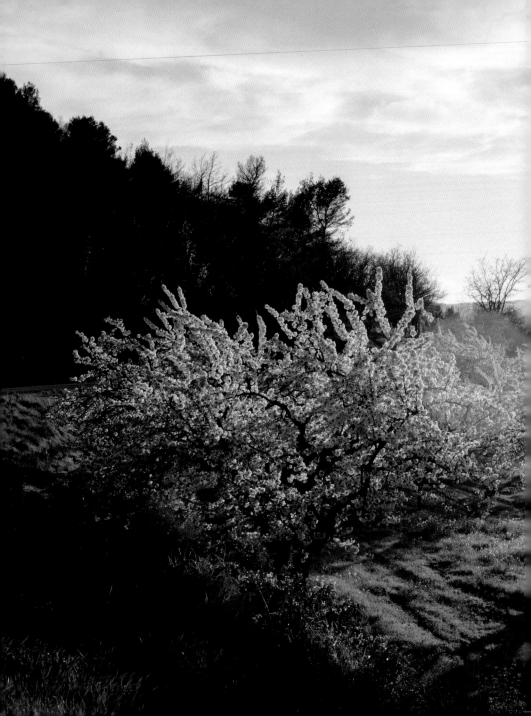

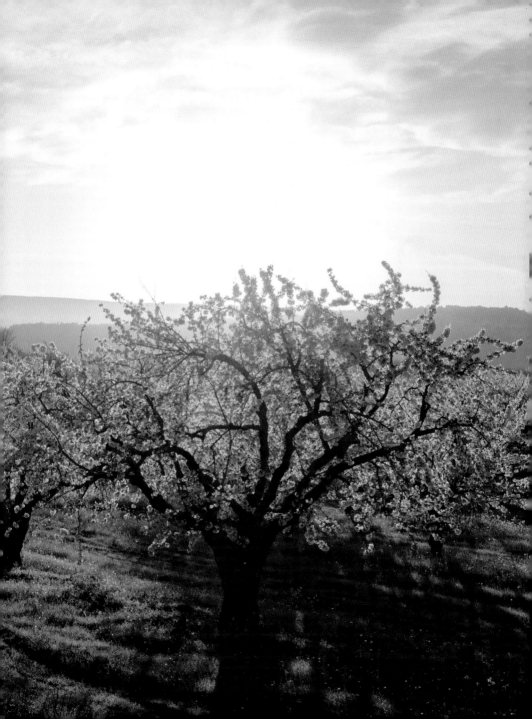

custom of sharing lily of the valley—or *muguet*, as it's called here—with loved ones dates back to the mid 1500s, when King Charles IX was given the flower as a token of good fortune. I first experienced this when my eighty-year-old neighbor, Madame Jackie Bouyer, left a small bouquet bundled with burlap on my doorstep as a gesture of goodwill to a foreign stranger. To me, there's something so lovely about this timeless tradition that has endured over centuries and continues to ring out from these delicate white floral bells. Ever since, I've returned the tradition of good luck with my own gifted bouquets to Madame, and to all the friends I've made here over the years.

One of my favorite flowers and springtime discoveries happens to be one of the most symbolic in all of France. The iris, or *fleur-de-lis*, has represented French royalty since the thirteenth century. The three petals of the *fleur-de-lis* signify wisdom, faith, and chivalry in the French monarchy, while in the Catholic religion, they represent the holy trinity and its virtues. Irises, the national symbol of France, pop up everywhere in late spring, especially along the roadsides and the edges of old stone villages. In one of the most poetic visual moments of my life, I stood in a sea of purple irises hidden beneath the majestic Mont Sainte-Victoire. Apart from a woman hanging laundry on a clothesline in the far distance, I was alone, and amazed at how in a world that's seemingly busier, faster, and more crowded than ever, I could find myself in solitude with such magnificent beauty. I never knew irises until I moved to France, and I never belonged to a community of people, either. To my delight, I have fallen in love with both.

As spring turns to summer, the irises, lilacs, and wisteria fade, making room for something new. Soon the markets are bursting with color as farmers harvest their plums, grapes, and sweet melons. In the village squares, men sip pastis in the shade of tall trees as the cicadas sing their seasonal symphony. The summer heat touches everything here, baking into the earth and surfaces of old stone. By evening, the temperatures dip ever so slightly, and the countryside breathes a sigh of relief. Meanwhile, outside the town, poppies, sunflowers, and lavender turn the countryside into a kaleidoscope of colors.

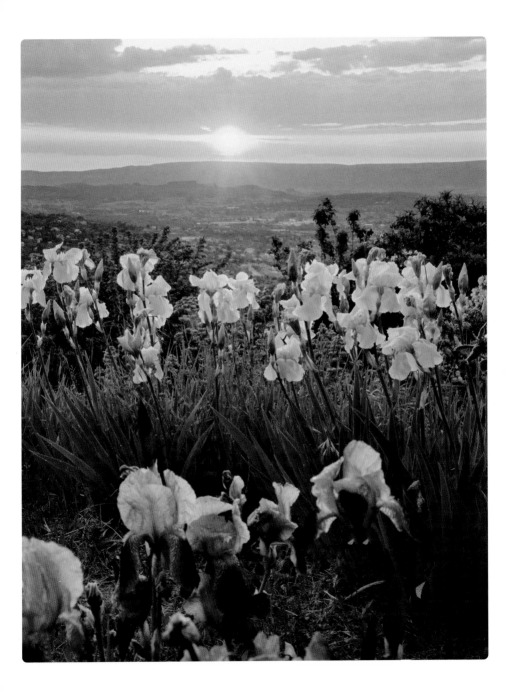

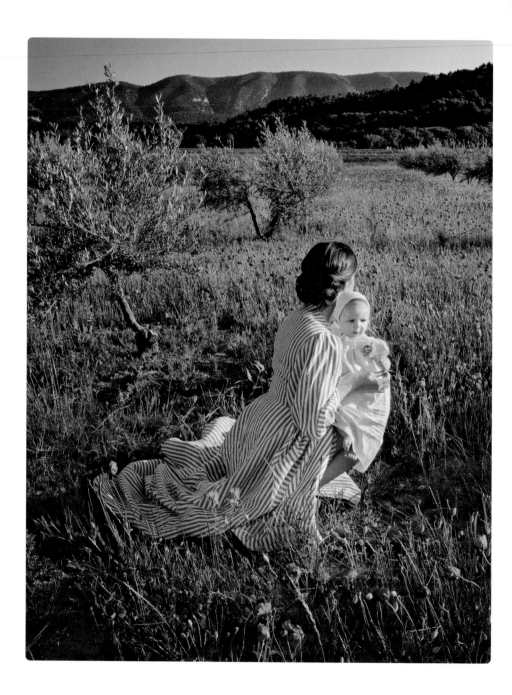

There's something almost sacred about the poppy flower, whose brilliant bloodred petals glow like stained glass in the summer sun. It amazes me how these flowers can survive intense rains and strong storms, but the moment they're picked from the earth, they lose their vitality, and the petals fall away into the wind. Determined to create a photograph and successfully transport them back to my studio, I discovered through trial and error that immediately burning their cut ends seals in the moisture. Often, I find poppies, along with other flowers like the delicate ruine de Rome, blooming between ancient steps or from old, crannied walls. Once again, Mother Nature imparts her wisdom, reminding me that wonderful things can grow from the tiniest openings in life.

Poppies aside, nothing says summertime in Provence like endless fields of purple lavender. There's a lavender field by my village that I love to visit every June, when the buds are young and at their most vibrant. The field sits at the base of a steep climb below the hilltop village of Saignon. There in the center of the neat rows is a picturesque stone farmhouse with a lovely terrace where a small table sits in the sun. People in Provence don't shy away from such pleasures; they build these little worlds to enjoy, even if for no one but themselves. I like to daydream about what it would be like to live there and wake up intoxicated by the scent of lavender year after year, a fairy-tale home afloat in a purple flowering sea.

As summer slips to fall, the light in the Luberon takes on a new hue. Tractors hauling grapes signal the start of the harvest season, and soon the air is cool. September in Provence feels like a second spring, softer and sweeter after the scorching summer months. Somehow, the flora and fauna have endured the heat for another year, and I always marvel at how the roses come to bloom anew in autumn, when the markets are filled with mushrooms, pears, and ruby-red pomegranates freshly torn from their trees.

As the year ends, frost covers the ancient stone streets in my village and a roaring fire crackles in our hearth. I find both color and comfort in the yellow mimosa flowers that brighten the market on these gray-and-black days. When the holidays come and go along with the season's truffles, I await the frosty mistral and the blooming almond trees. Even the darkness of winter

can't stop the ranunculus from blooming or the birthdays from coming, or the years that keep on passing. Even then, there's a little bit of light, just enough to fill our innocent hearts with hope for a better tomorrow, until we find ourselves again under the spell of spring flowers.

There's something reassuring about each of these four seasons and the cyclical nature of life itself. When I work in my garden, I remember this seasonality and feel the presence of my beloved grandmother. Though it has been many years since she passed away, I know for sure that she lives on within me. Now, when I plant tulip bulbs with my daughter, I feel that presence within her, too, with every handful of dirt we dig and with every flower that comes to bloom. One day, I'll be a grandmother myself, and the cycle will continue in perpetuity with every blossom that graces our earth.

When I look at my white iceberg roses, I see this continuity quite poignantly. On any given branch, every stage of life is represented, from the newly formed bud to the fully realized rose to the fading bloom bereft of its petals. The garden allows us to see what life is—an ever-evolving picture of living and dying, beauty and wonder. We are all flowers, the same and yet vastly different, our diversity and depth mirrored in the nuance of scent and silhouette. To study that and touch it, and know that it will continue indefinitely, makes us a part of Mother Nature for eternity.

Without flowers there is no life, and there are no fairy tales, either. Here in Provence, both exist in this place where dreams end and reality begins. I choose to live amongst the châteaux, to dance with the butterflies in the winds of the mistral, and to lie naked among the poppies. In many of my photographs, the flowers pictured are cascading from vases or spilling out of earthenware jugs. It's a fitting image for how I feel. My cup runneth over with gratitude for the opportunity to live and work here amongst the next generation of Provençal artists. Whether it's a momentary transport to fields far away or a spark of motivation to plant your own garden, create your own art, or find joy in the place you call home, my hope for you is that this book brings beauty to your life, as Provence has brought to mine. Perhaps you might even see yourself reflected in the fragility and nuance of nature or the personality of a flower

in bloom. As you flip through these pages, I invite you to stop and smell the perfume of lavender and rose, to take in the magic of a butterfly's wings, and to listen to the sounds of bees and birdsong. Walk with me down Provence's ancient stone paths and allow me to show you the magic through the lens of my camera. What I found here in France's magnificent garden is out there for you, too, buzzing, blooming, and waiting to be discovered.

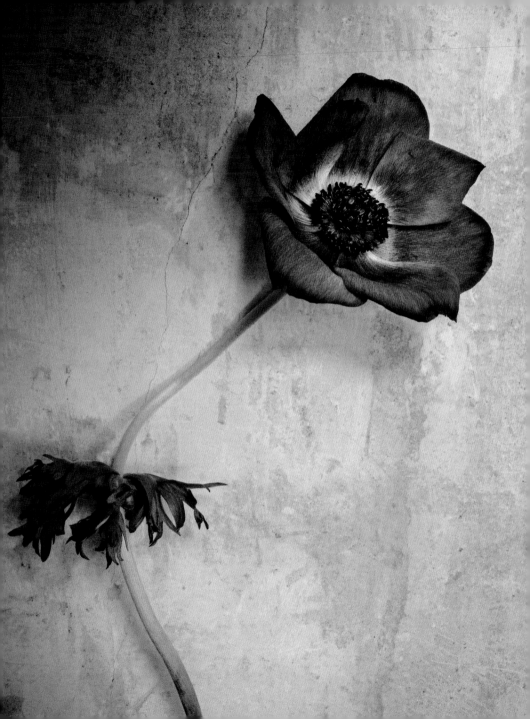

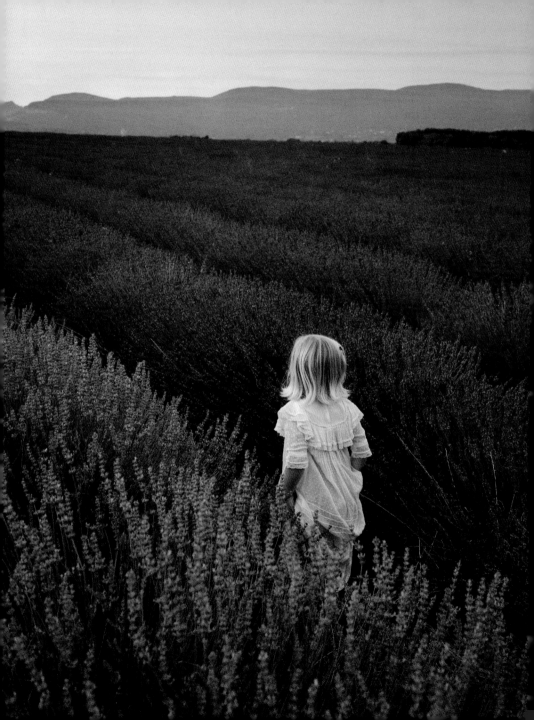

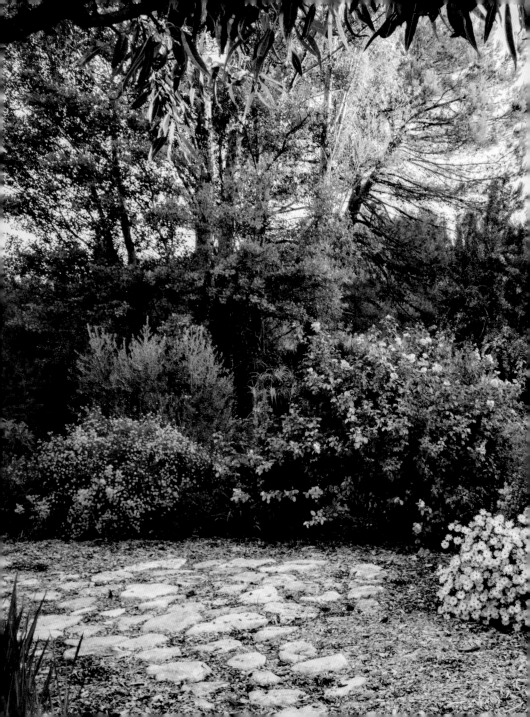

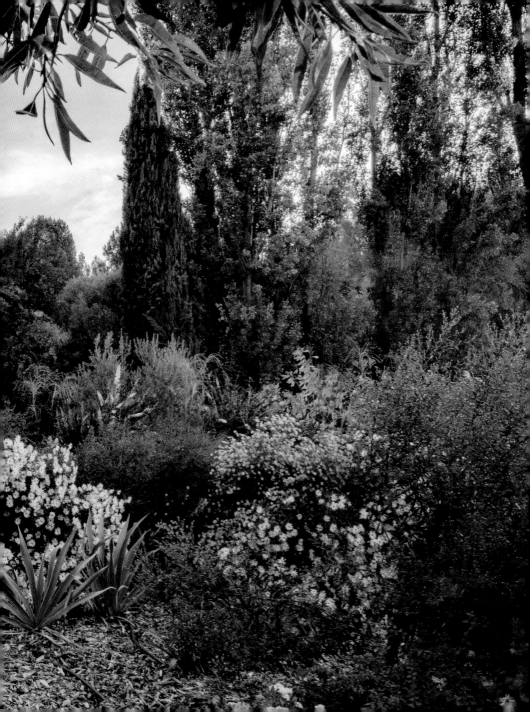

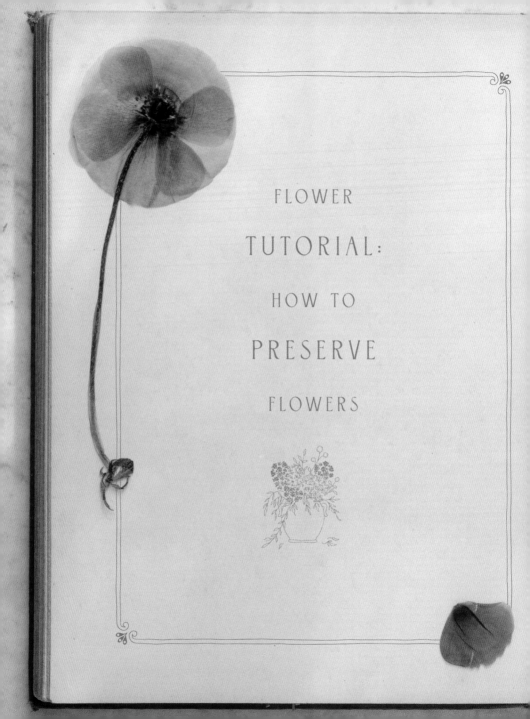

FLOWER TUTORIAL:

HOW TO

PRESERVE

FLOWERS

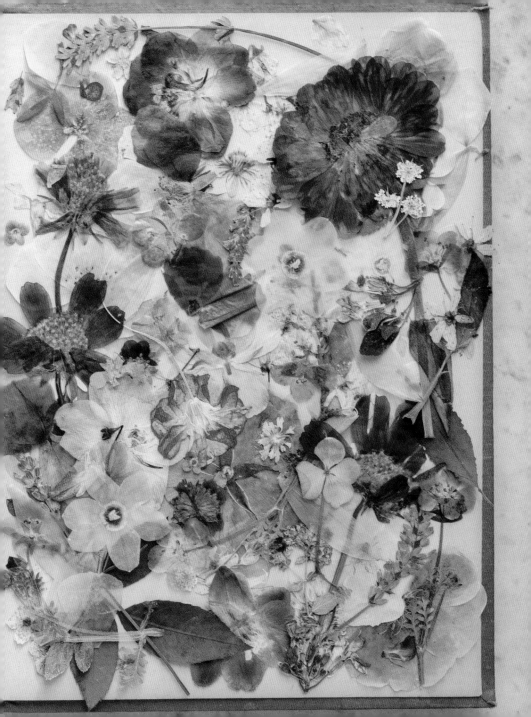

FLOWER TUTORIAL

Just next to the bike trail that cuts through the landscape between Goult and Menerbes is a field of ever-changing flowers—from sunflowers to peonies, zinnias to hydrangeas, roses, and linens—all tended to by Florie Meyssard. Florie's family history of farming goes back so many generations that she's lost track. "My family is a long generation of farmers in Provence [growing potatoes, *gourdes* (pumpkins), artichokes, and other heritage vegetables]. While I help to grow heritage vegetables, my true passion is flowers," she tells me as she slides open a large pale blue barn door, revealing an ocean of dried flowers. Layers upon layers of lines strung up between piled stone walls under vaulted wooden rafters suspend endless bouquets from the most delicate of buds to robust saturated peonies still rich in stunning color. I cup my hands over my mouth to mute my audible gasp. "It's like a forever rainbow!" I tell her. Florie might be a contemporary flower farmer nestled away in her farming heritage, but she's truly a dried-flower artisan.

The smells and textures immediately bring back memories of drying flowers with my grandmother on her southern porch, and for a moment I'm that innocent child again, idling away the days doing craft projects before iPhones and the internet existed. Aside from the obvious beauty of dried flowers, I ask Florie why she does this. She tells me, "I have a memory from when I was young of my grandmother. They always had dried buckets of flowers around the house as *objets de décoration*." I realize that she and I, across the globe from each other in childhood, were both given this same memory of our grandmothers that lives on within us, just as drying flowers allows for the memories of summer to live on in our homes.

Florie continues to explain, "I would go to the Sunday market in Coustellet to see an elderly woman who would grow great flowers, and I would dry them with my family. I like the smell and the texture of dried flowers. It's an interesting way to keep their beauty alive for years to come. In general, we buy fresh flowers, and after a week we throw them away. I feel sad when I have to put them in the garbage, so drying became a way to preserve their beauty." A process that couldn't be simpler for the lasting effect these dried flowers have on one's home and memories of time spent with the ones we love.

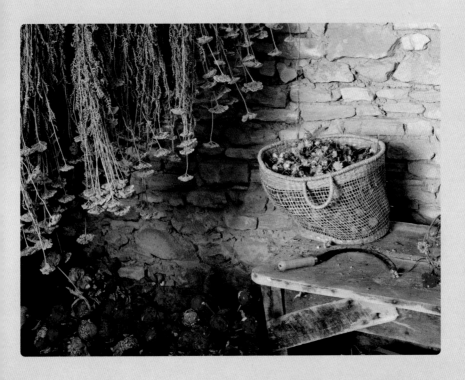

TOOLS NEEDED

i.

SHEARS OR SCISSORS

ii.

NATURAL TWINE OR STRING

iii.

GLOVES (DEPENDING ON FLORAL VARIETY)

iv.

DARK AND DRY ENVIRONMENT

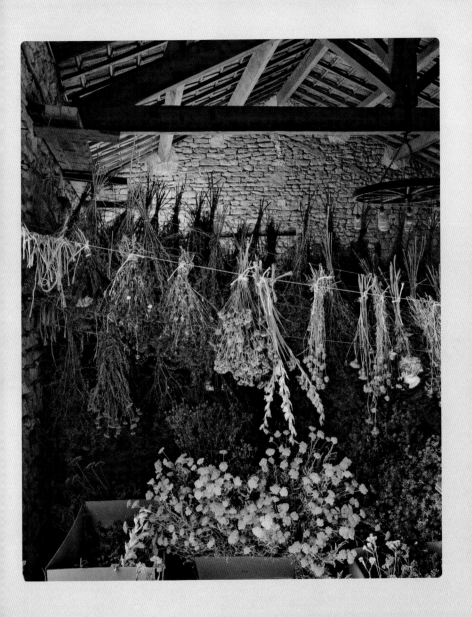

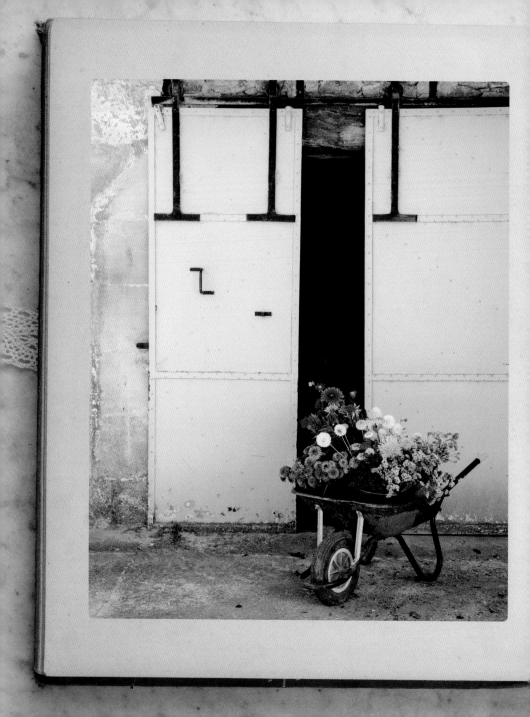

FLOWERS OF PROVENCE
THAT WORK WELL FOR PRESERVING/DRYING

---❧---

i.

SUNFLOWERS
TOURNESOLS

ii.

PEONIES
PIVOINES

iii.

YARROWS
ACHILLÉE

iv.

STRAWFLOWERS
IMMORTELLES

v.

HYDRANGEA
HORTENSIA

vi.

ANNUAL HONESTY
LA MONNAIE DE PAPE

vii.

LAVENDER
LAVANDE

viii.

LOMELOSIA STELLATA
SCABIEUSE ÉTOILÉE

ix.

BABY'S BREATH
GYPSOPHILE

x.

ZINNIAS
ZINNIA

xi.

ROSE PETALS
PÉTALES DE ROSE

xii.

ORNAMENTAL GRASSES
GRAMINÉES ORNEMENTALES
(CAREX, FESTUQUE, STIPA, PENNISETUM)

xiii.

WOOLFLOWER OR COCKSCOMB
CELOSIA CRISTATA
(COMMUNÉMENT APPELÉE AMARANTE CRÊTE DE COQ)

TO BEST PRESERVE THEM

—·❦·—

Step 01 Cut or select flowers (depending on the variety, blooms can be tighter buds or open) with shears.

Step 02 Remove all the leaves from the stem and surrounding the flower bud to create a single long stem.

Step 03 After collecting around ten pruned flowers, hang them upside down in a bouquet tied with natural twine or string.

Step 04 Flowers should be hung in a dark, dry environment, as sunlight will bleach, or remove the color from, the flowers. The ideal place is a barn, basement, or closet with very little to no humidity, as that will cause the flowers to rot instead of drying. The drying time is dependent on the species of flower—for example, sunflowers take up to three weeks to dry.

Step 05 You can keep flowers preserved by using a light hairspray to lacquer them after the drying process. (optional)

Depending on the variety of flower, gloves may be needed for Steps 1 or 2.

WHAT TO DO WITH DRIED FLOWERS

———❦———

Nº 01

Create bouquets, as you
would with fresh flowers,
in vases for the home or table

Nº 02

Make wreaths or garlands
for decoration around the
home, interior or exterior,
or to hang on doors

Nº 03

Make flower crowns

Nº 04

Make potpourri for the
home or to be thrown at
ceremonial events such
as weddings

*You can clean dried flowers on display in your home with a
hairdryer set on the cool air setting to blow away dust.*

TO CREATE POTPOURRI
WITH YOUR DRIED FLOWERS

❖

Step 01 Collect fragrant flowers such as lavender or roses, or even herbs such as mint.

Step 02 Pull lavender buds, rose petals, and mint leaves from their stems and spread them out to dry in a single layer across newspaper or atop a mesh drying rack in a dark, dry environment.

Step 03 Once the flowers have dried, add a few drops of essential oil to the mix for a stronger fragrance and let dry for another day or two.

Step 04 Mix the petals, then place in vases or bowls around your home for room fragrance, or in sachets to be hung amongst clothing in a closet or in drawers. The potpourri can also be distributed in baskets or in individual sachets at ceremonial events to be thrown into the air.

Potpourri can be kept for up to five years and refreshed from time to time by spreading the dried petals out atop newspaper and reapplying essential oils.

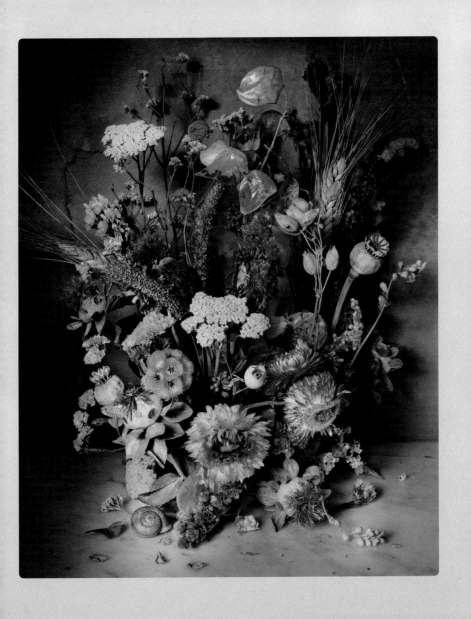

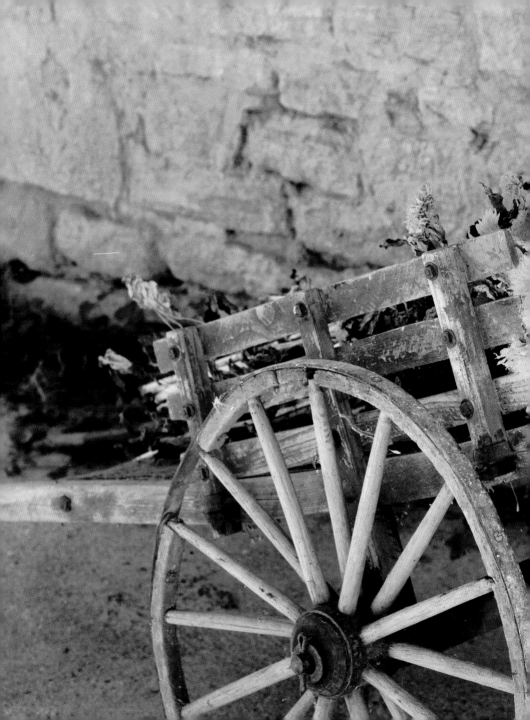

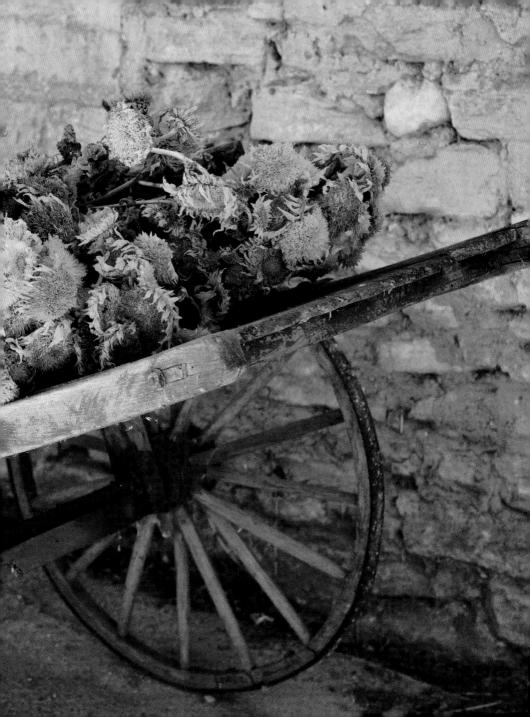

TIPS FOR CUTTING AND PRESERVING
FLOWERS FOR THE HOME VASE

with Provence Floral Artisan Helen Puillandre

———————❖———————

Nº 01 Cut flowers in the early morning, or at least before ten a.m.

Nº 02 Always cut at an angle and with very sharp shears to reduce infections.

Nº 03 Strip all the leaves and foliage from the bottom of the stem or anything that will be submerged in water.

Nº 04 Put cut flowers straight into water.

Nº 05 If buying precut flowers, bring a plastic bag with damp paper towels to wrap around the ends to transport, and recut the ends when you get home before placing in a vase.

Nº 06 Flowers with woody stems, such as hydrangeas, should be banged with a hammer to break the ends in order for the flower to drink.

Nº 07 Cut a one-inch slit into flowers with sturdy stems, such as roses and sunflowers, when preparing for a vase so the flower can drink more water, prolonging its life span.

Nº 08 To revive limp flowers, make a fresh cut in the stems and put into boiling water, so the hot water shoots directly up to the head. Remove, recut the ends, and place in cool water.

N° 09 Don't worry about putting plant food in the water. Refreshing the water is more important and impactful.

N° 10 To prolong the life of flowers in the vase, wash your vases really well, and replace the water with fresh, cold water every day or every couple of days.

N° 11 When changing the water, rinse and recut the ends of the stems before returning to the vase.

N° 12 Keep flowers on display away from direct sunlight, and leave them outside in the evening to "breathe" cool air.

N° 13 Flowers love cold water. Add a couple of ice cubes (but not too many) to help keep them fresh.

N° 14 To perk up dying hydrangeas, you can plunge the entire head into a bucket of cold water.

N° 15 To perk up limp roses, you can fill your sink and allow them to lie in the water for a minute or two to rehydrate.

N° 16 To create beautiful shapes in your arrangements, fill the hollow of the vase with chicken wire (which can be reused) to support the flower stems in an interesting array.

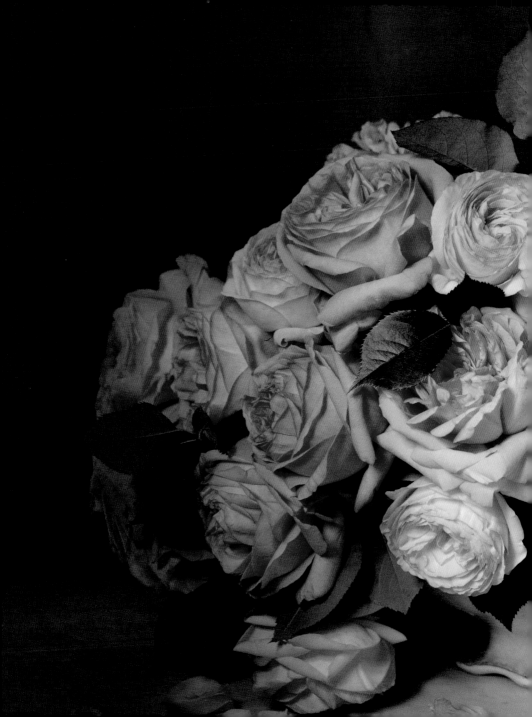

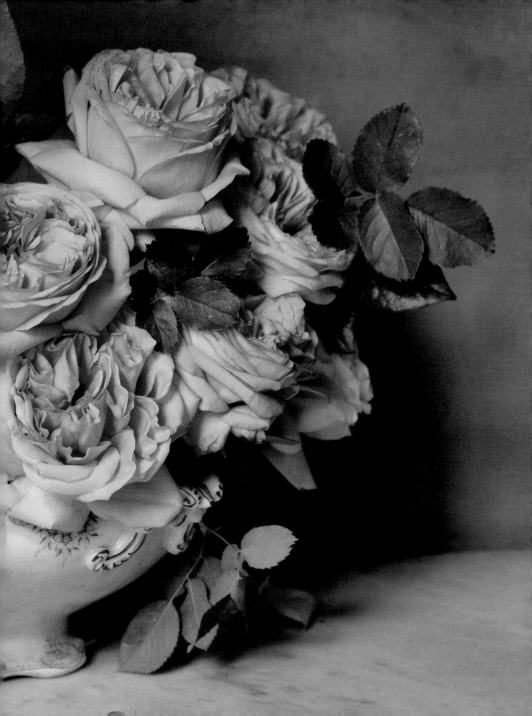

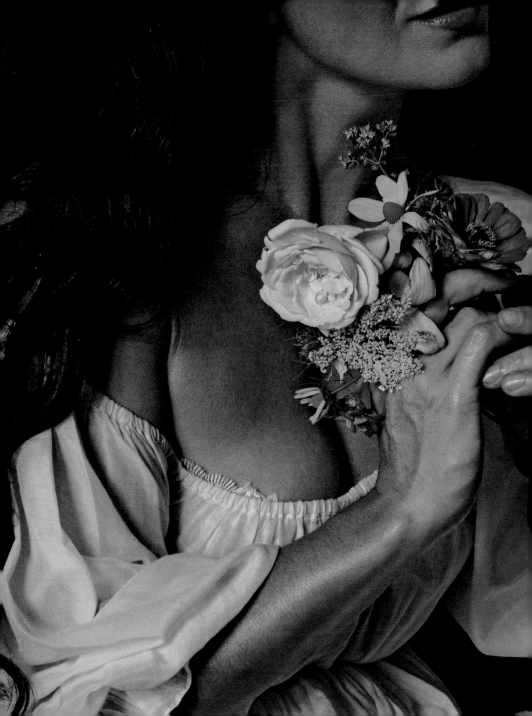

THE
FLOWERS

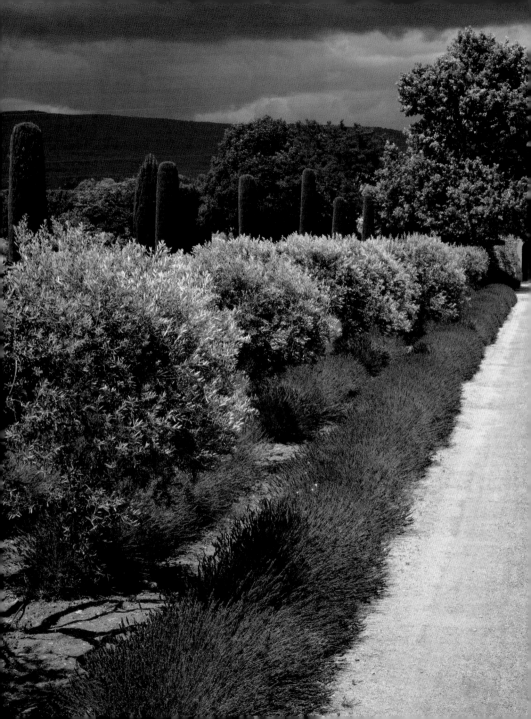

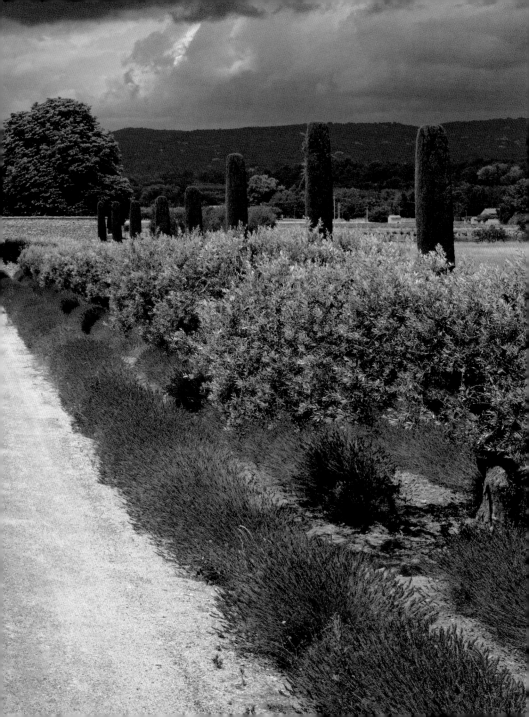

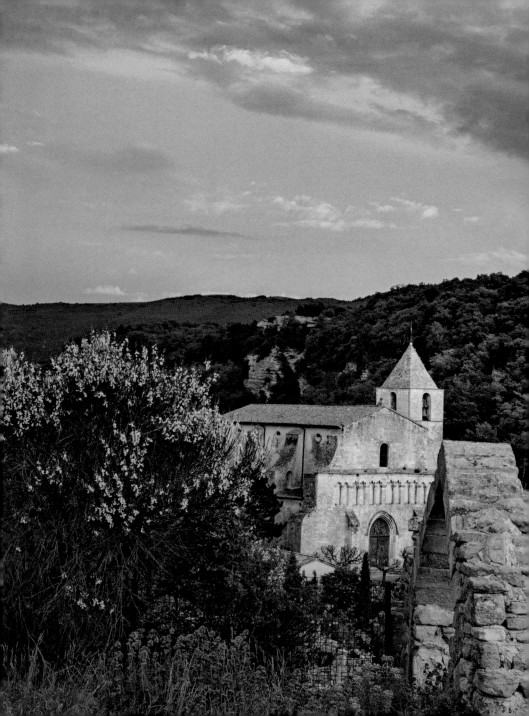

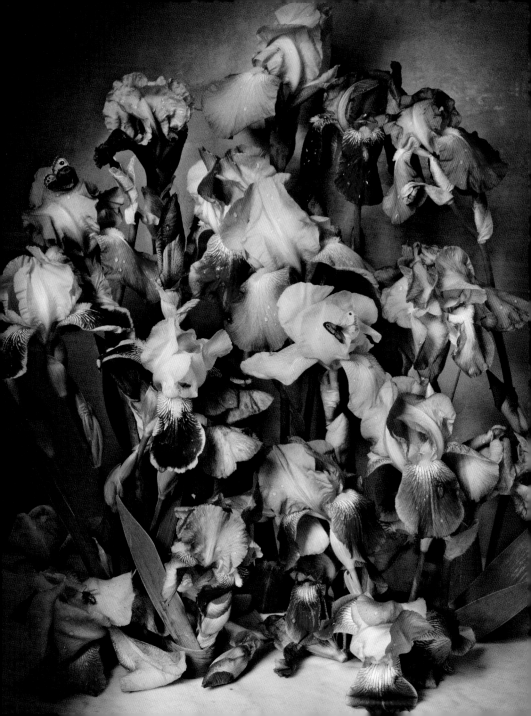

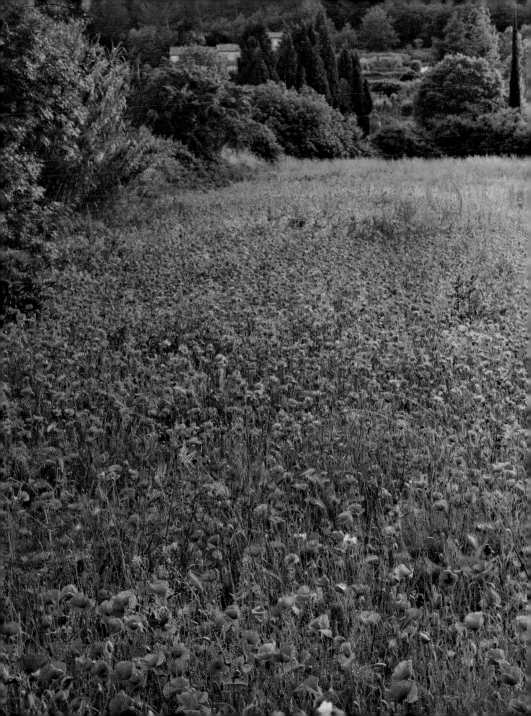

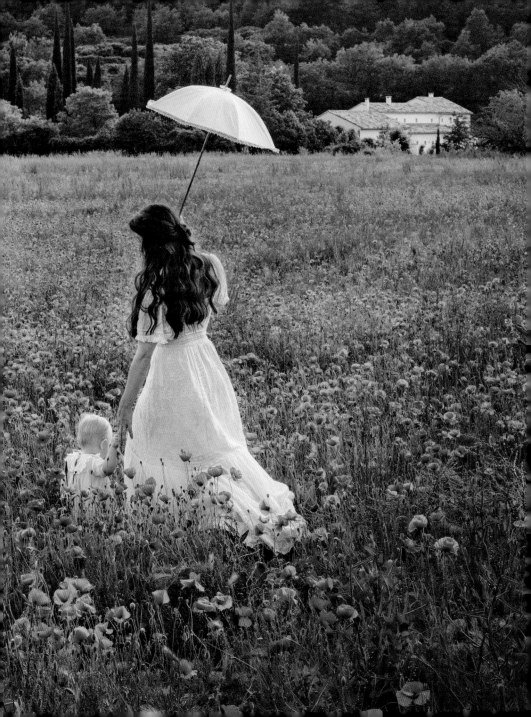

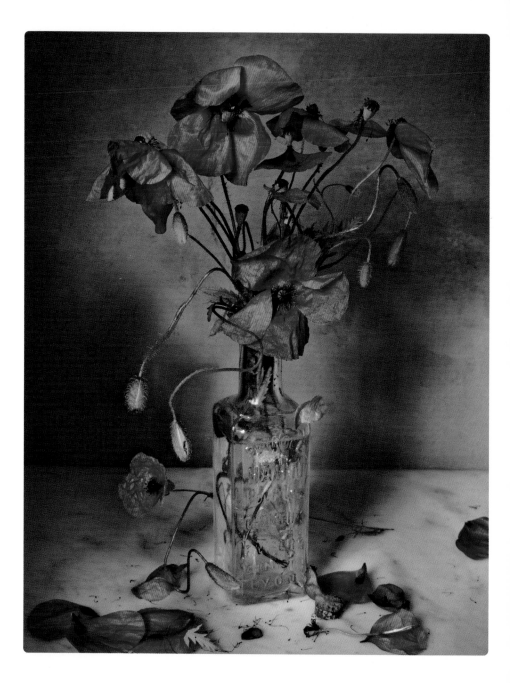

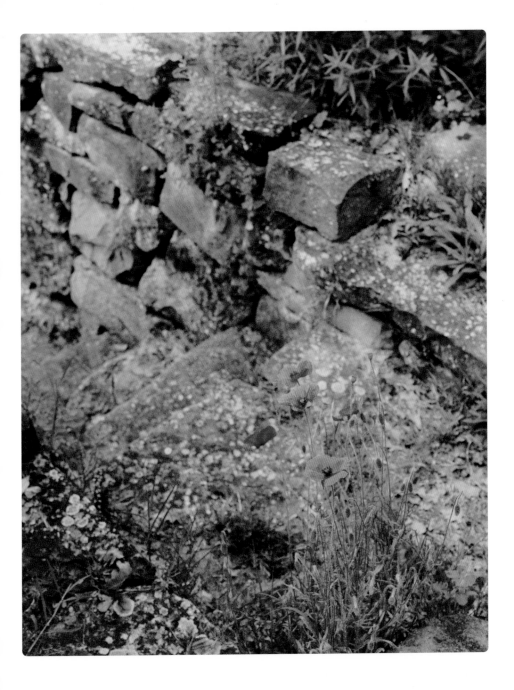

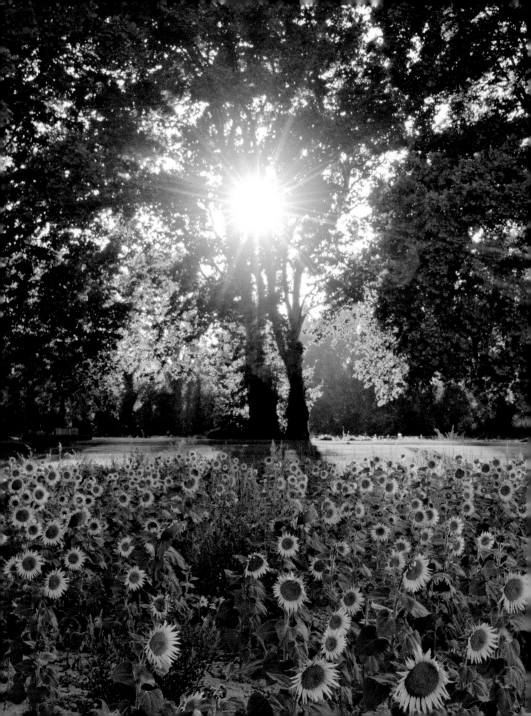

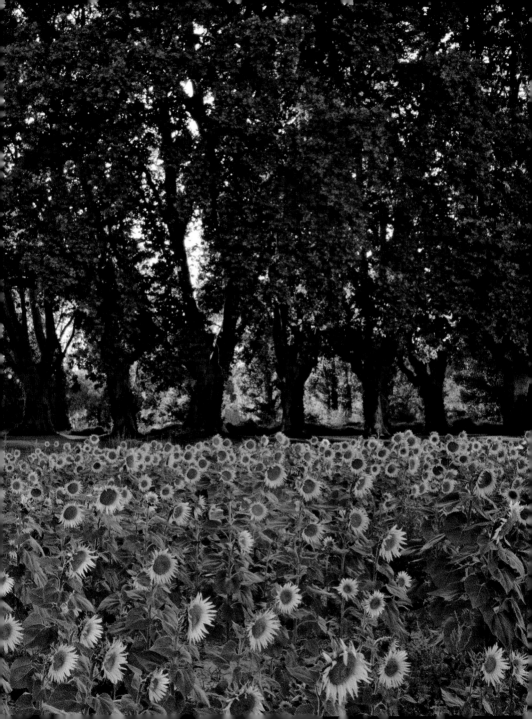

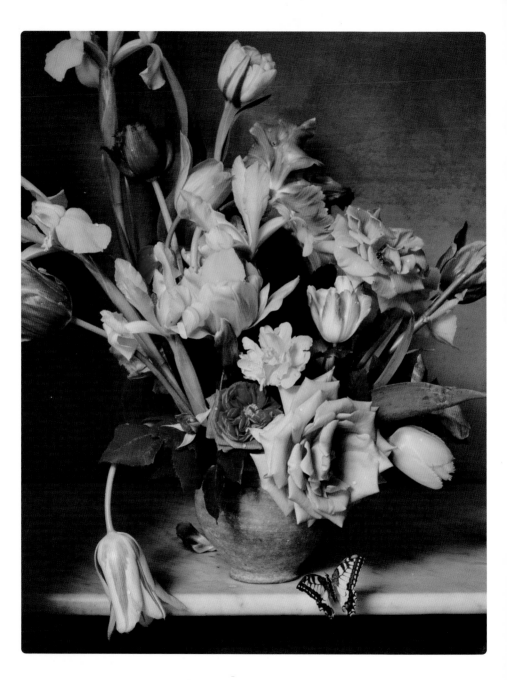

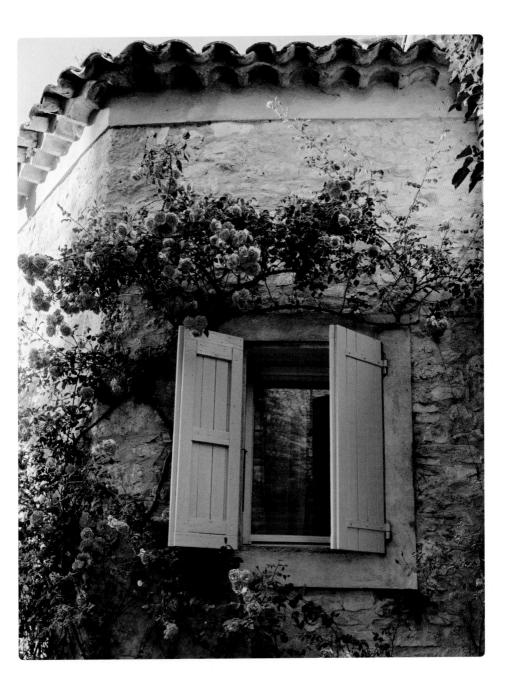

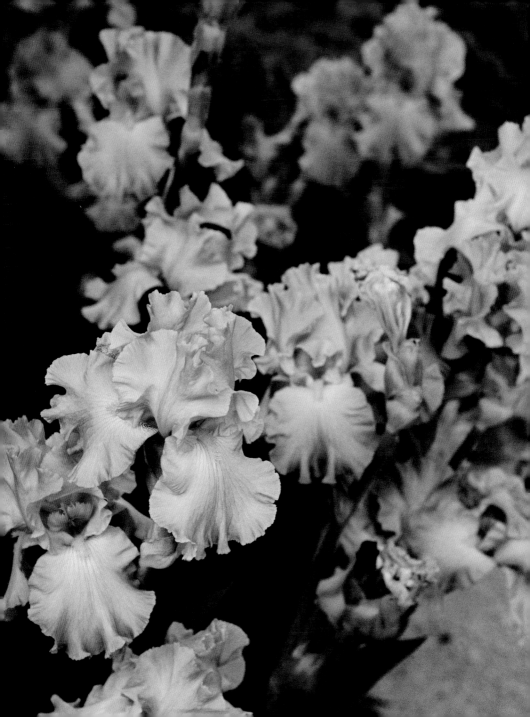

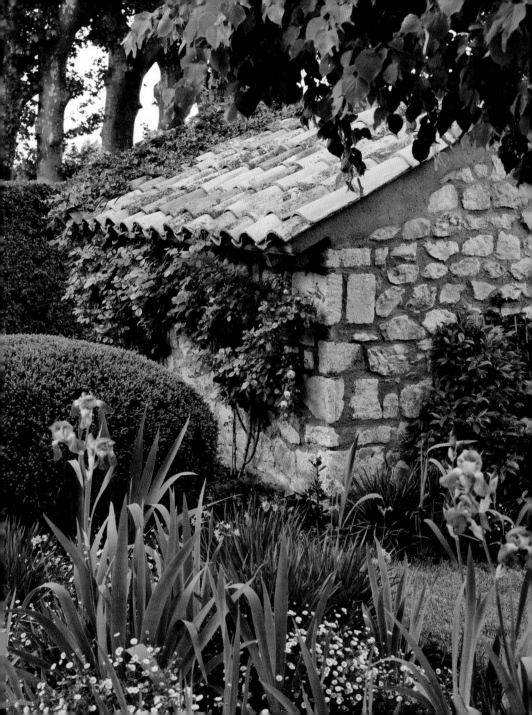

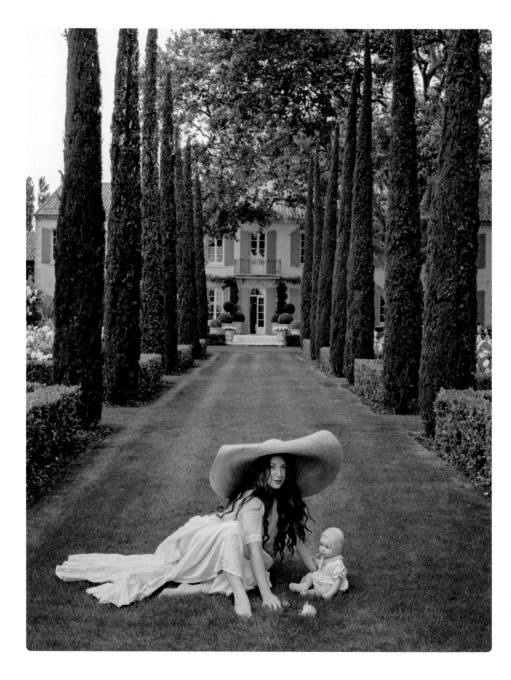

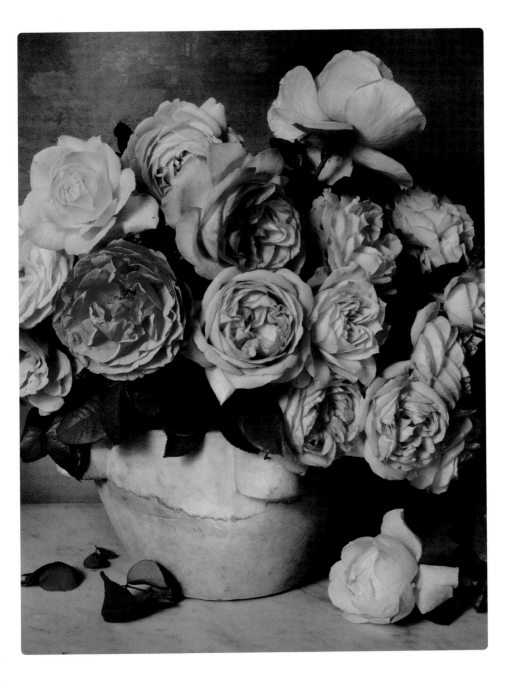

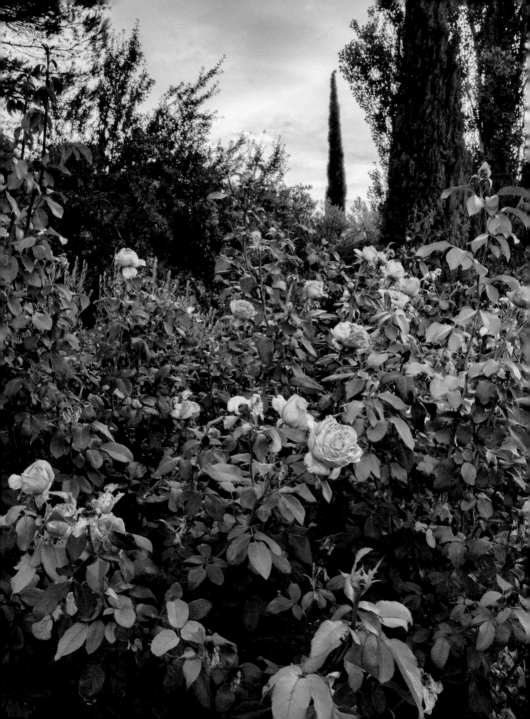

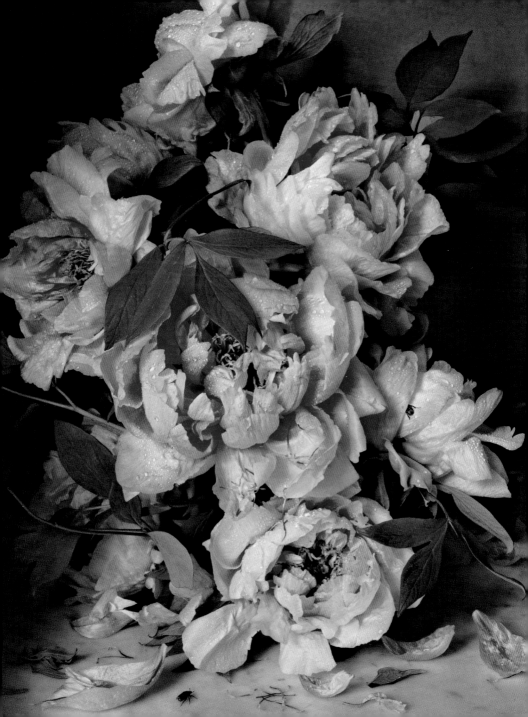

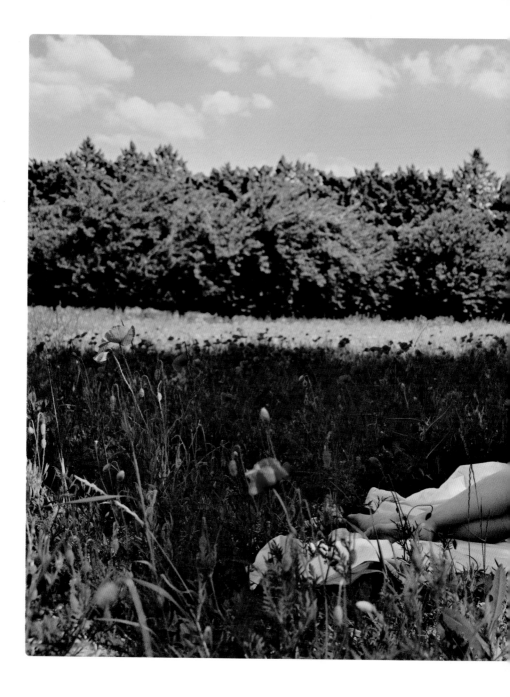

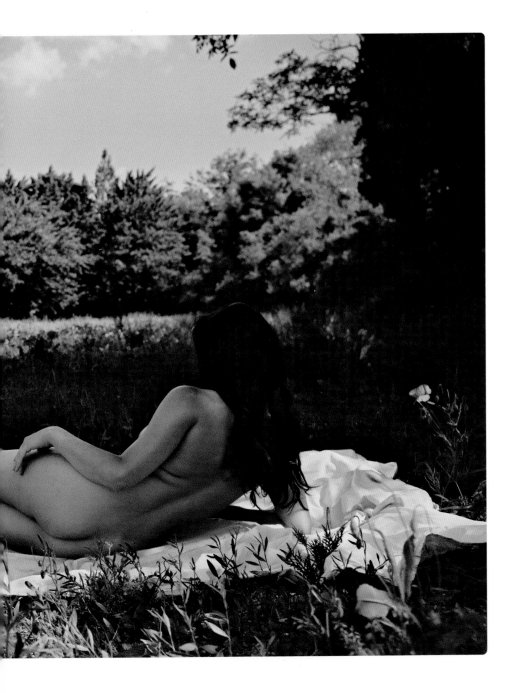

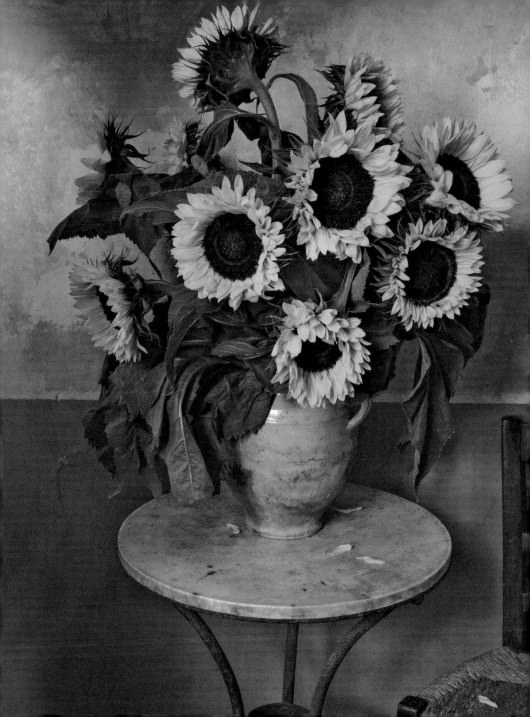

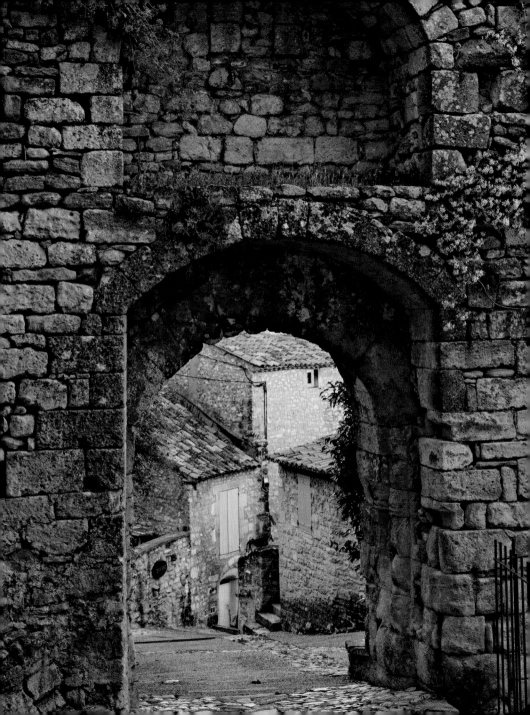

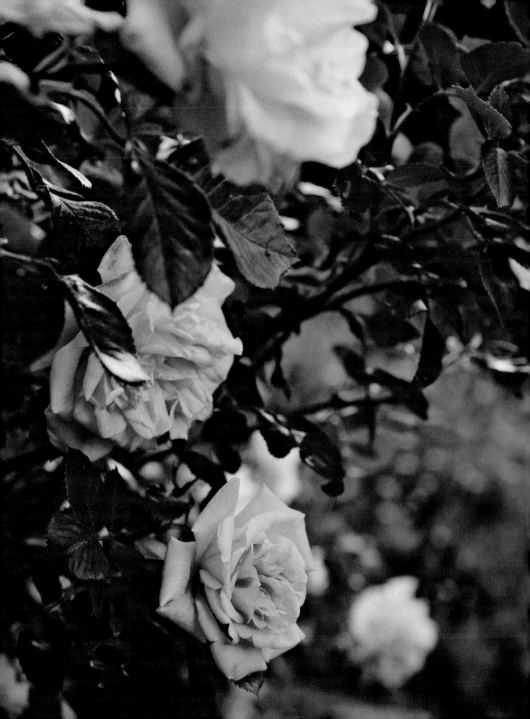

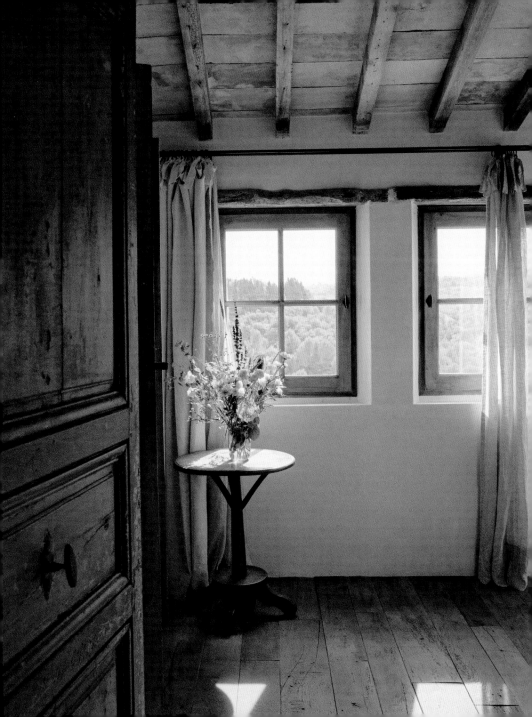

"Did you know roses bloom in France
in late November? I saw a caterpillar in the garden
a few weeks ago ... where was he going?
When I came back to find out, he was gone.
In the evenings I sit by the fire now,
in the morning the village will be under a layer
of frosty blue fog and there I will be,
at the kitchen window, looking across the square
at the light on in the bakery and knowing
I am not alone ... and somewhere outside
the roses battle on another day."

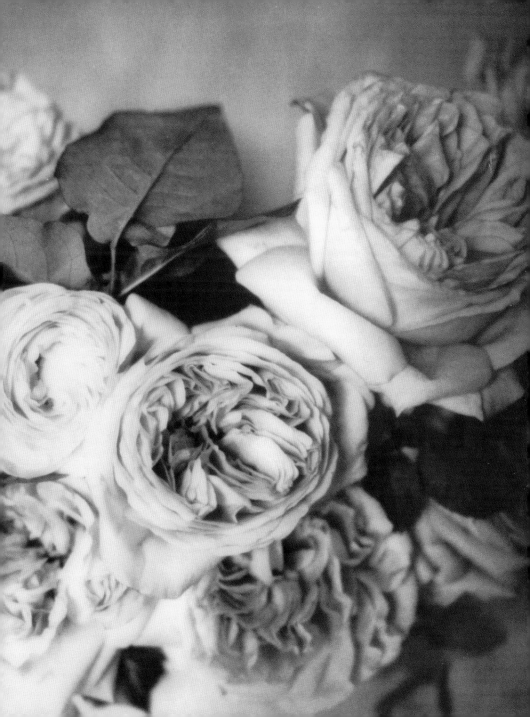

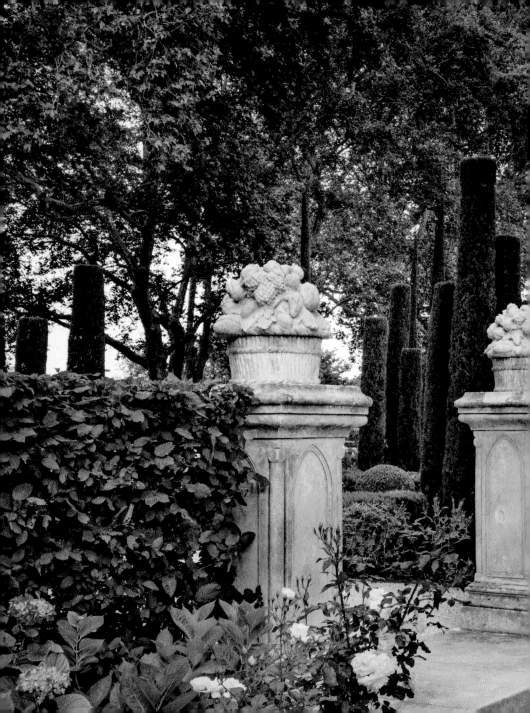

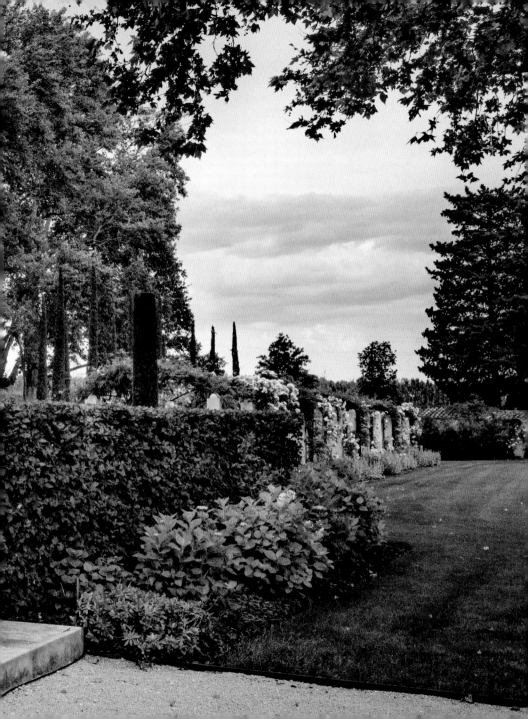

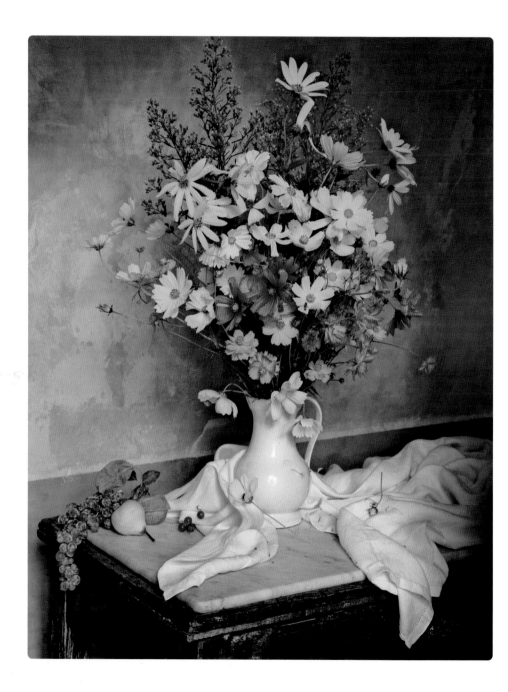

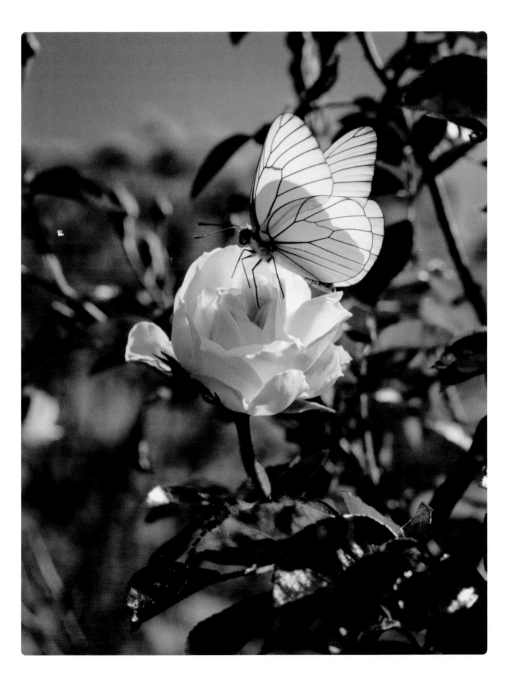

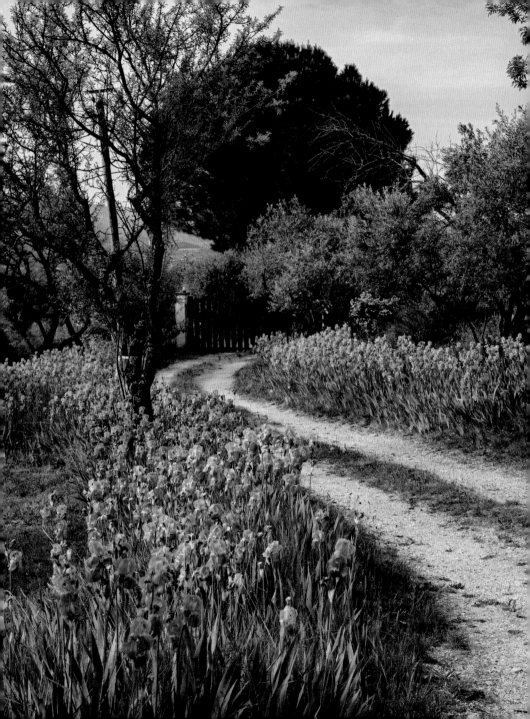

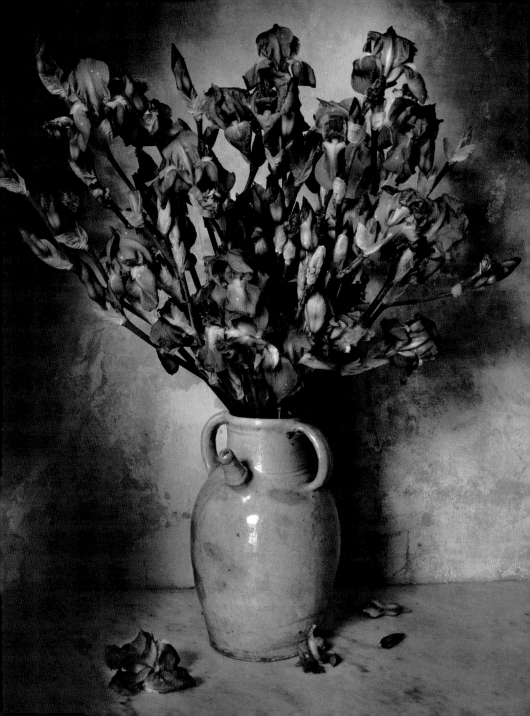

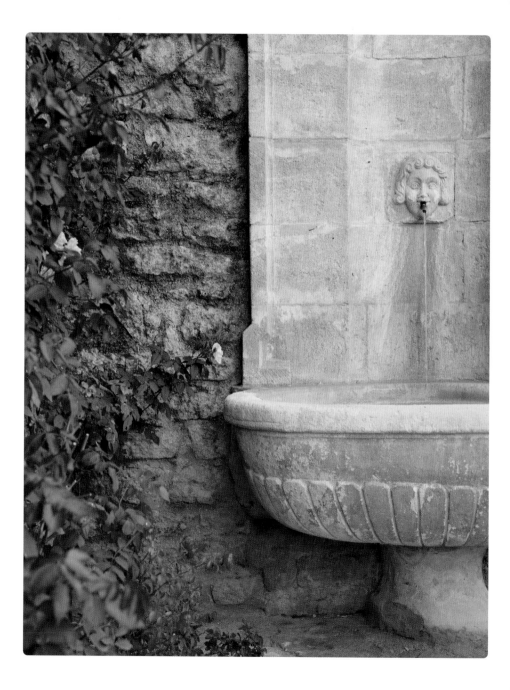

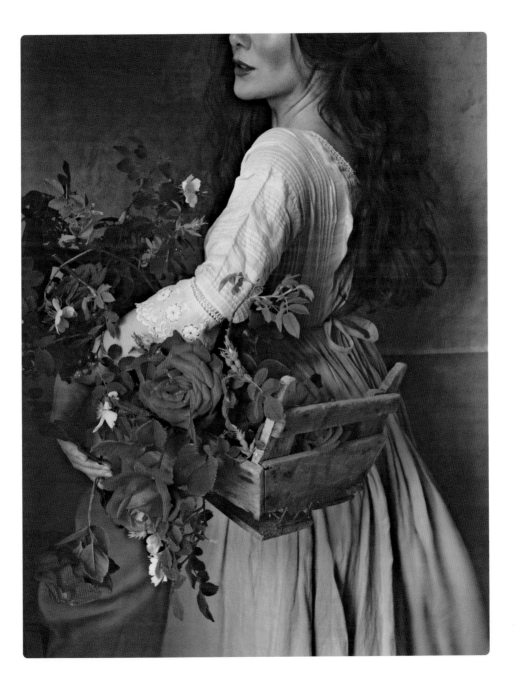

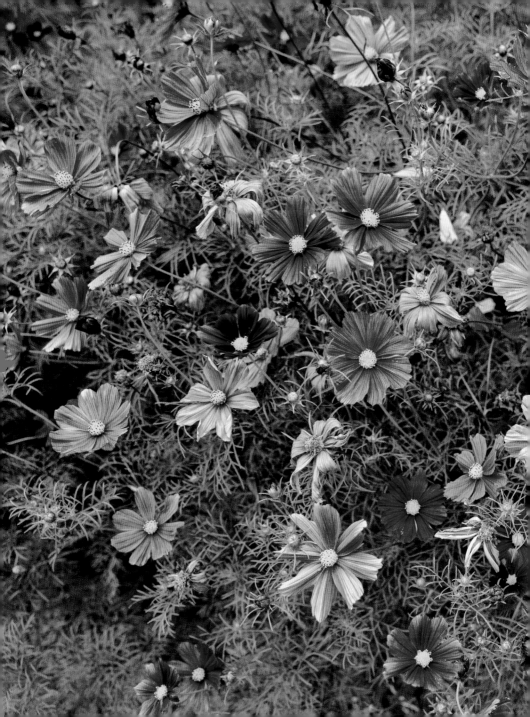

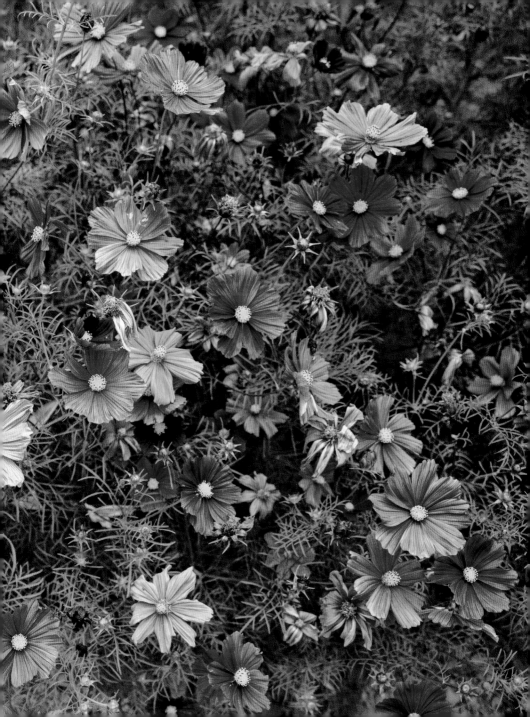

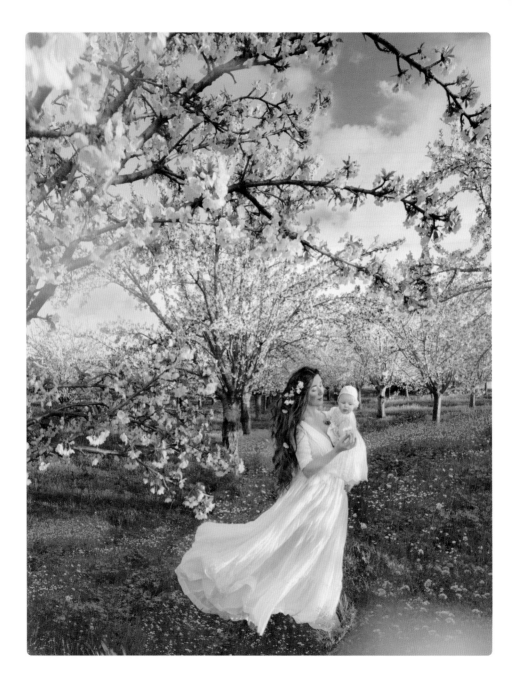

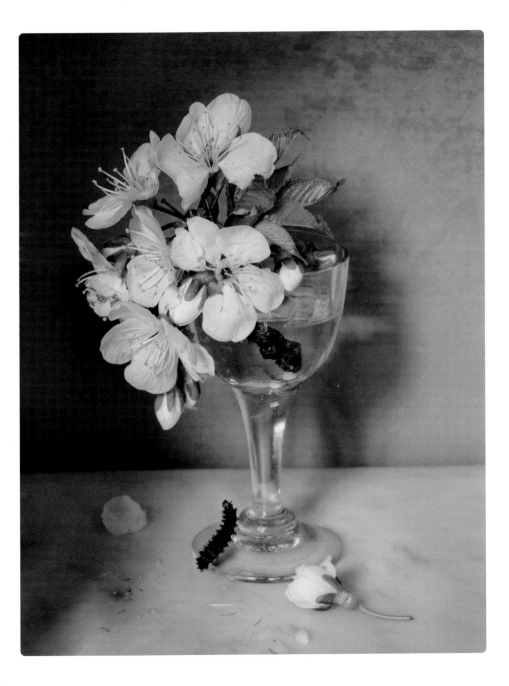

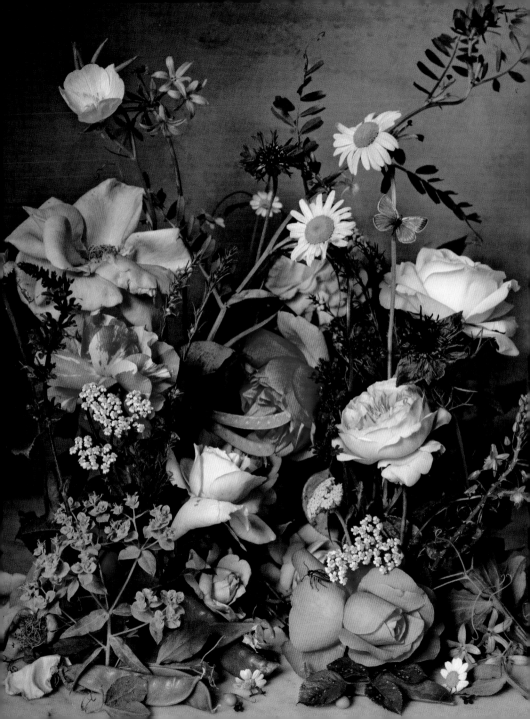

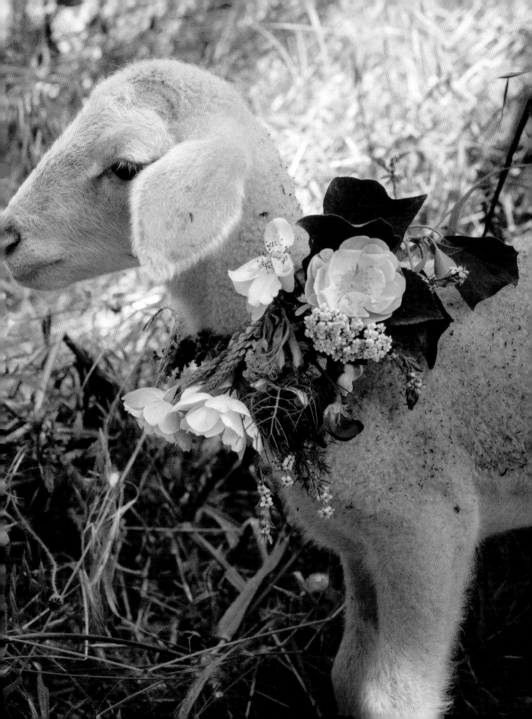

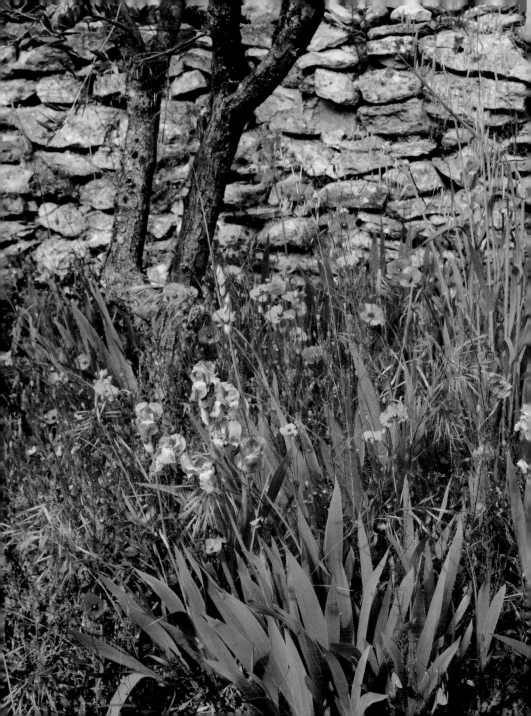

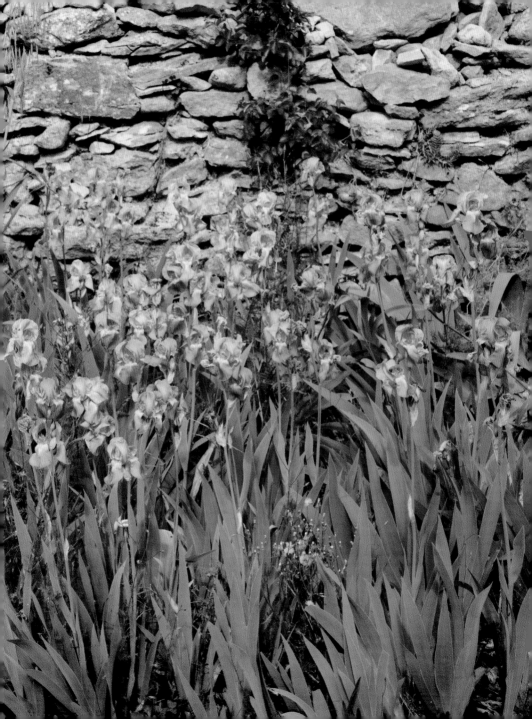

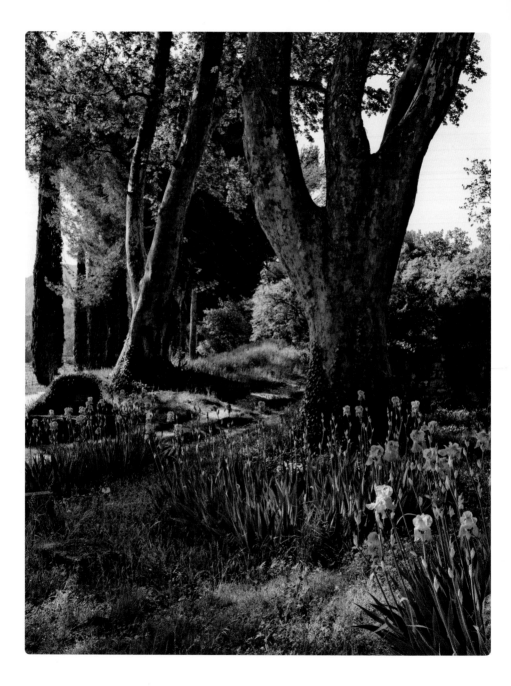

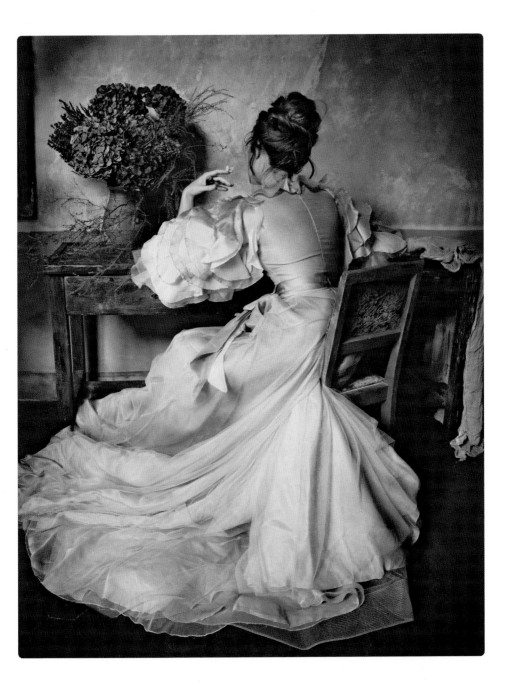

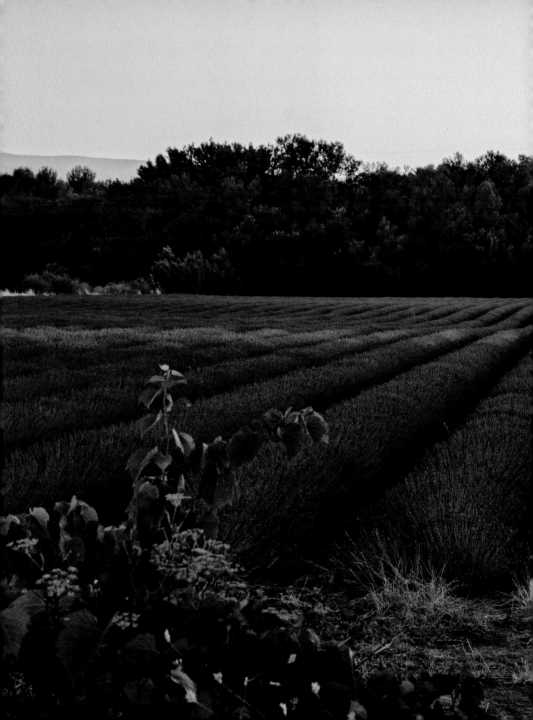

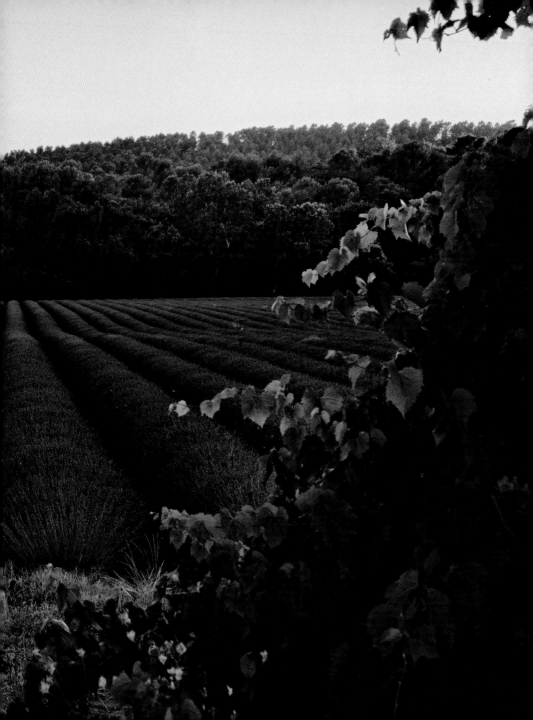

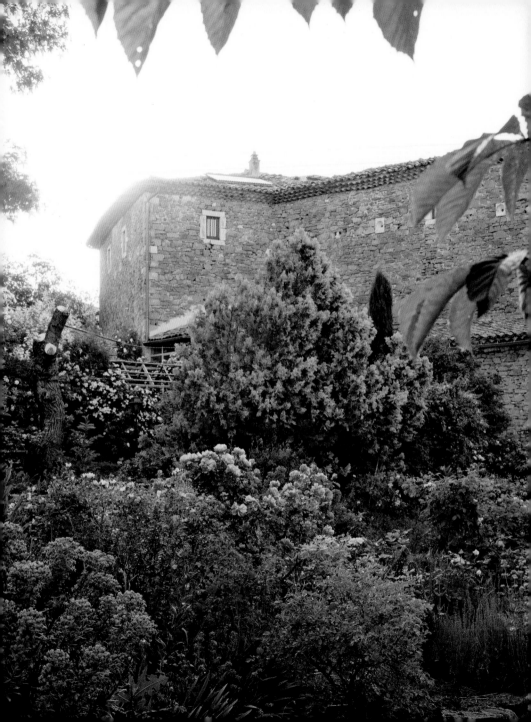

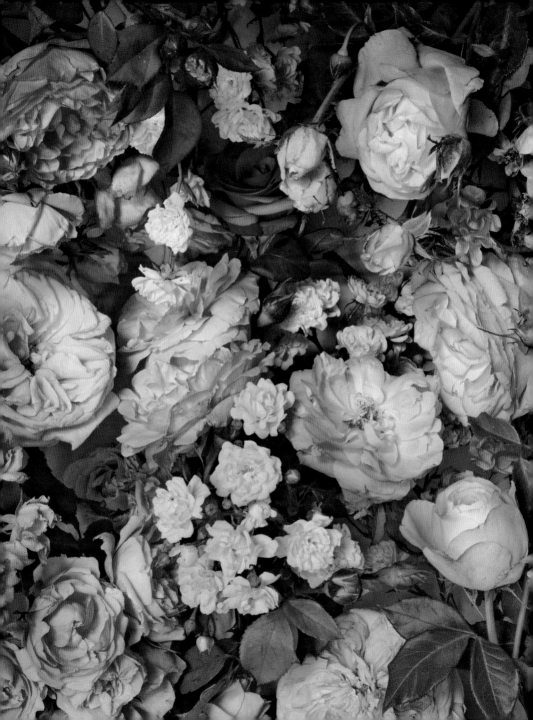

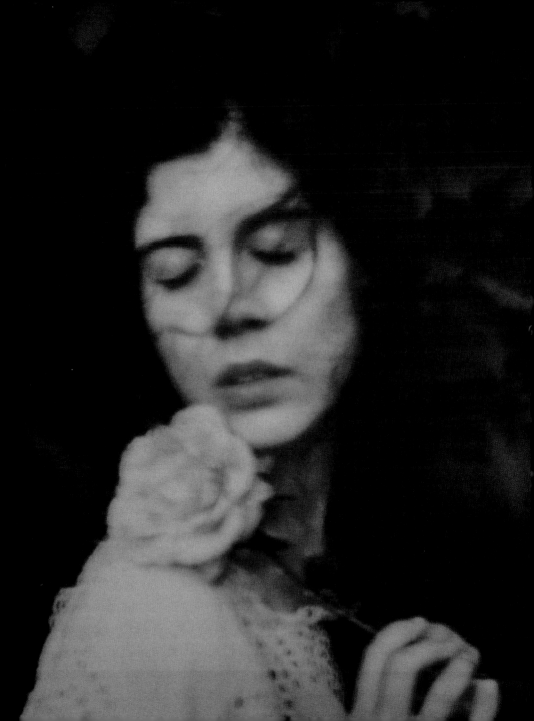

"Sometimes I imagine
putting my heart's secrets
on the back of a dragonfly's wing
and watching it weightlessly carry my
thoughts away from me around the garden,
whispering to all the flowers that will listen
what only my soul knows."

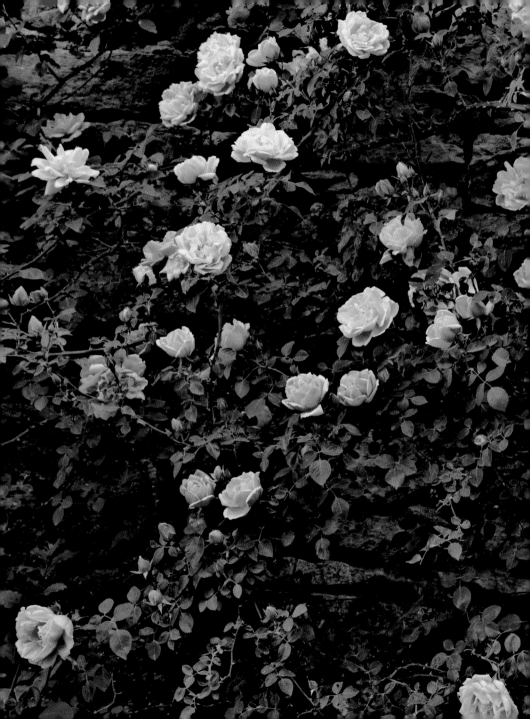

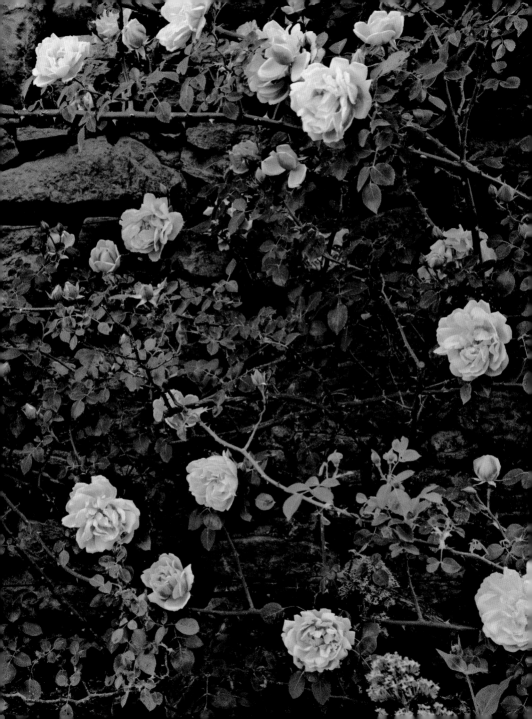

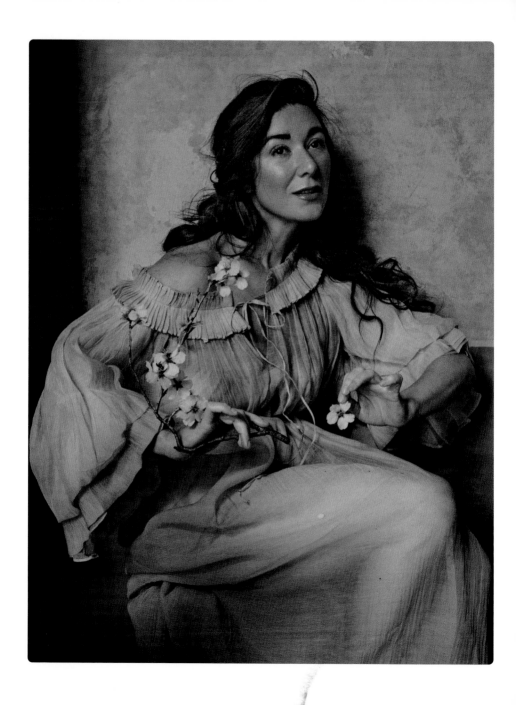

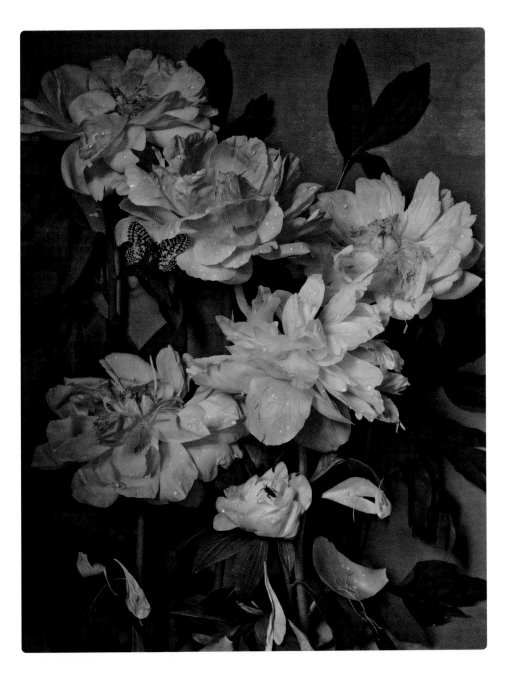

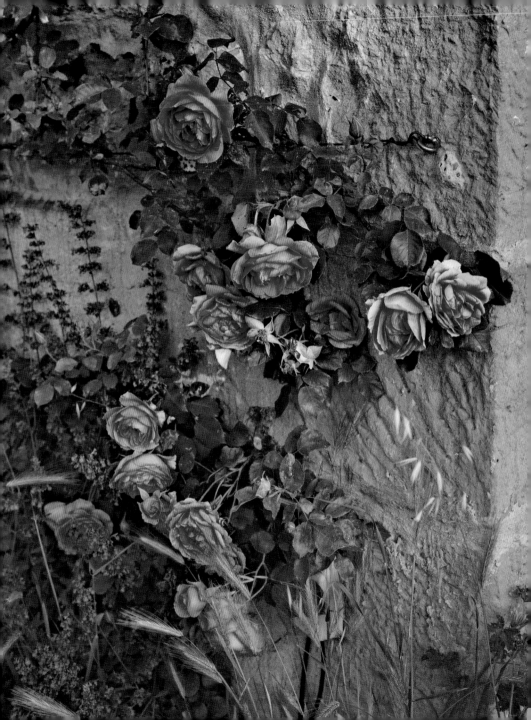

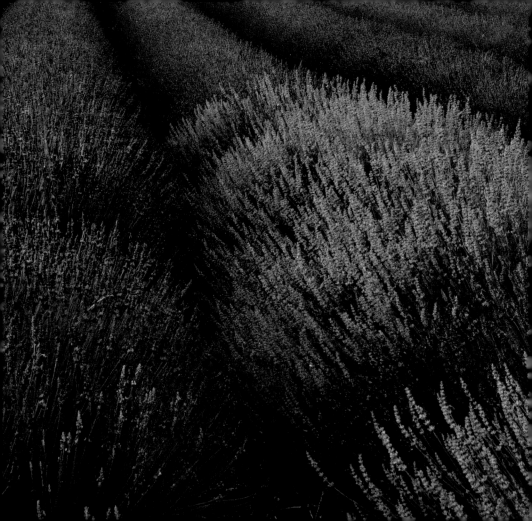

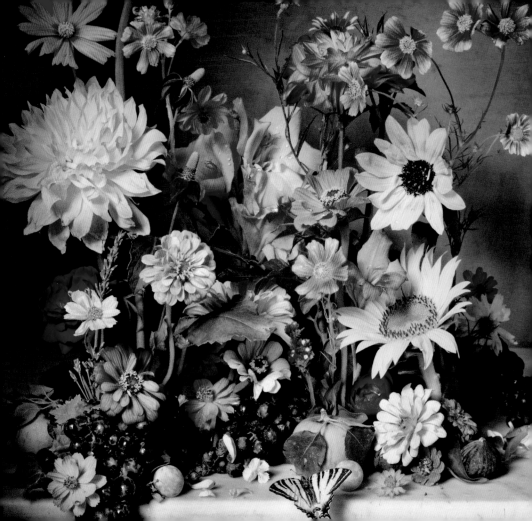

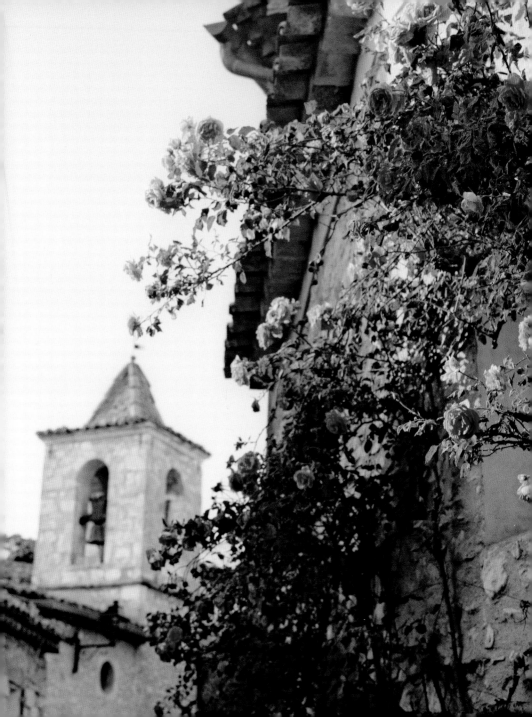

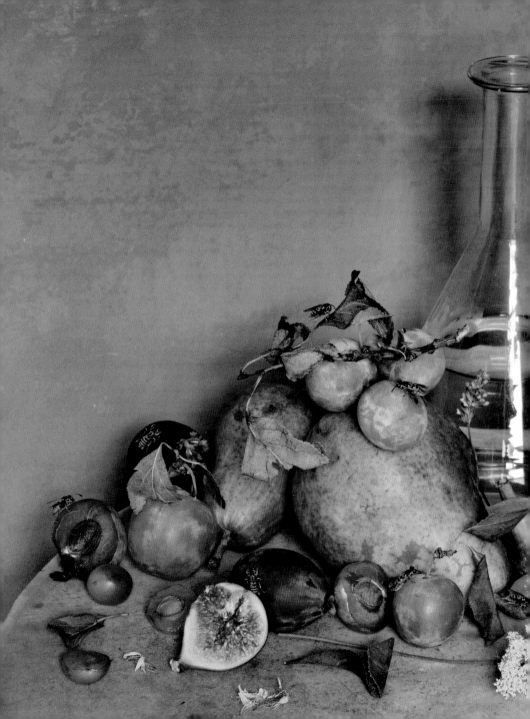

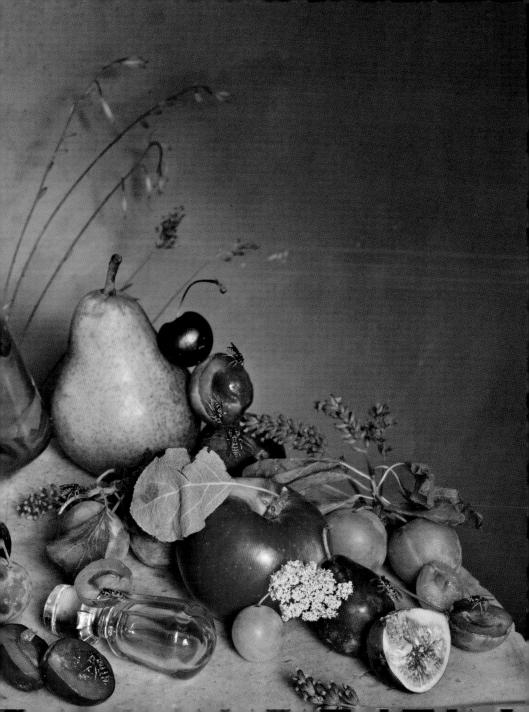

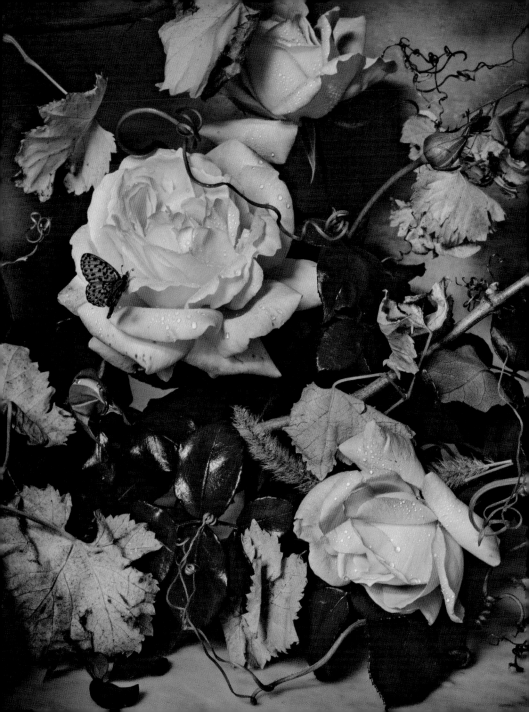

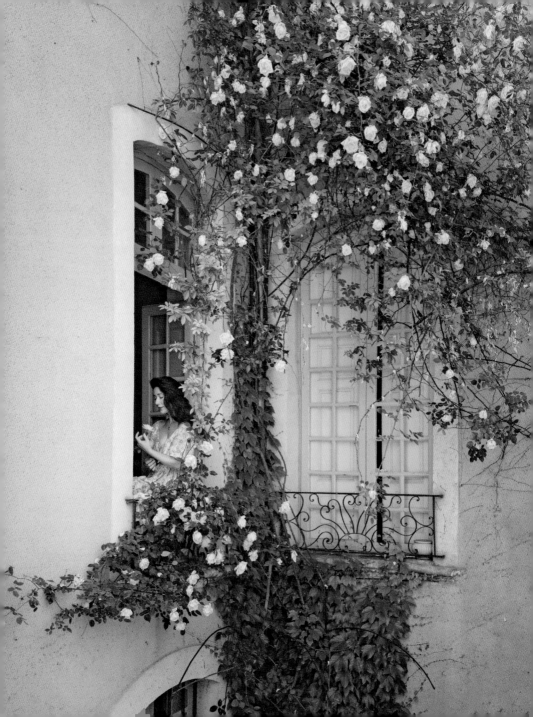

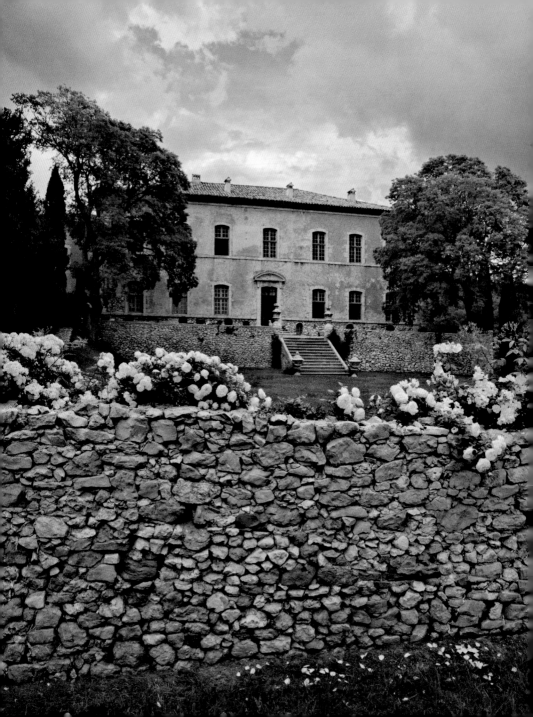

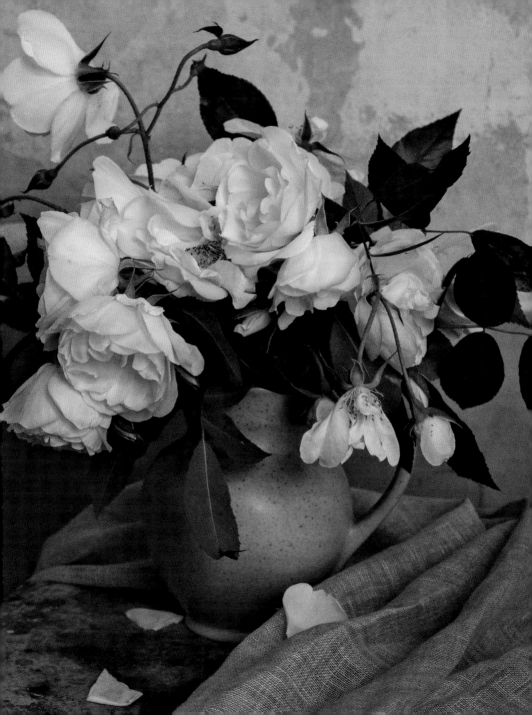

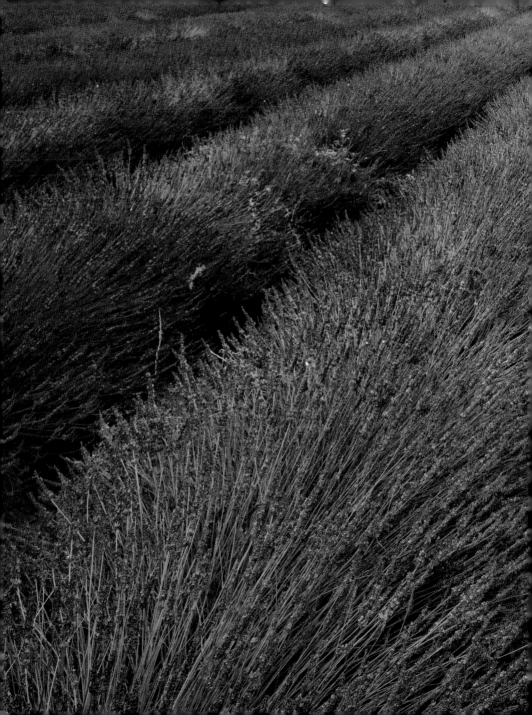

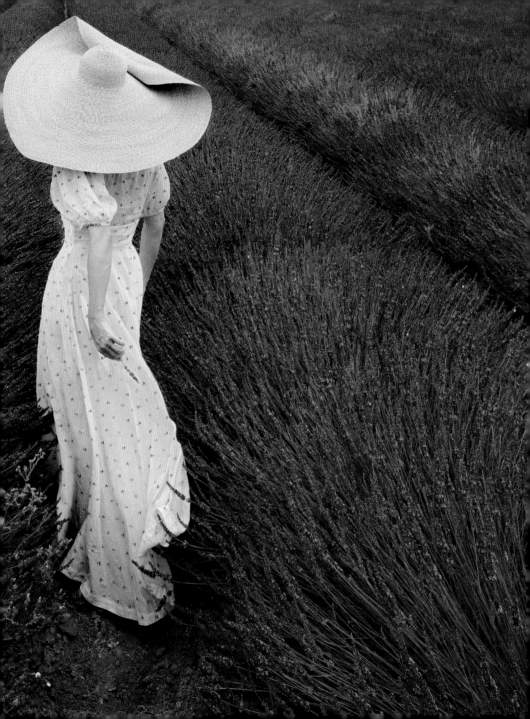

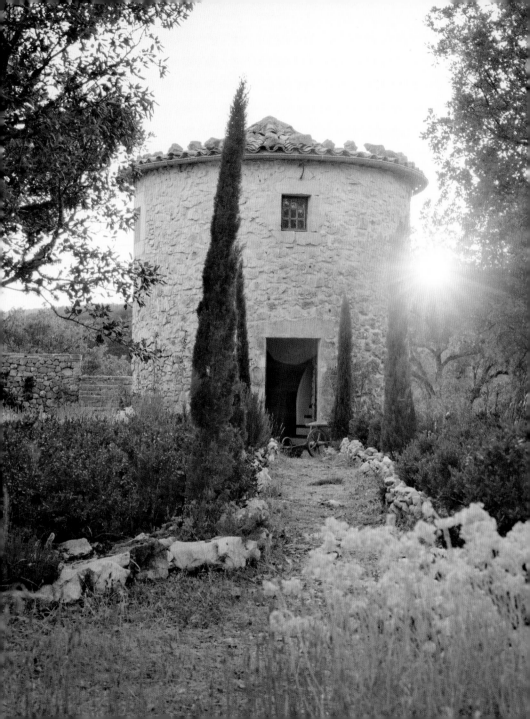

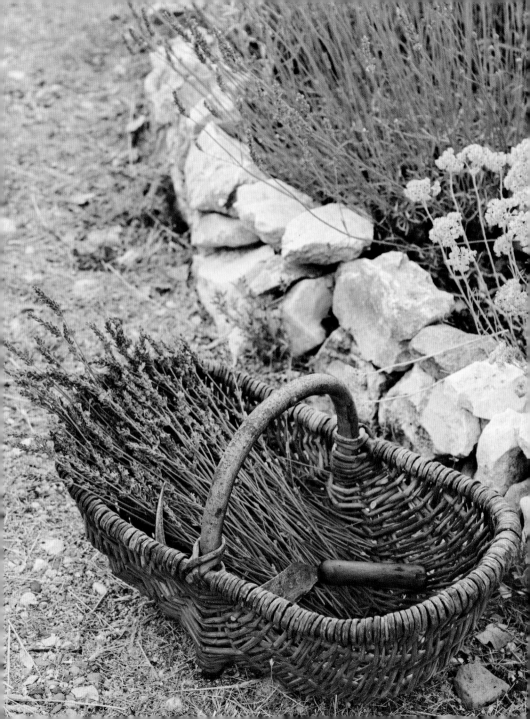

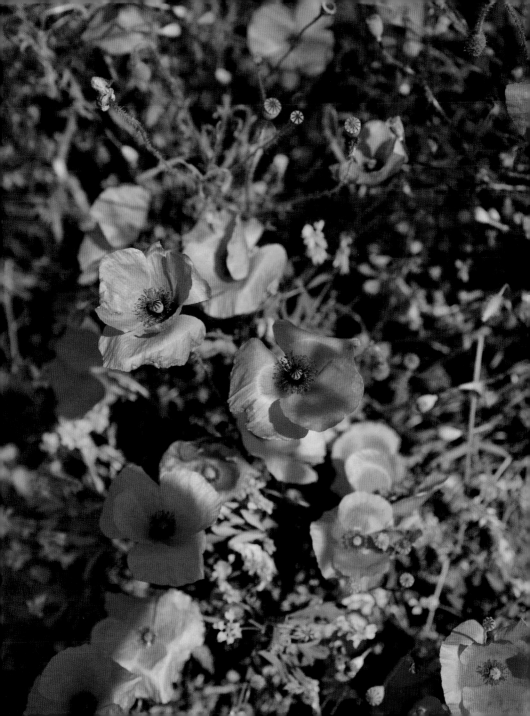

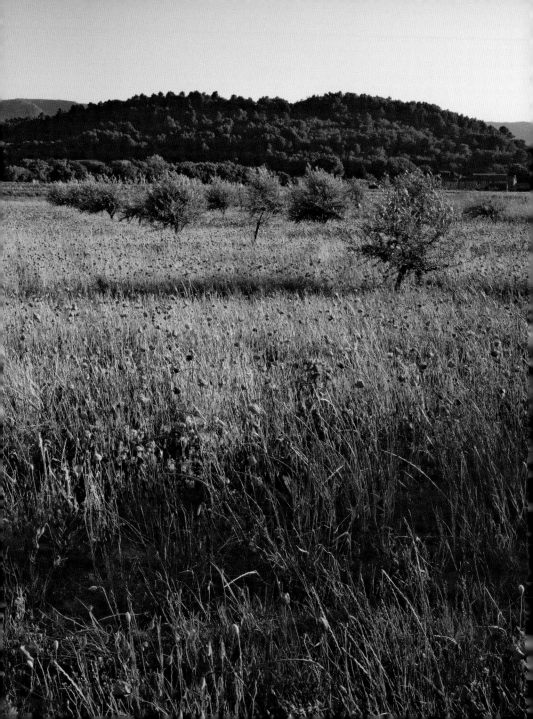

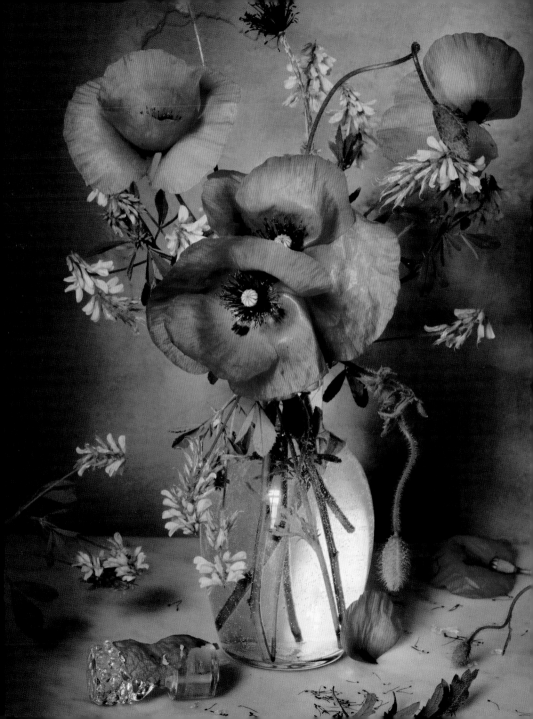

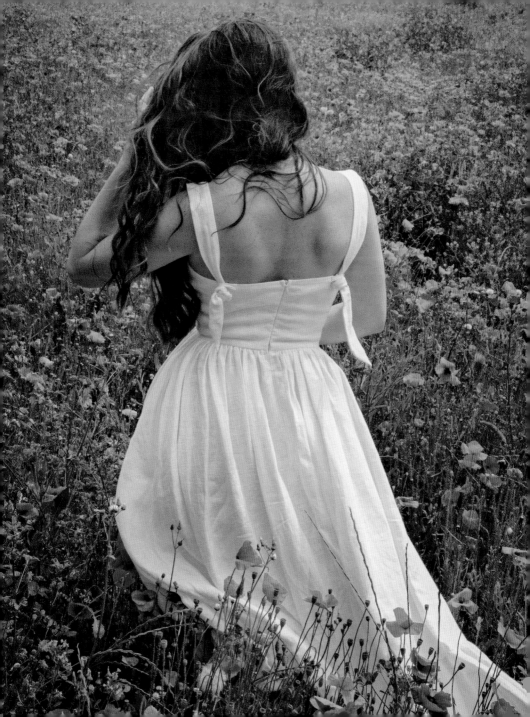

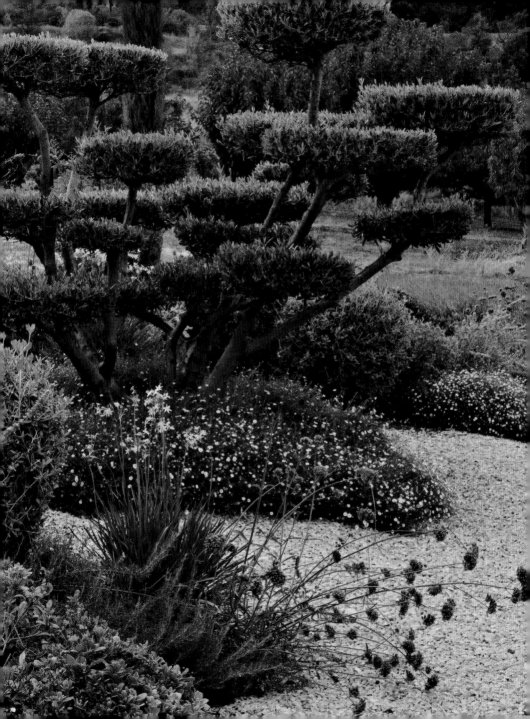

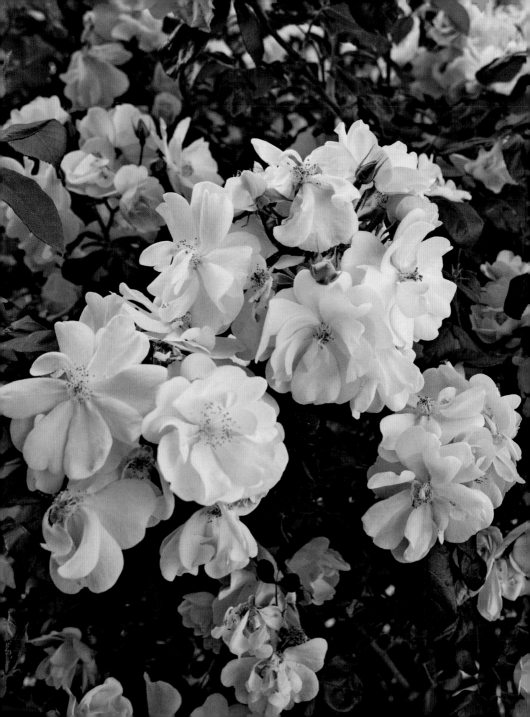

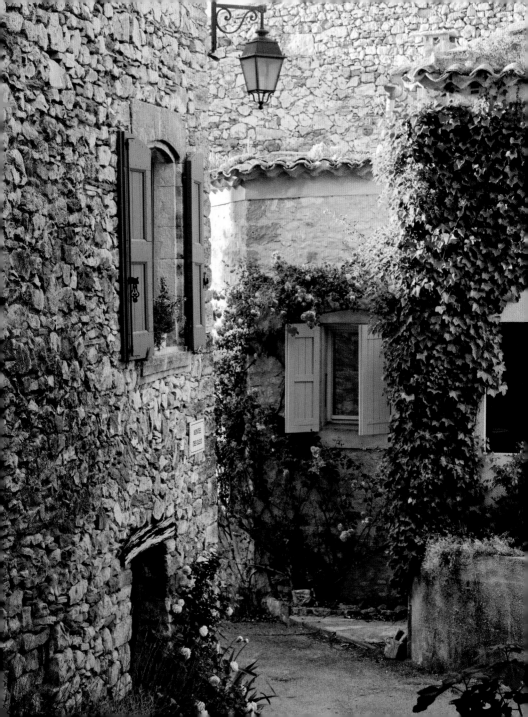

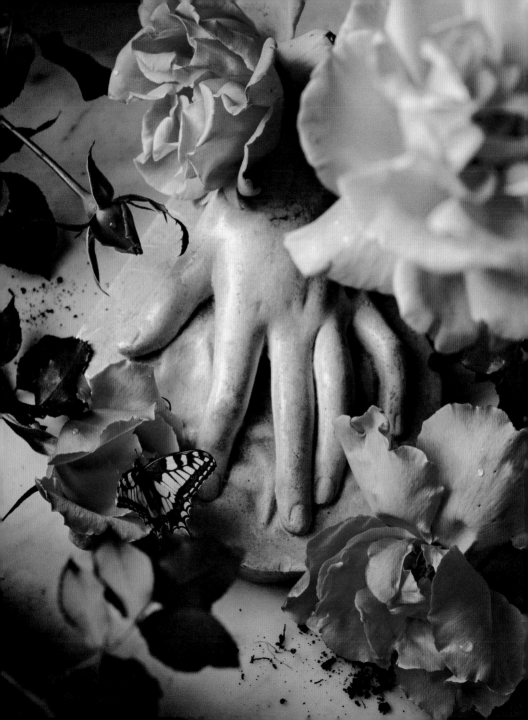

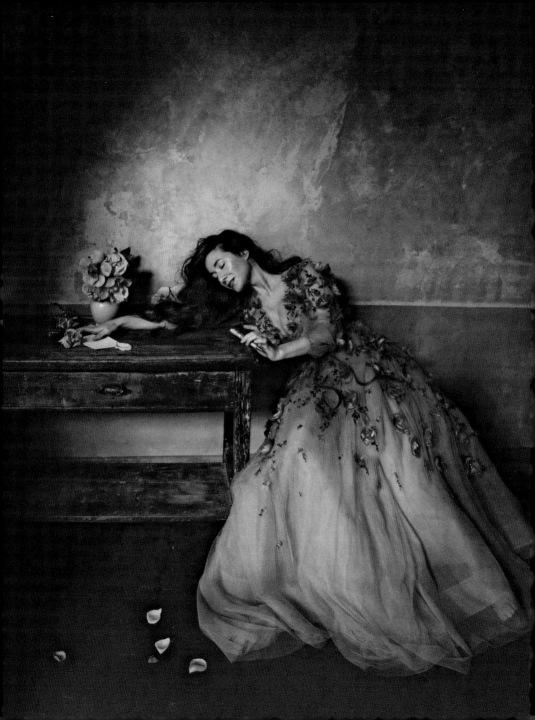

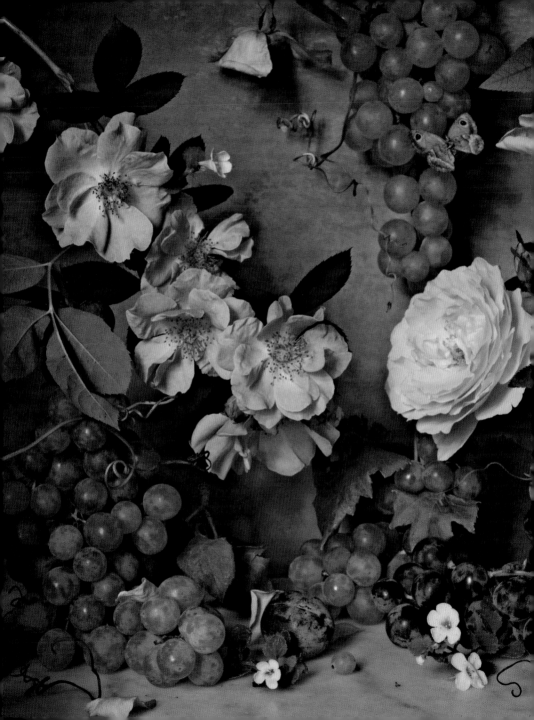

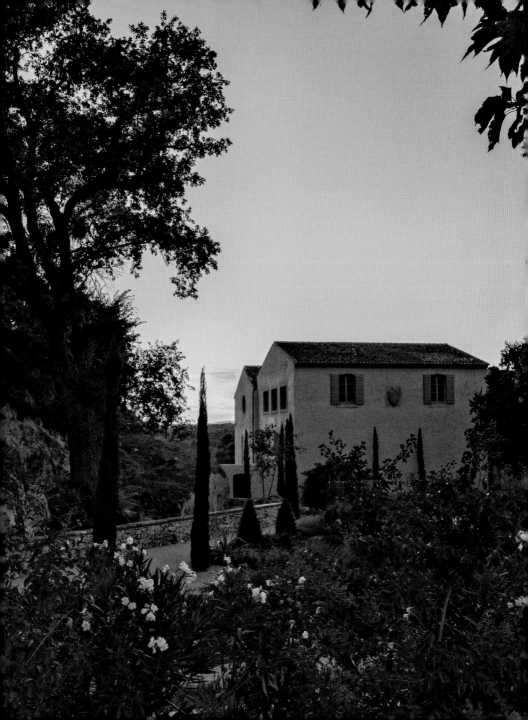

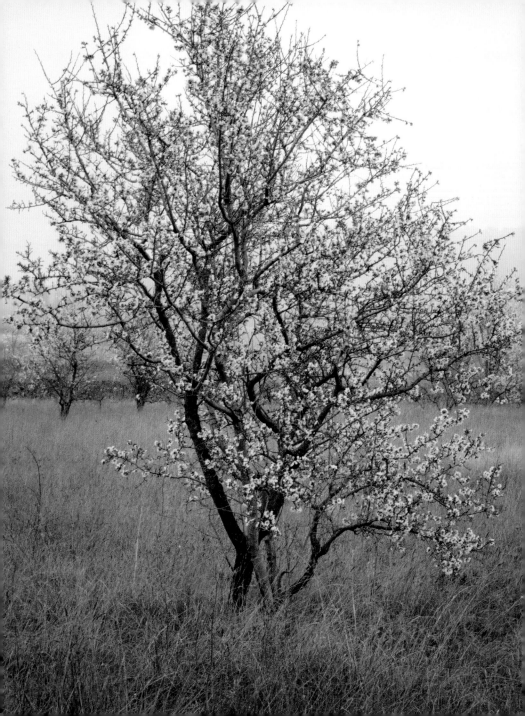

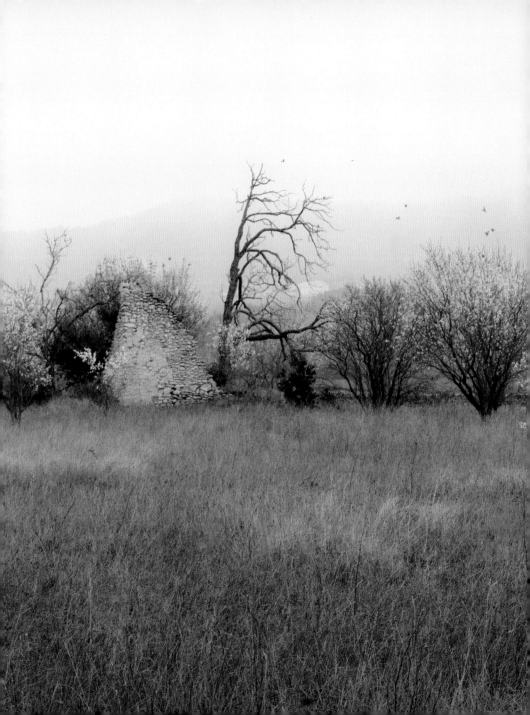

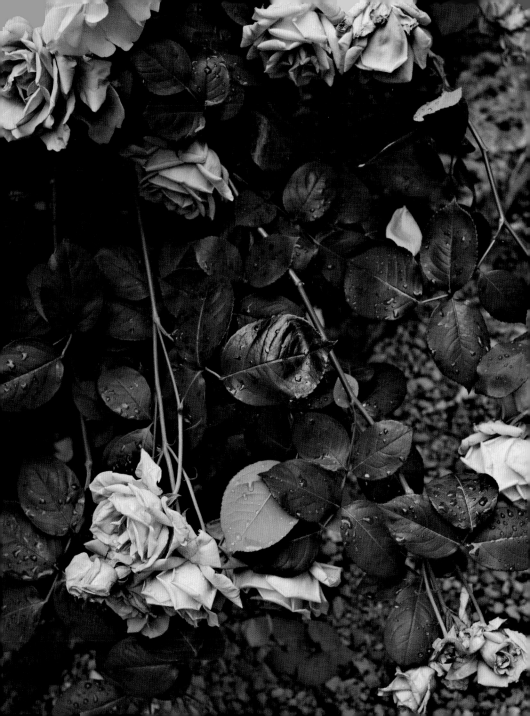

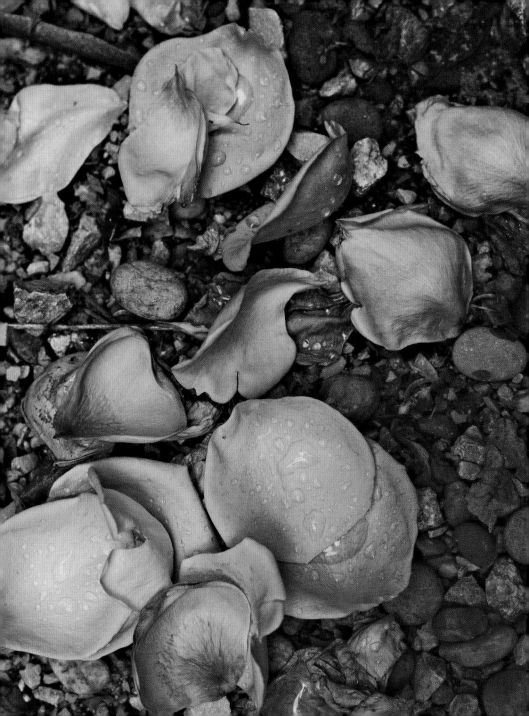

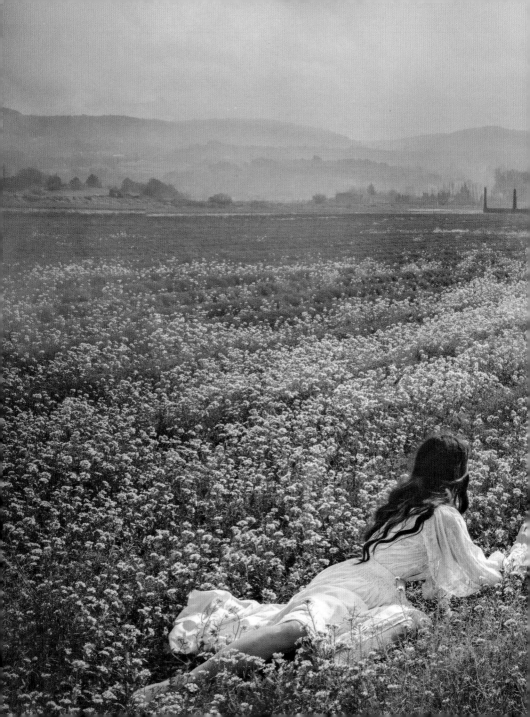

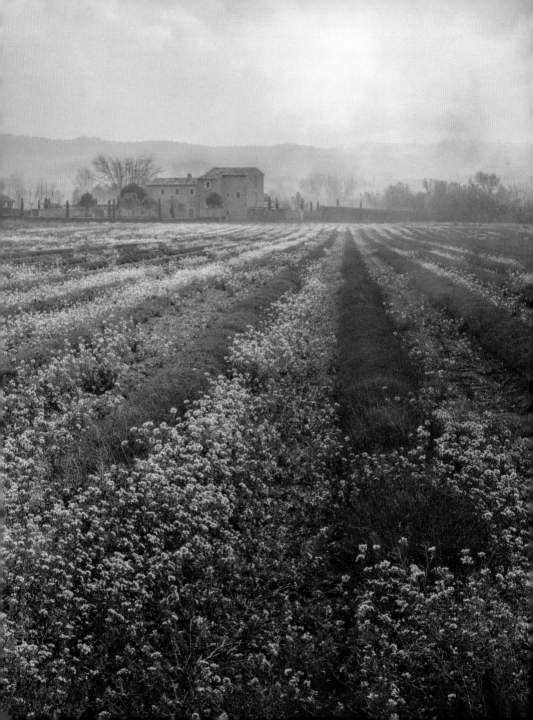

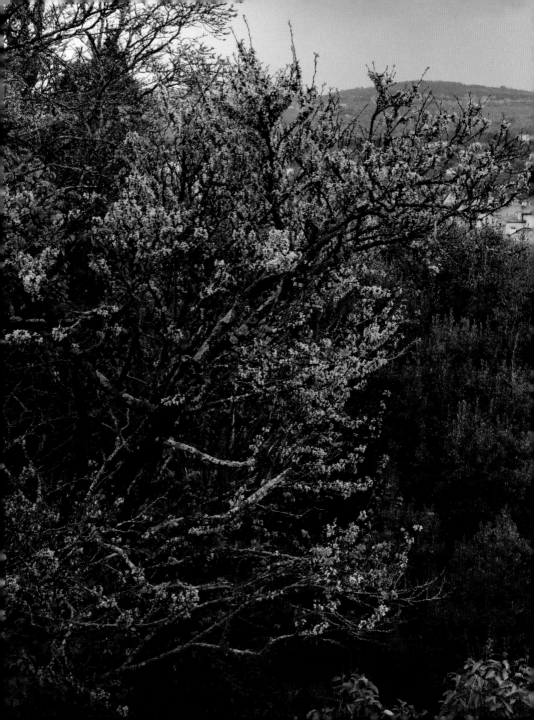

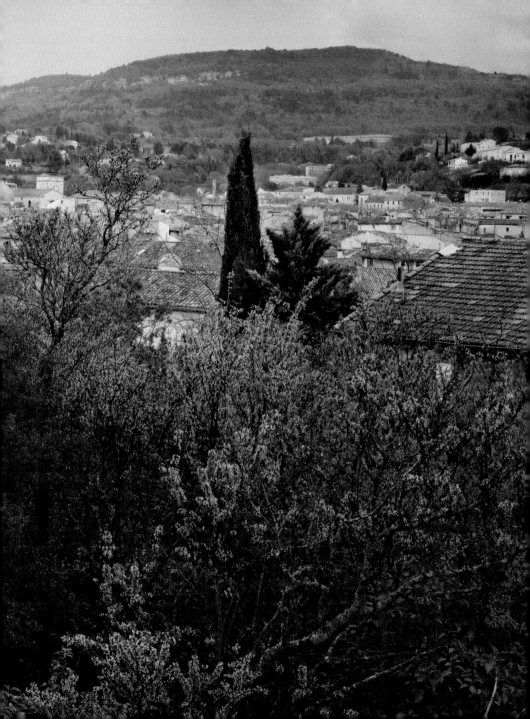

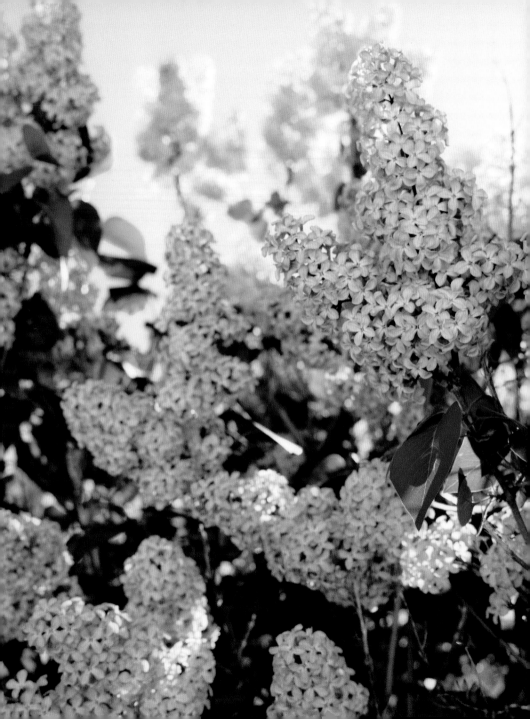

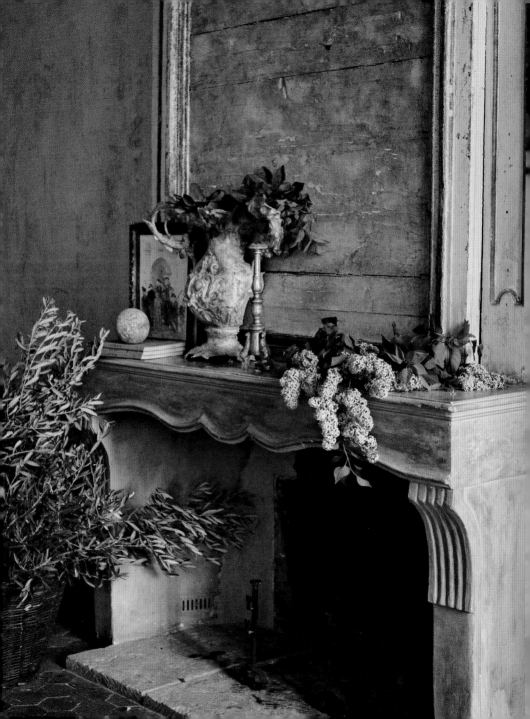

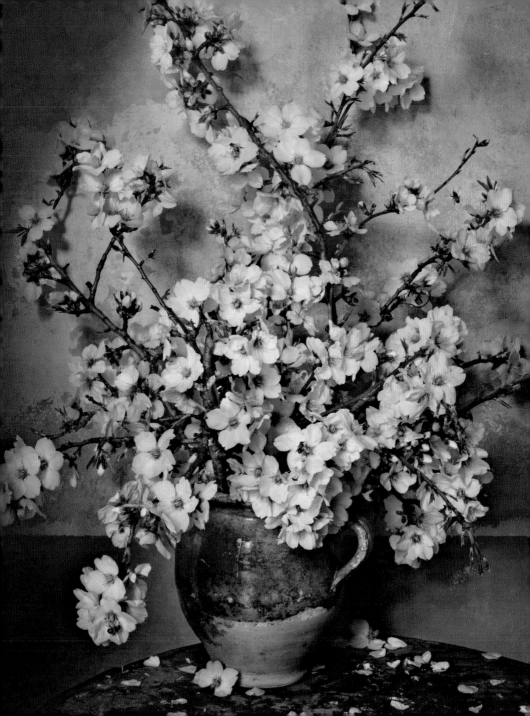

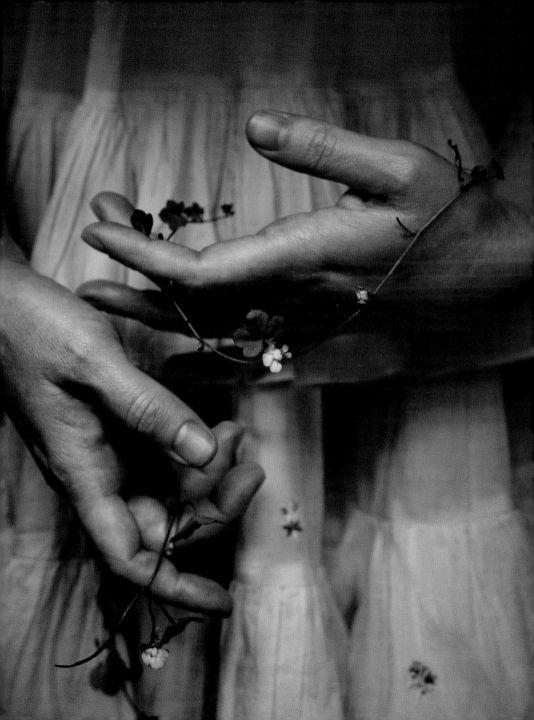

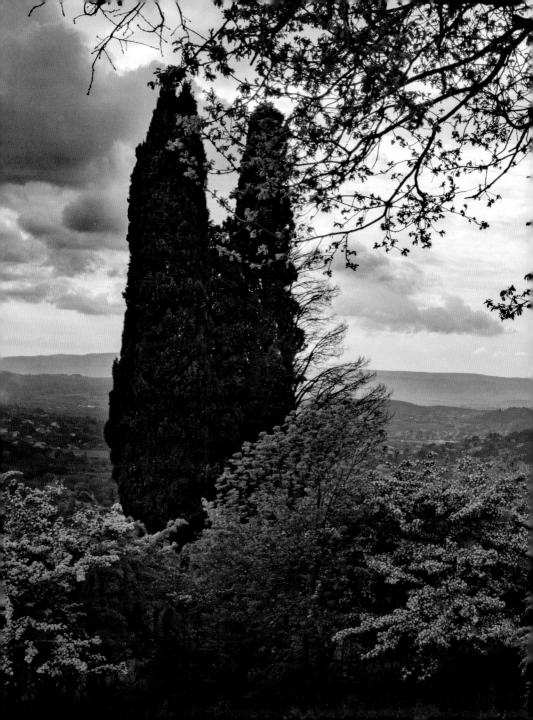

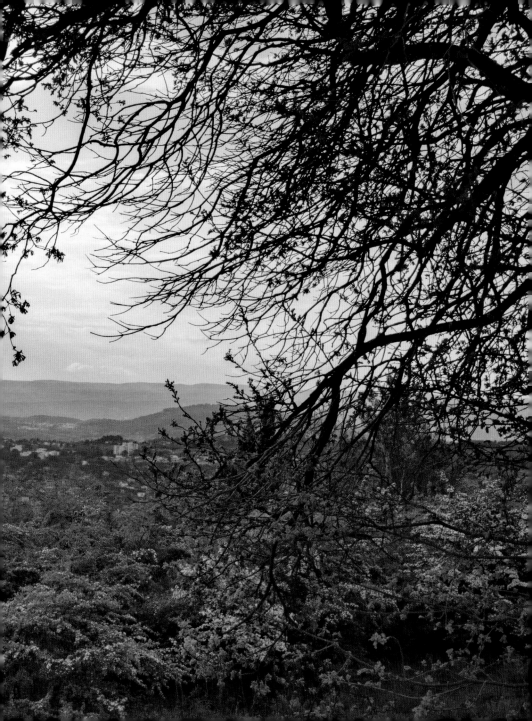

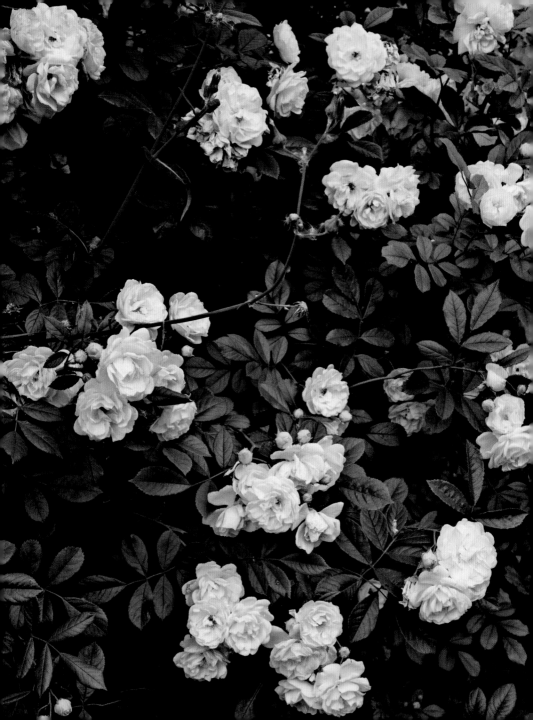

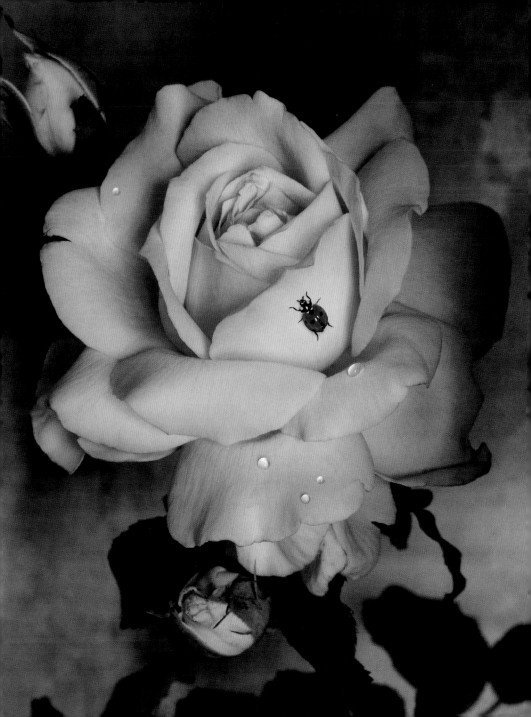

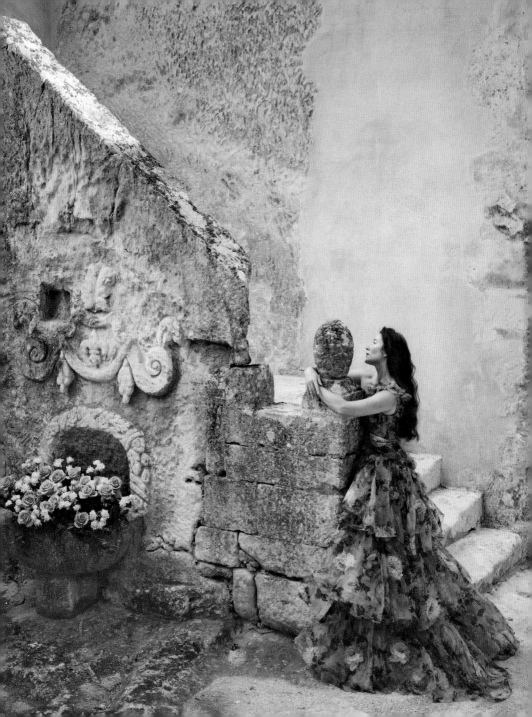

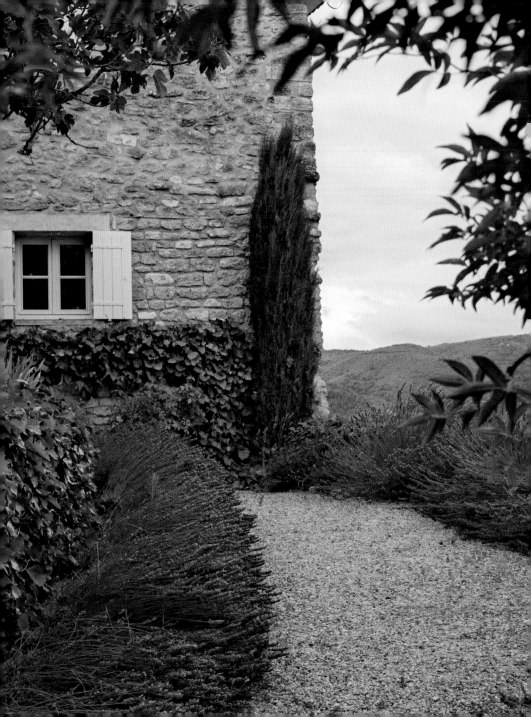

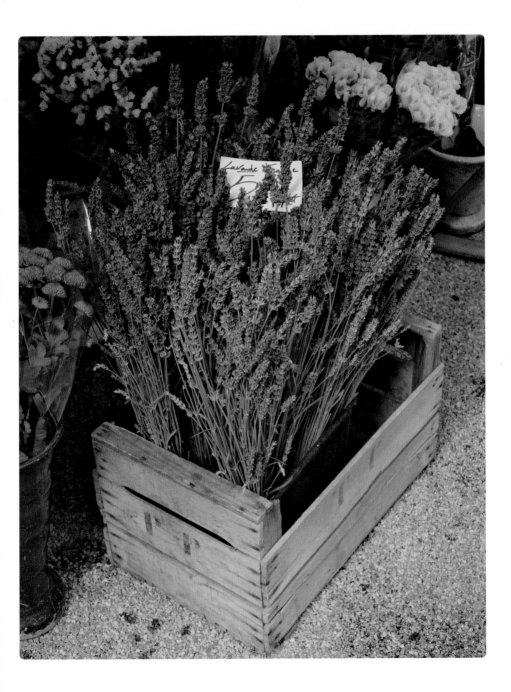

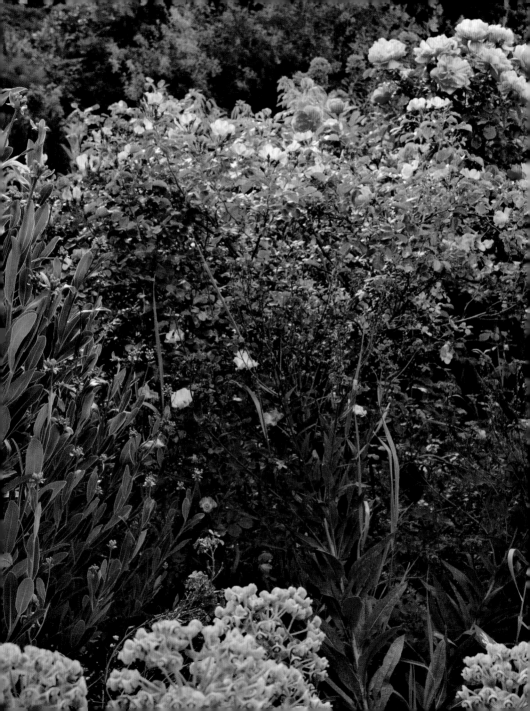

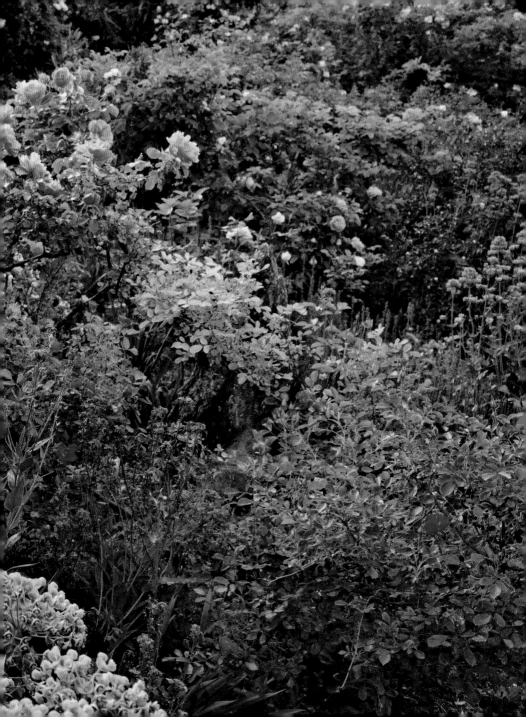

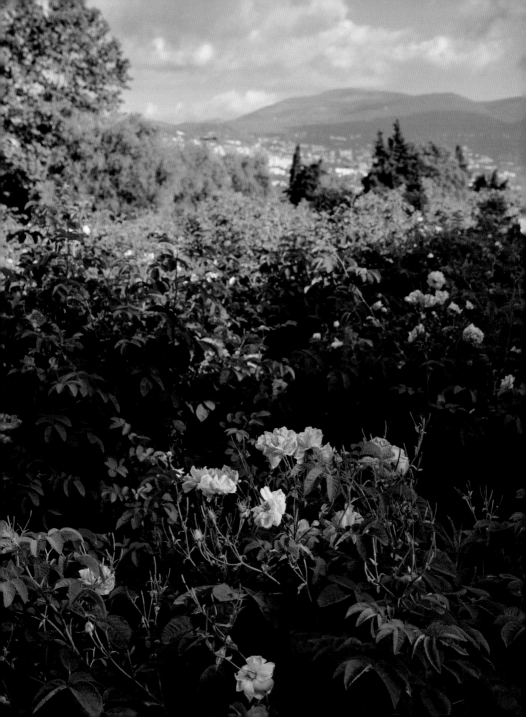

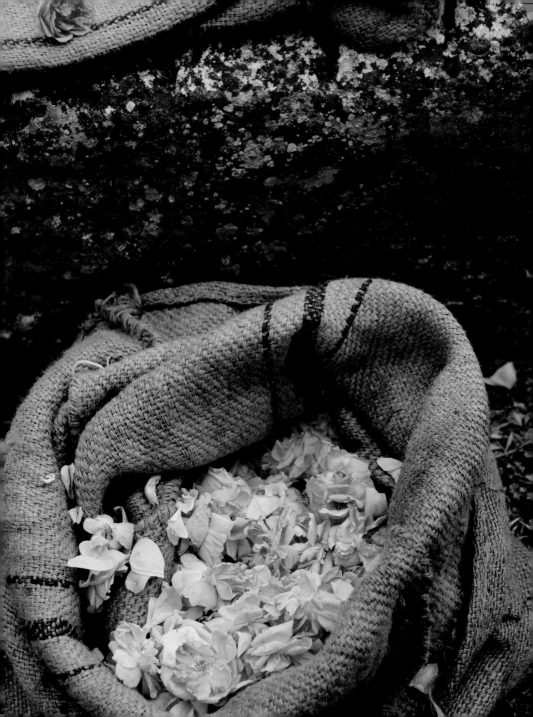

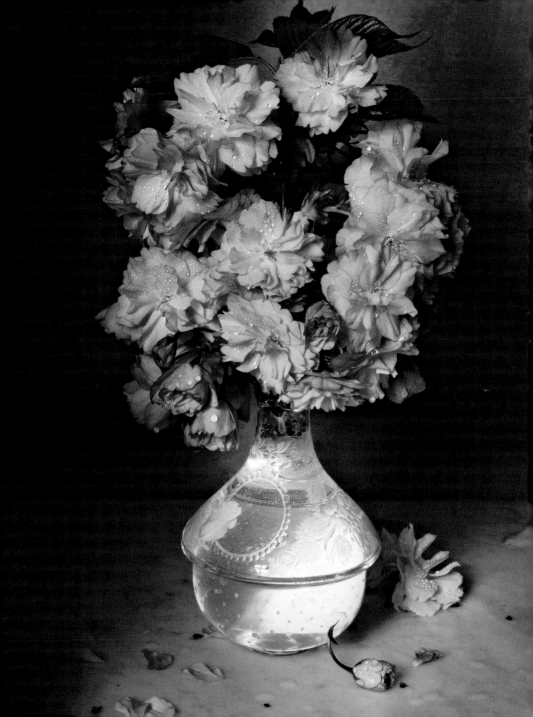

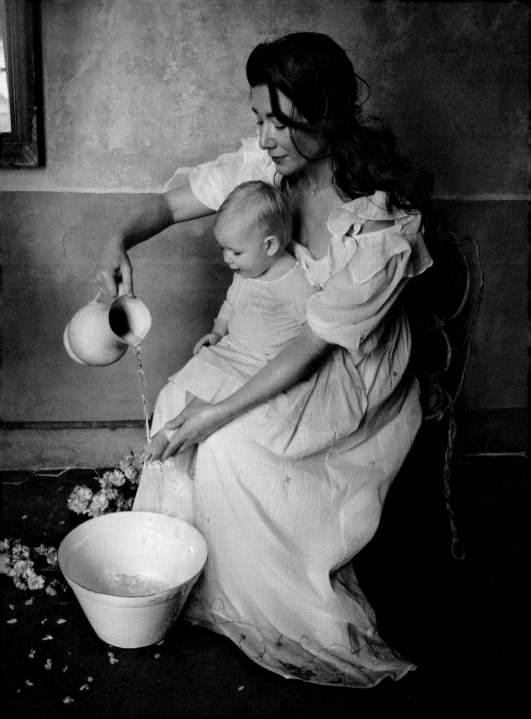

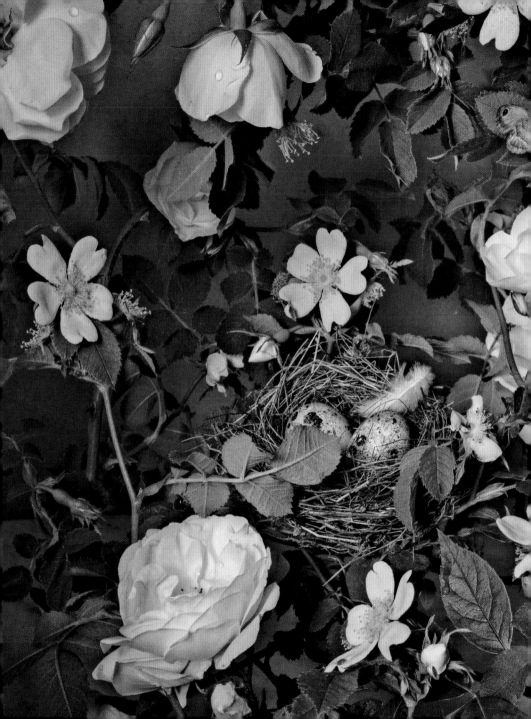

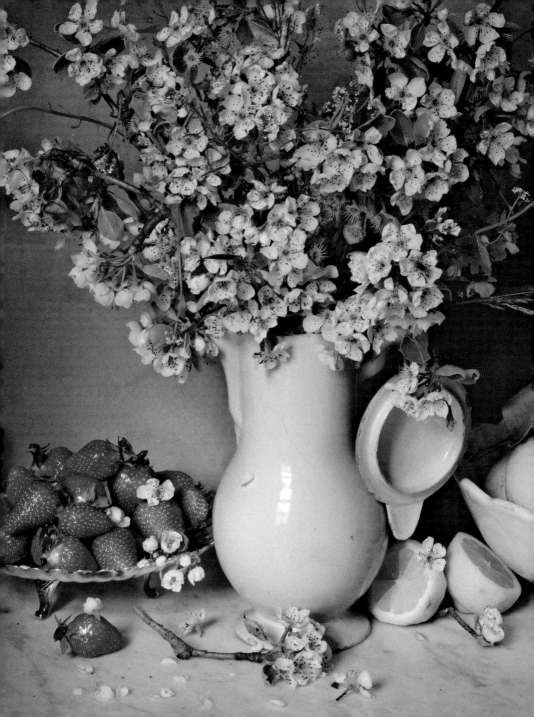

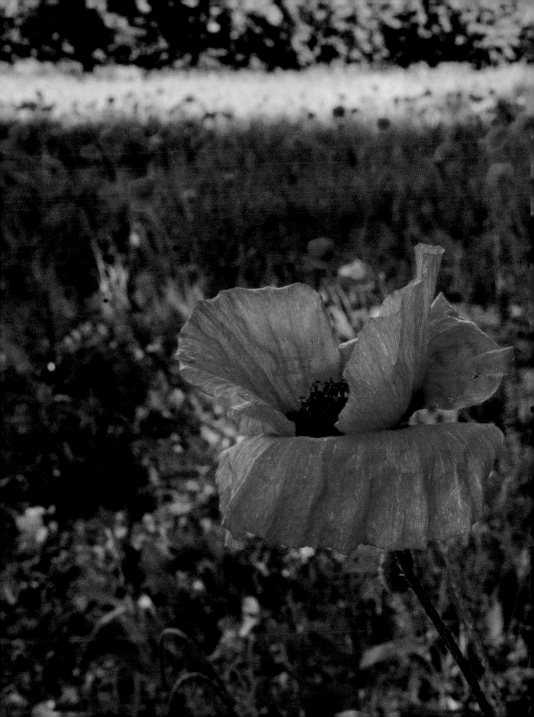

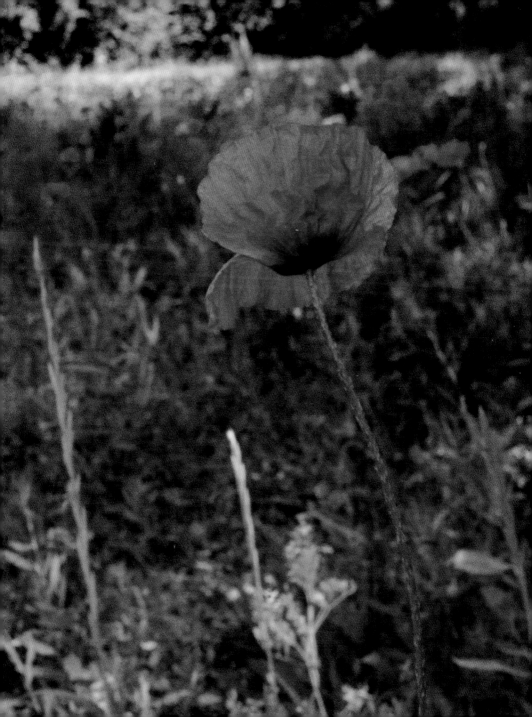

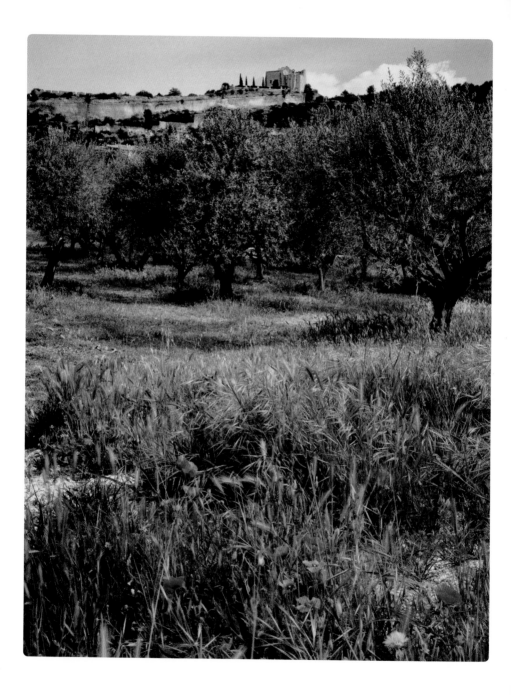

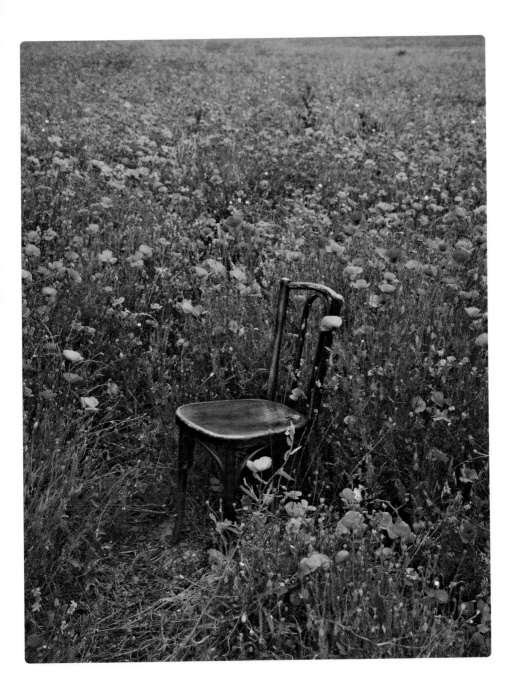

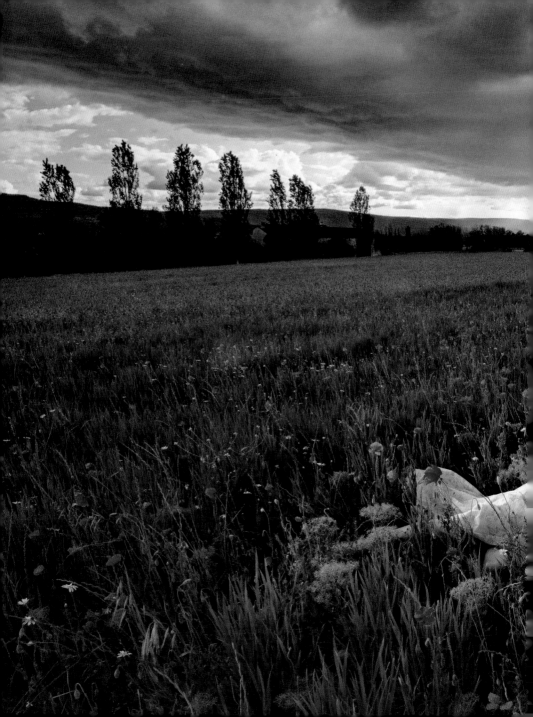

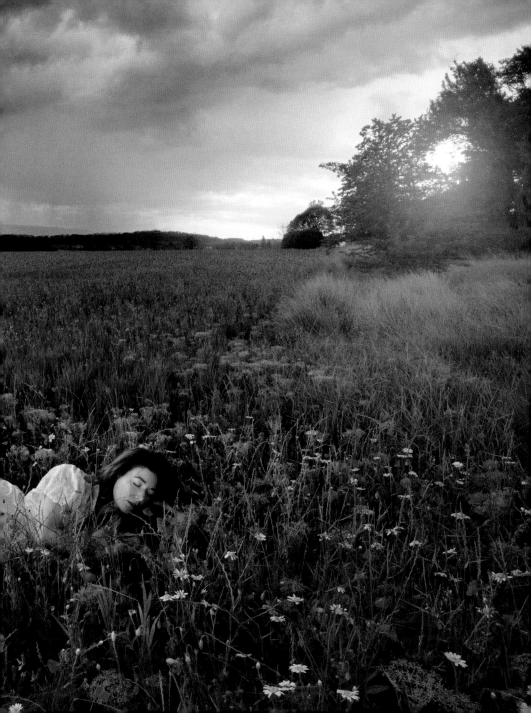

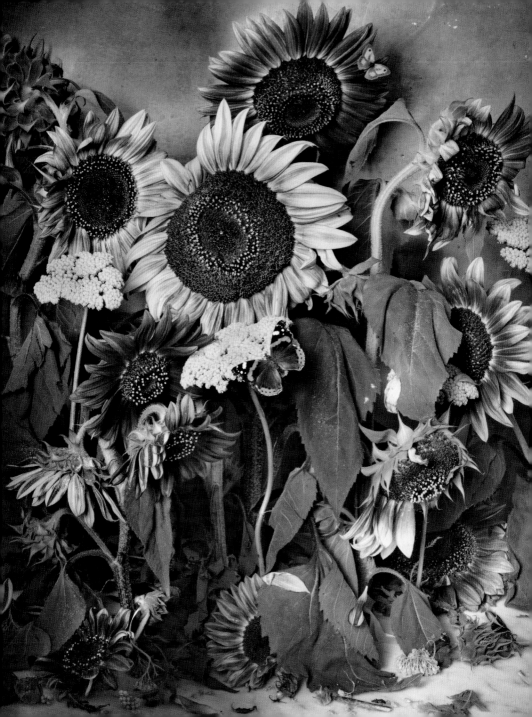

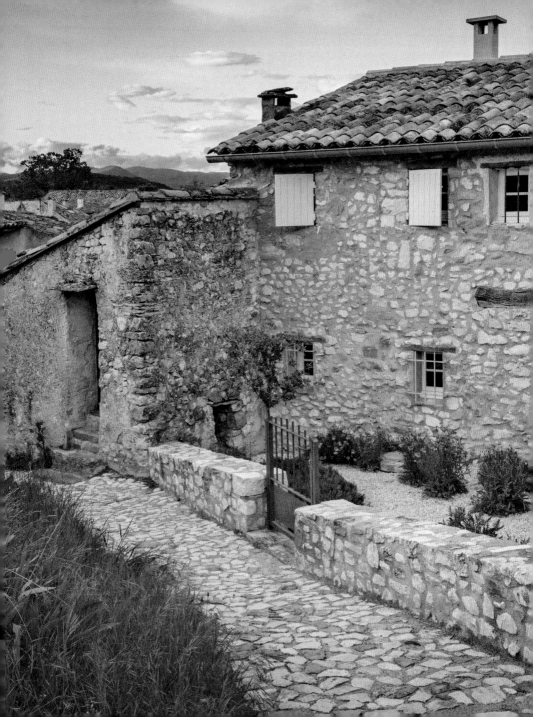

"As I sit on the floor of my studio
to create this photograph of flowers
I picked up from the farmer's market
in Cucuron, sweat drips down my back.
It is summer now and the heat touches everything,
even in the stillness of shadows. The French tell me
to close my shutters to help cool the apartment,
but I am a photographer, I live by the light.
I curse the arrogant sun who pierces through
the long, lingering days with rays as sharp
as a Roman soldier's spear ... but then I cradle
the oh-so-delicate flowers in yellow, peach,
white, red, orange, purple, and pink in my hands
and I touch all that this summer sun gave to us.
I feel thankful for her might that transforms
light and warmth into this rainbow of life."

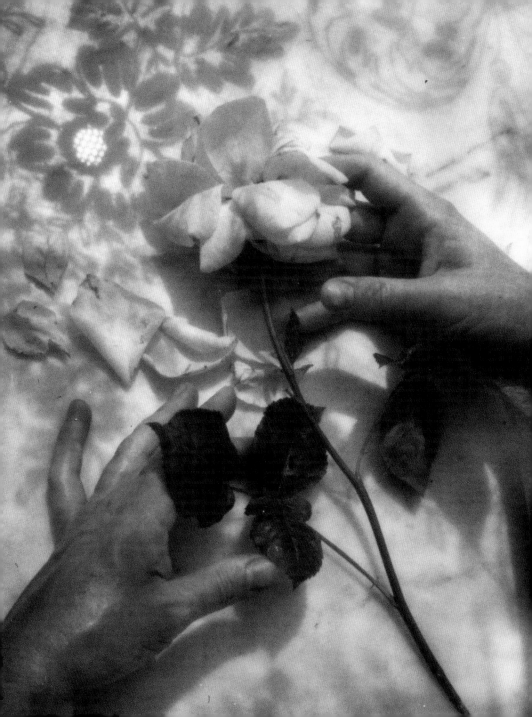

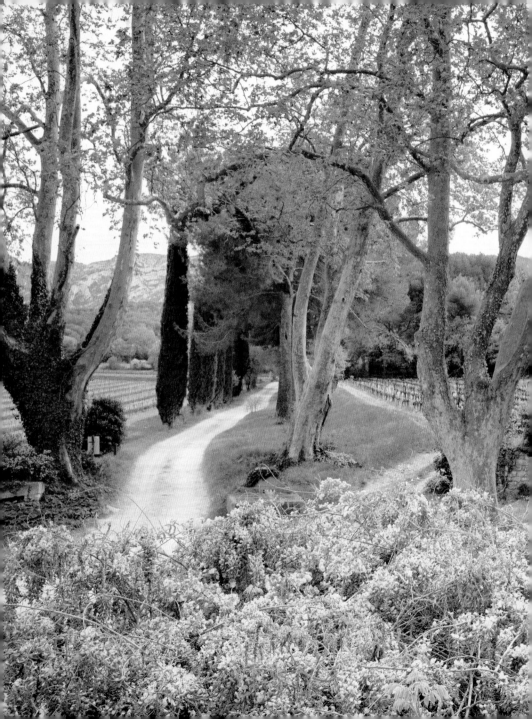

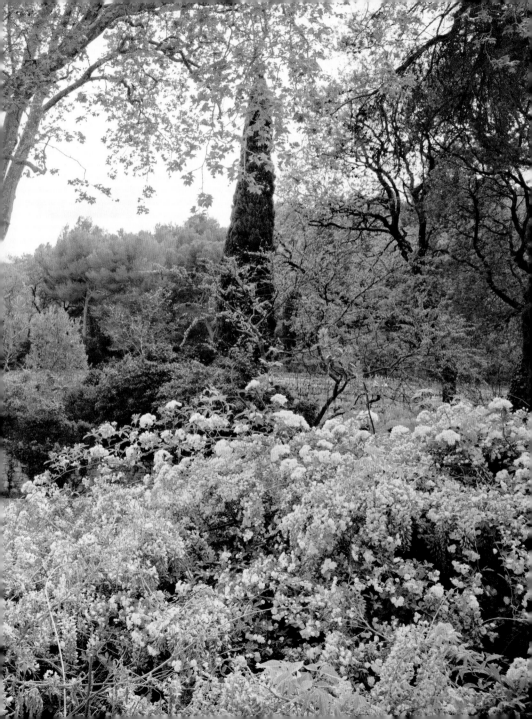

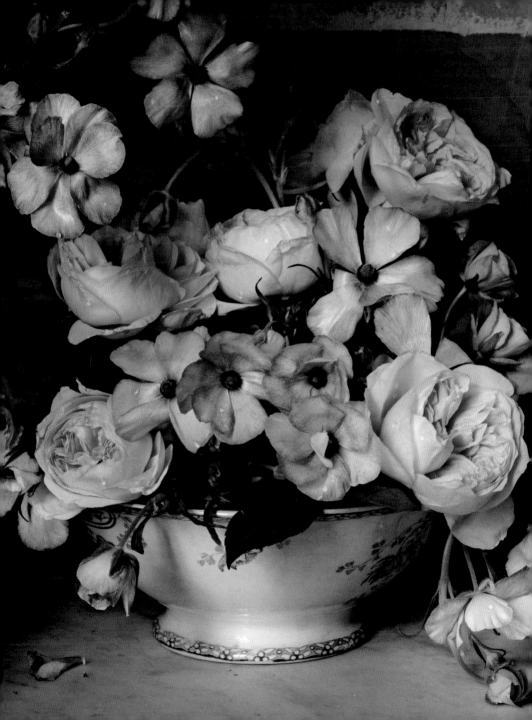

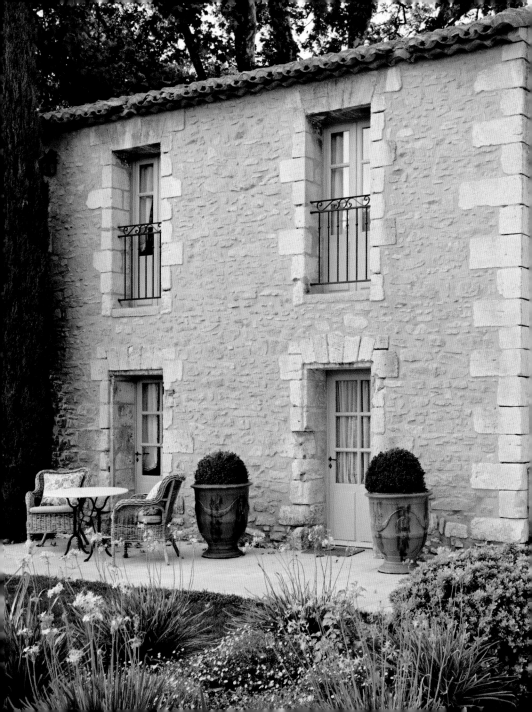

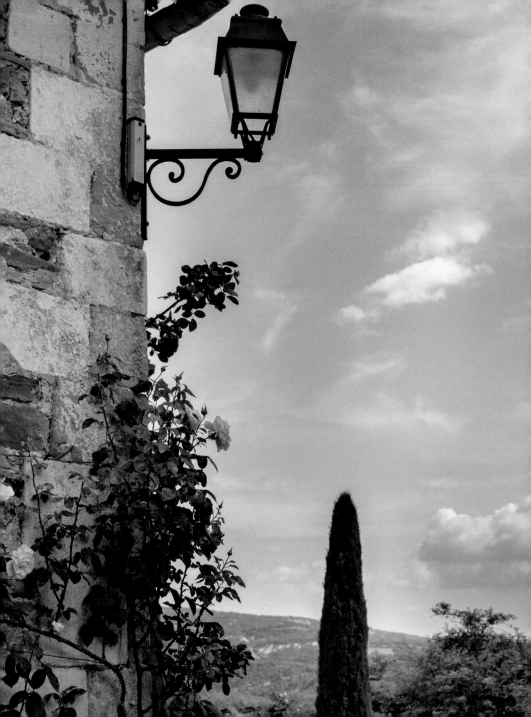

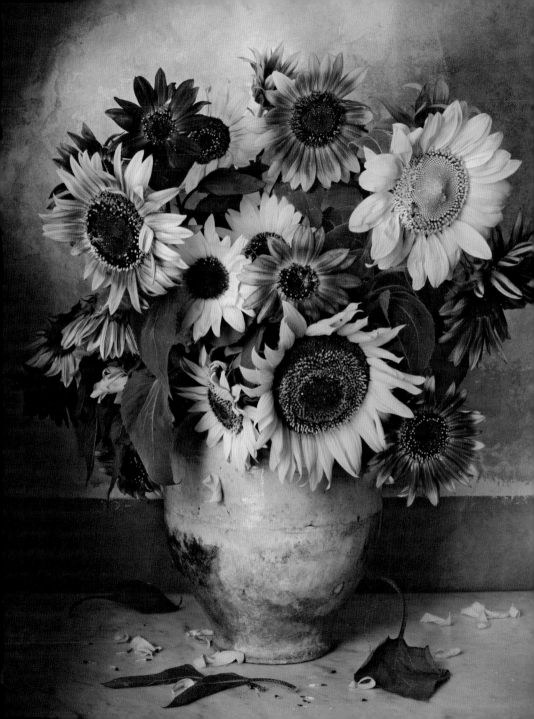

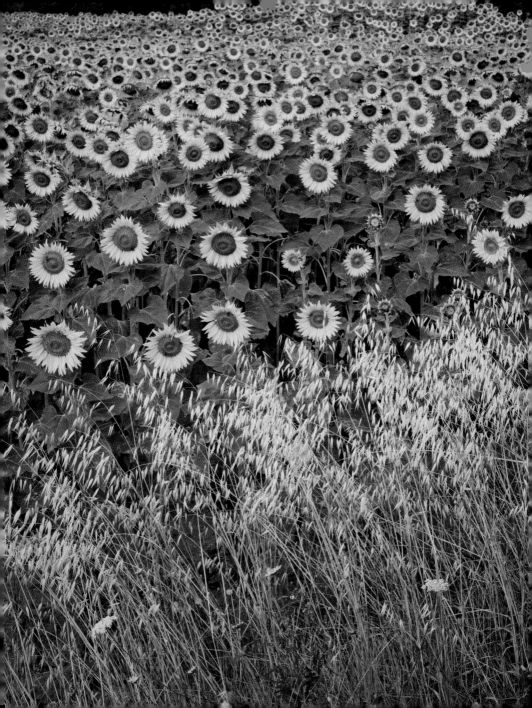

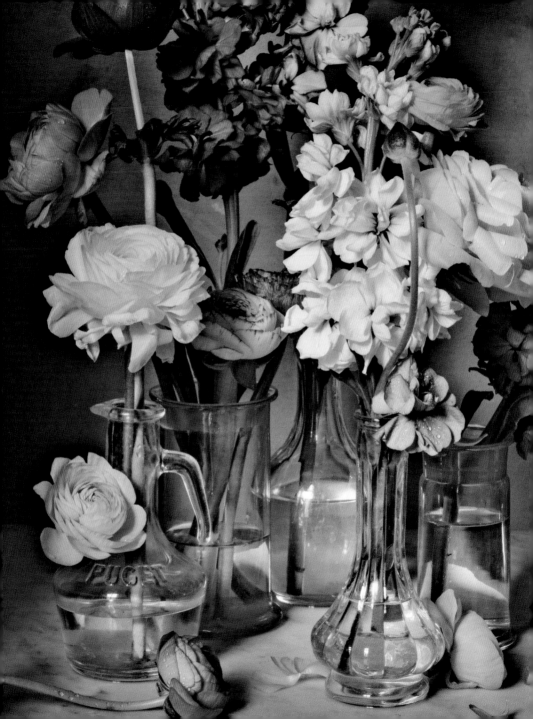

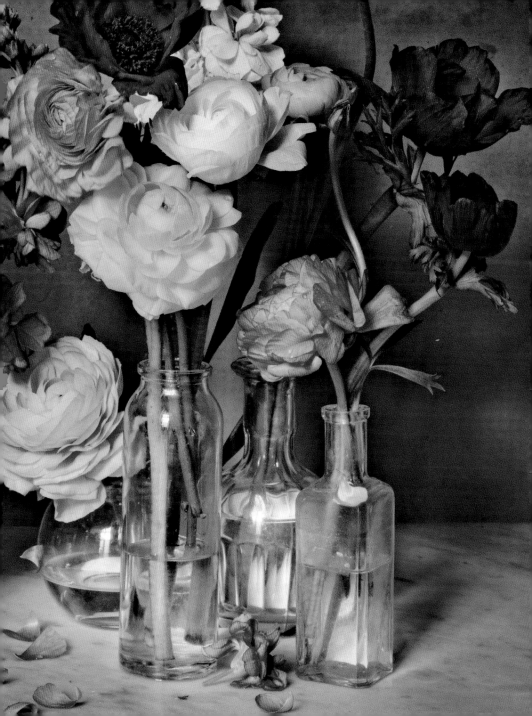

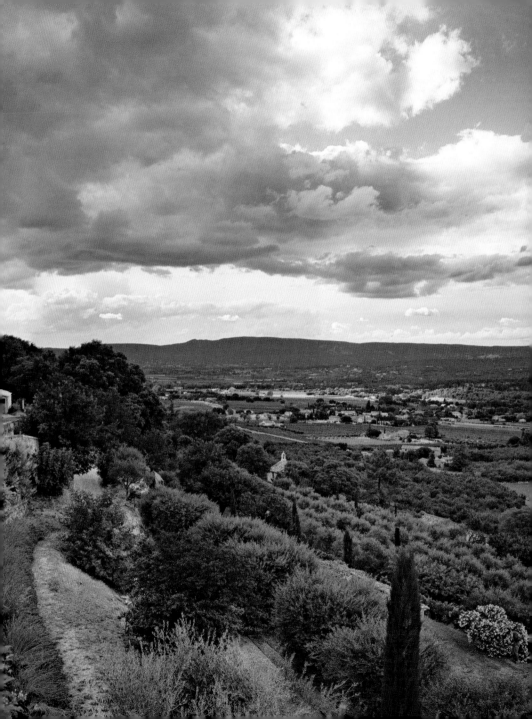

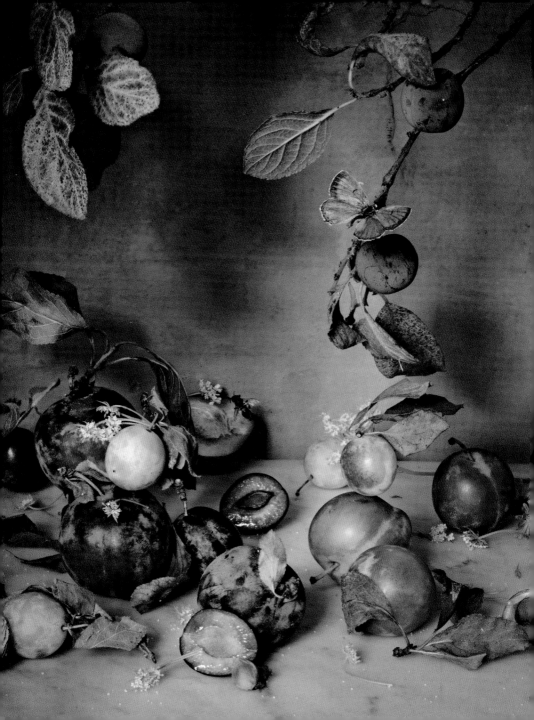

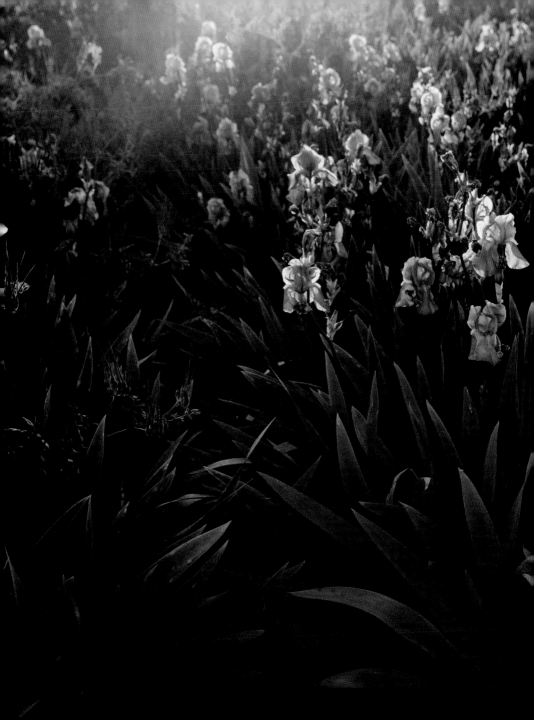

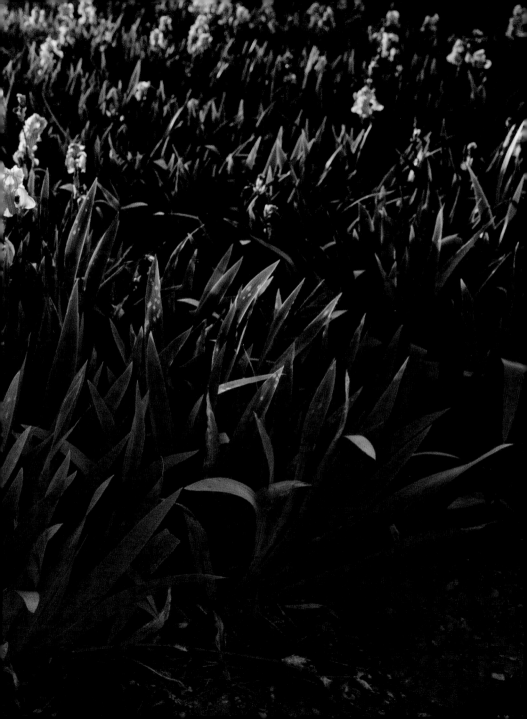

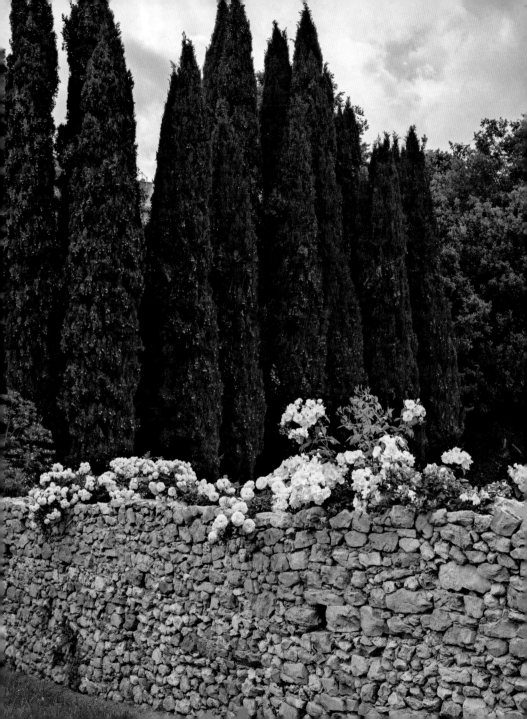

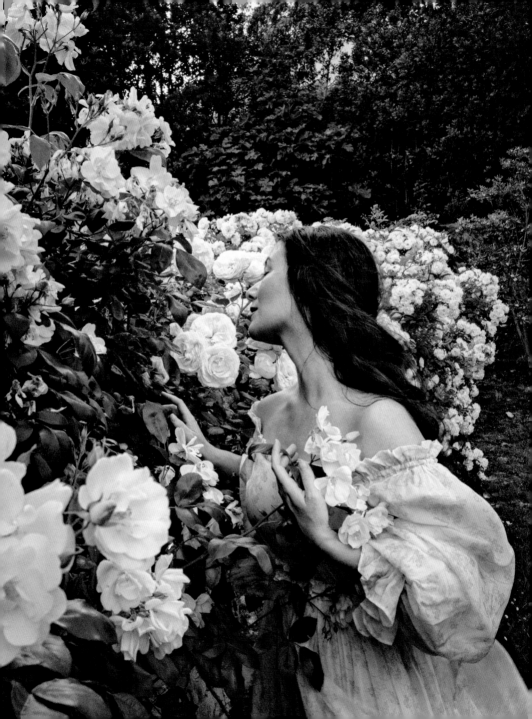

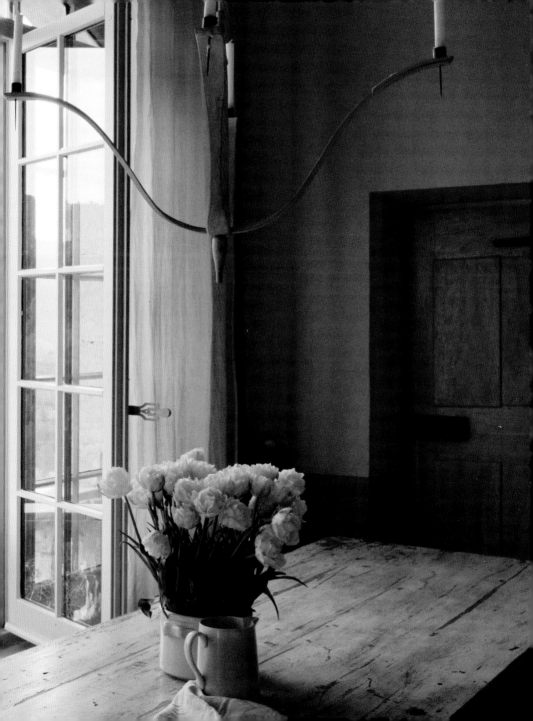

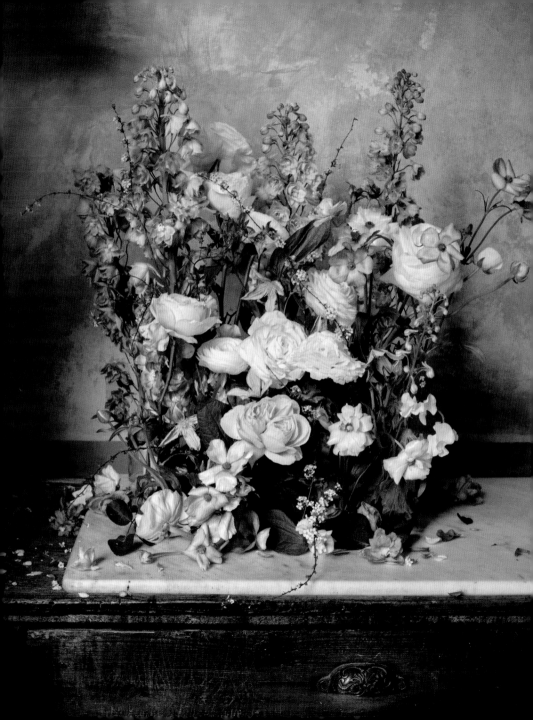

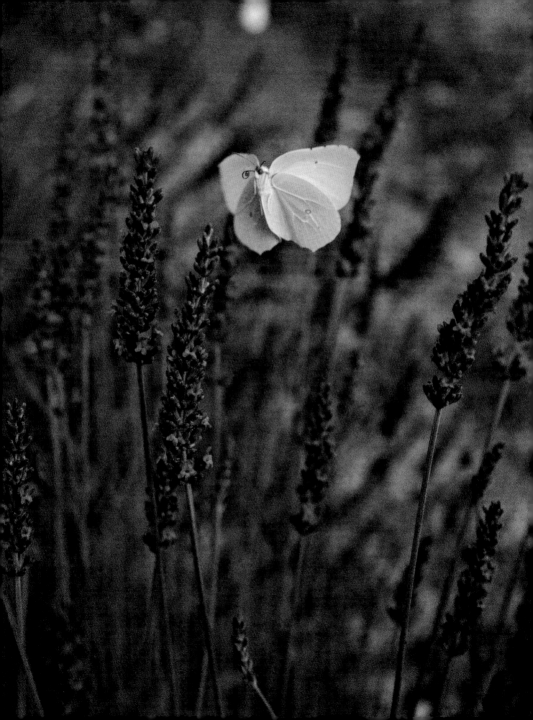

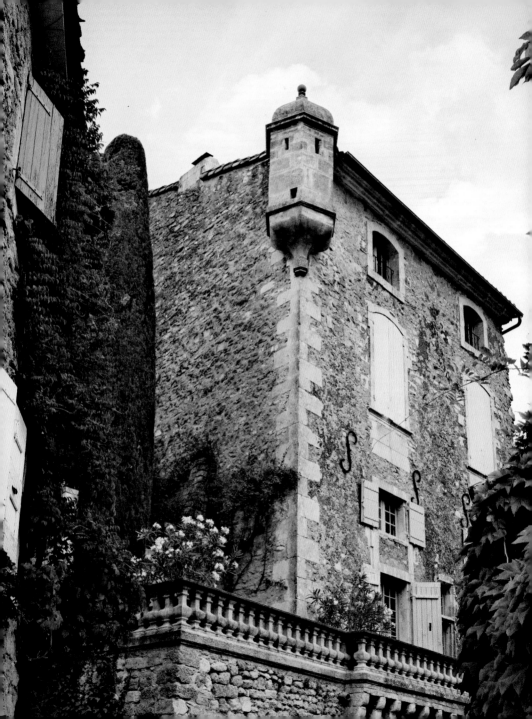

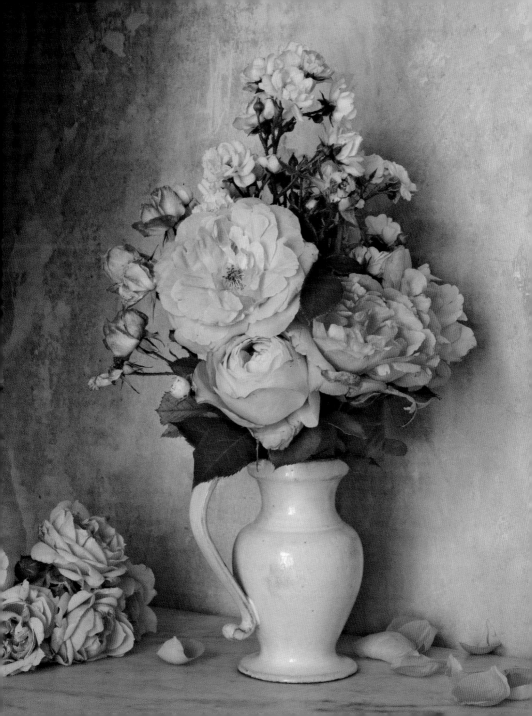

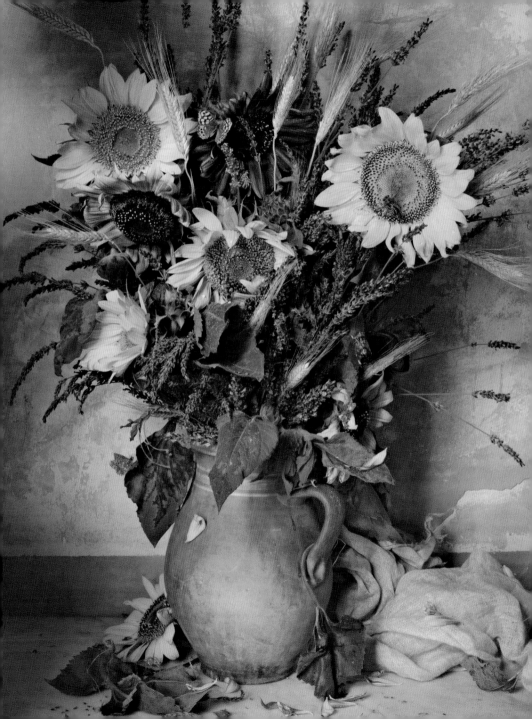

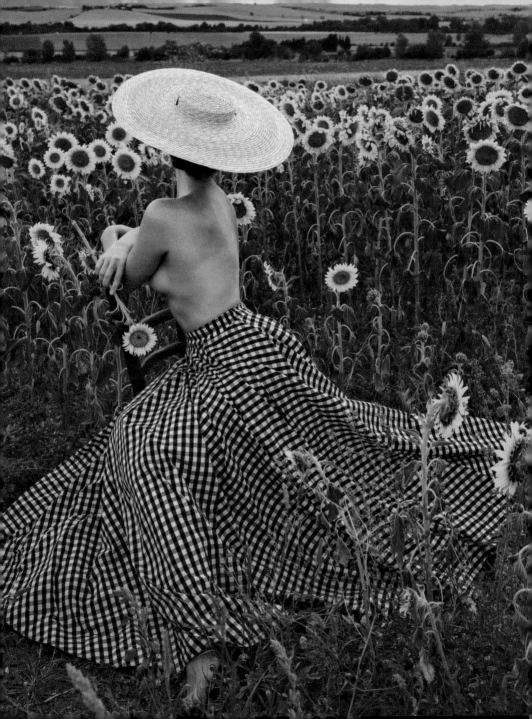

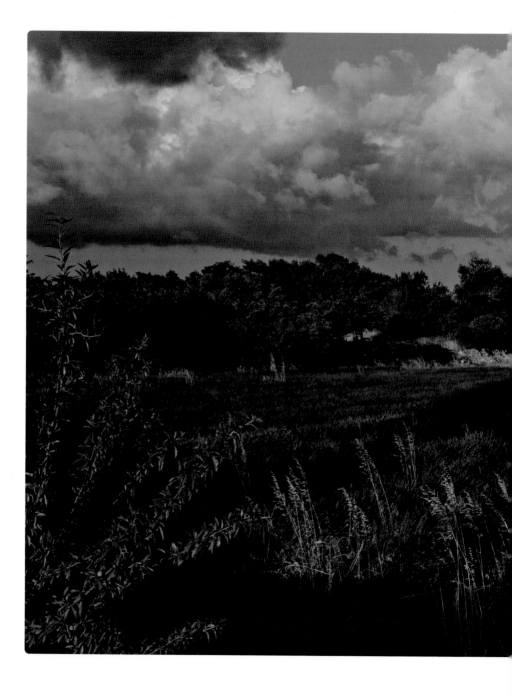

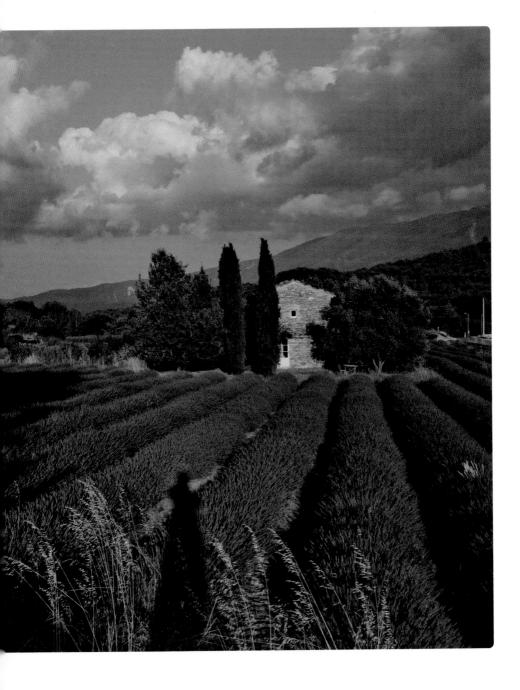

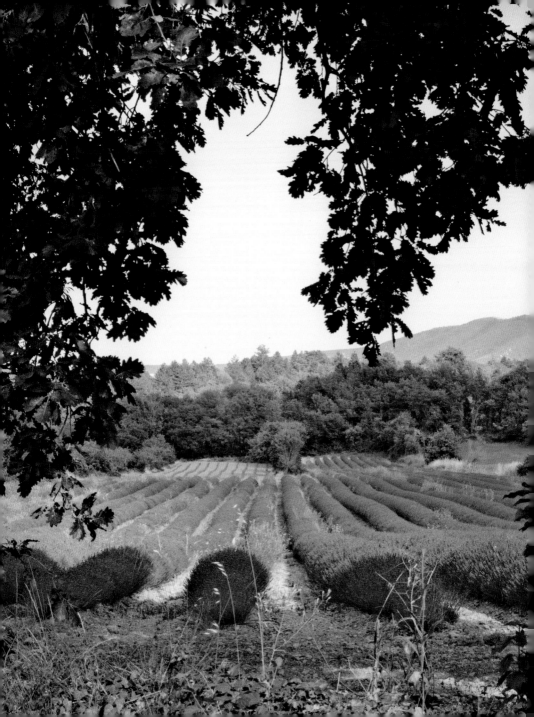

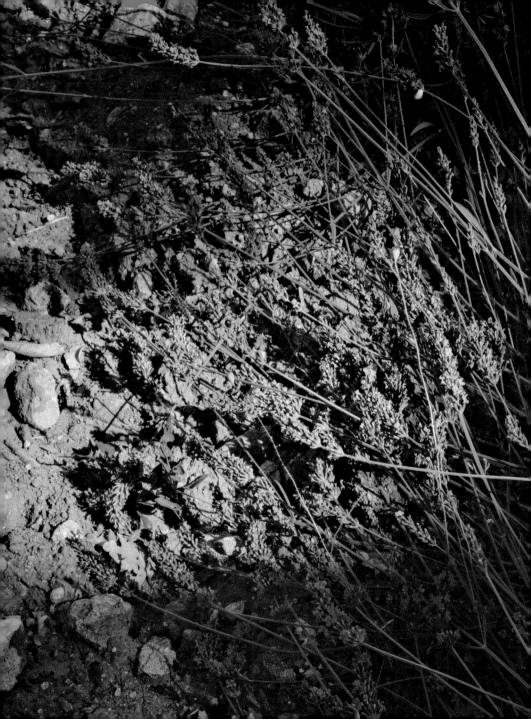

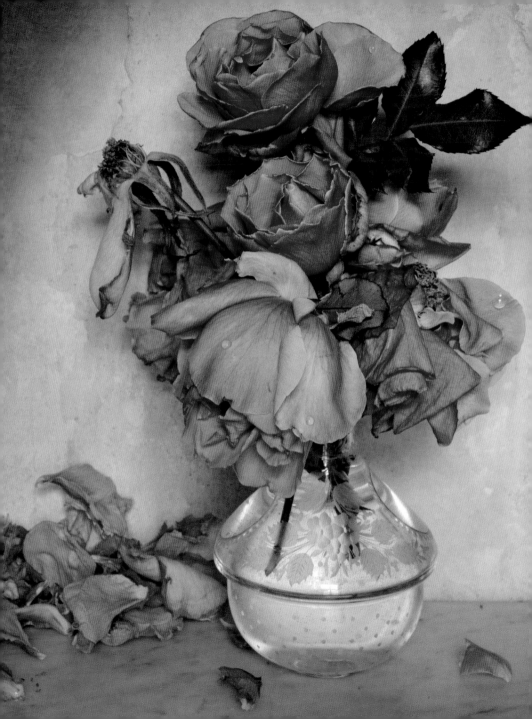

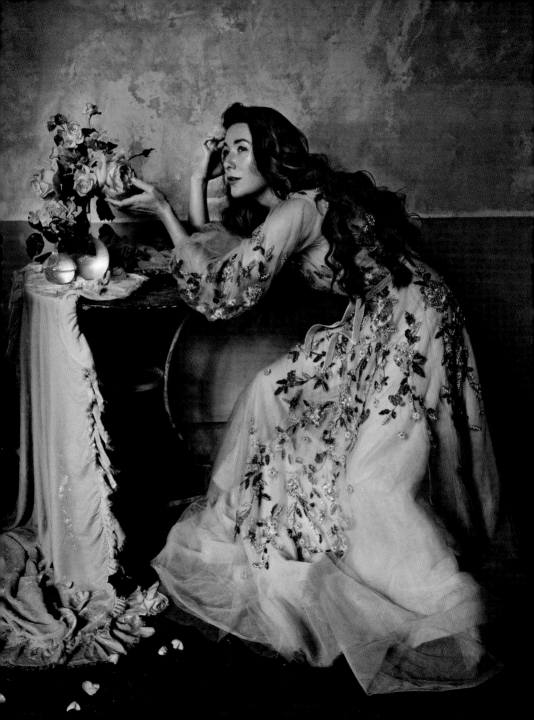

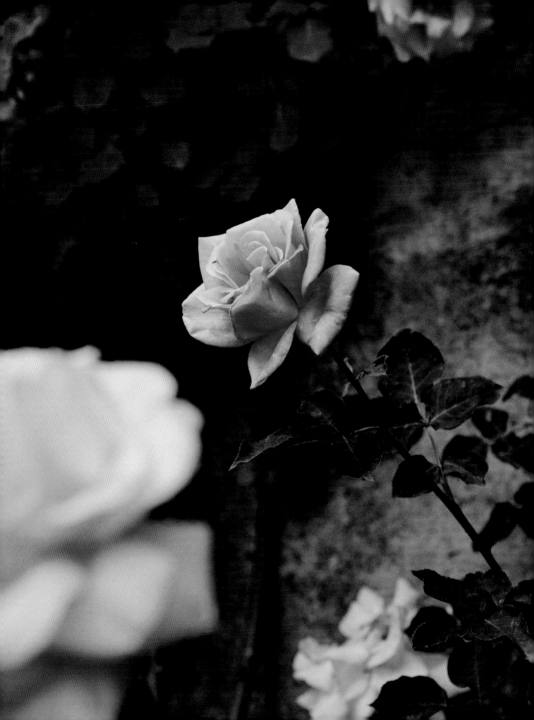

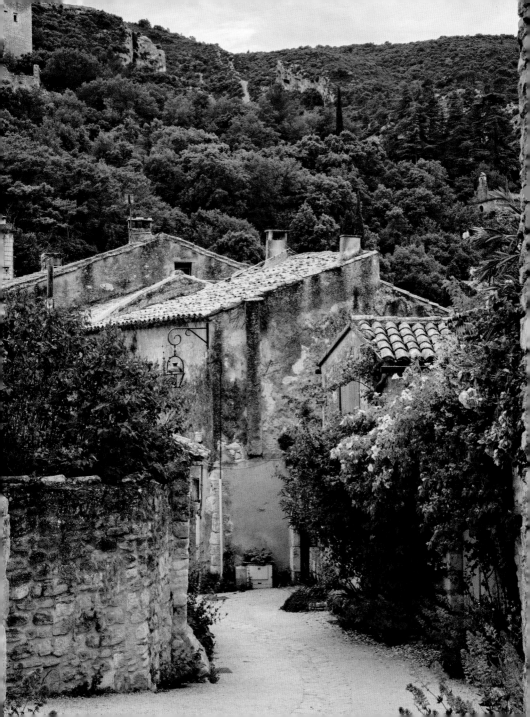

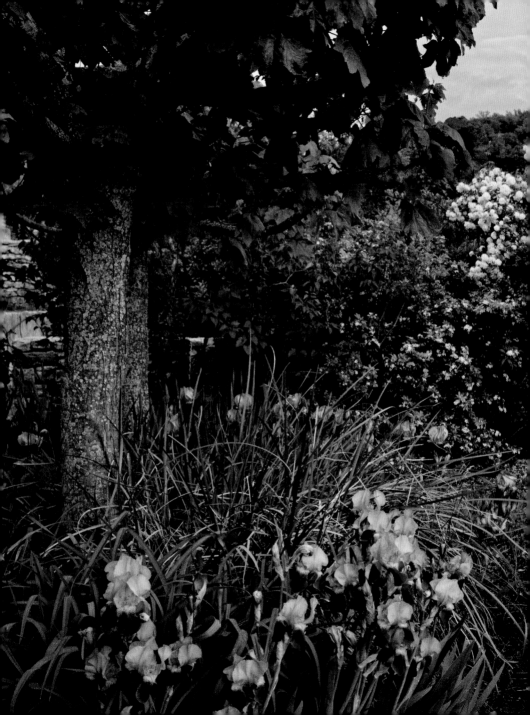

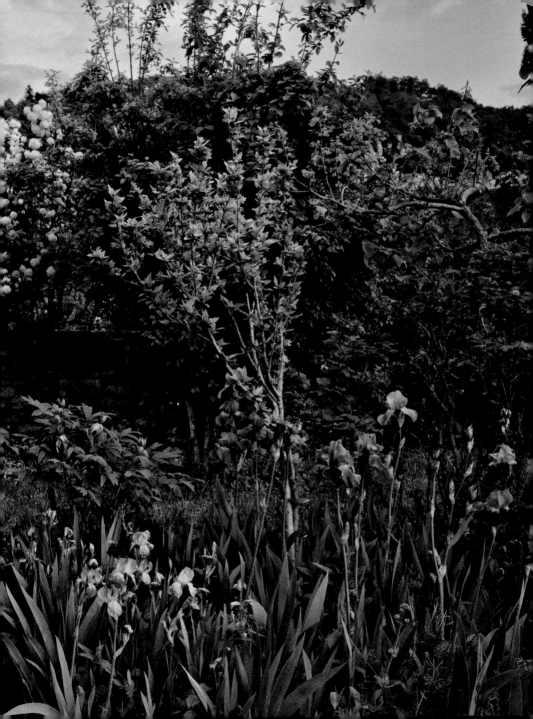

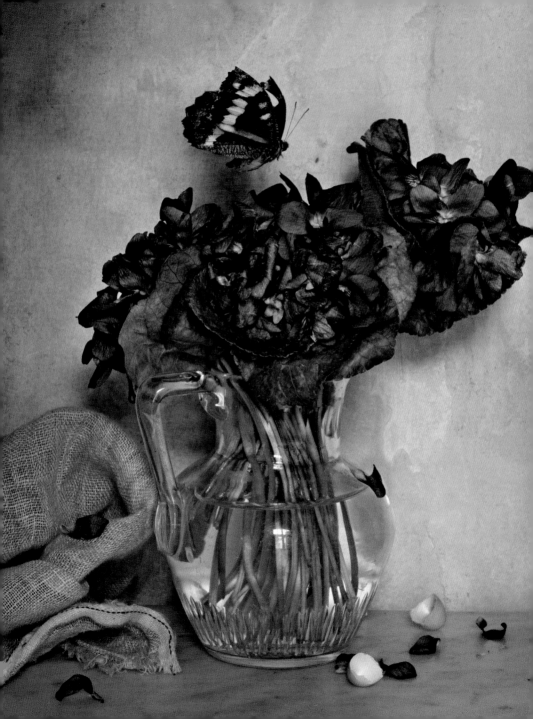

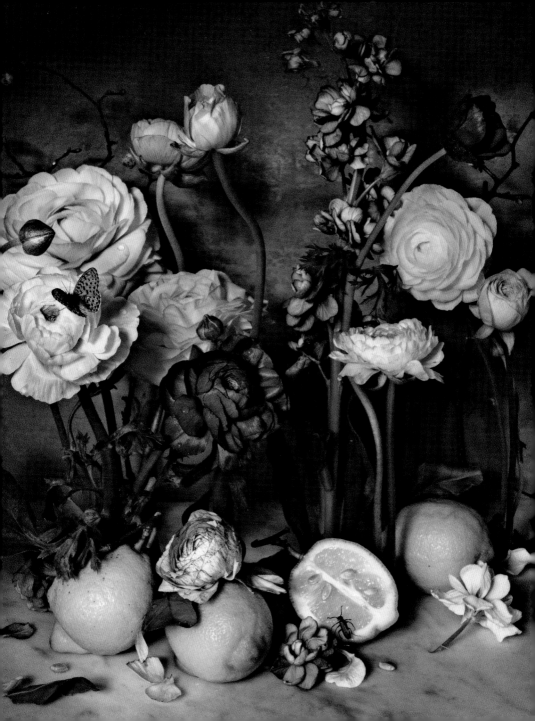

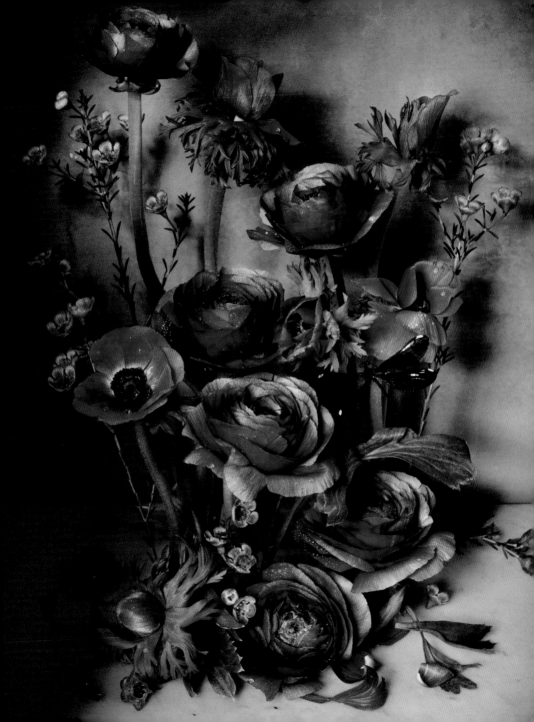

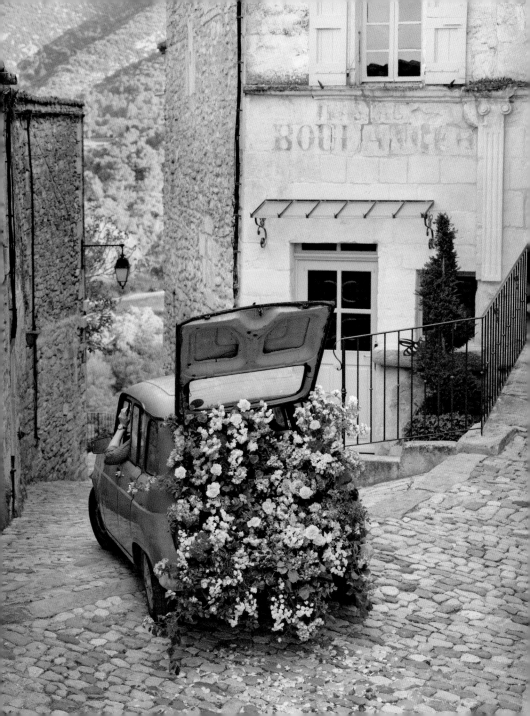

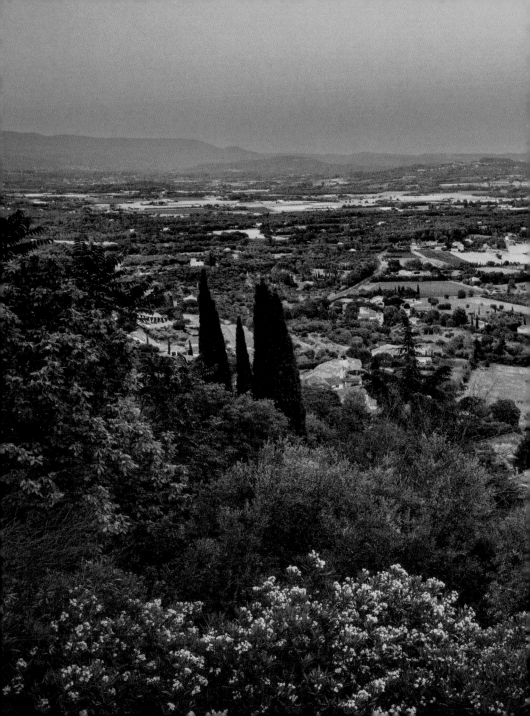

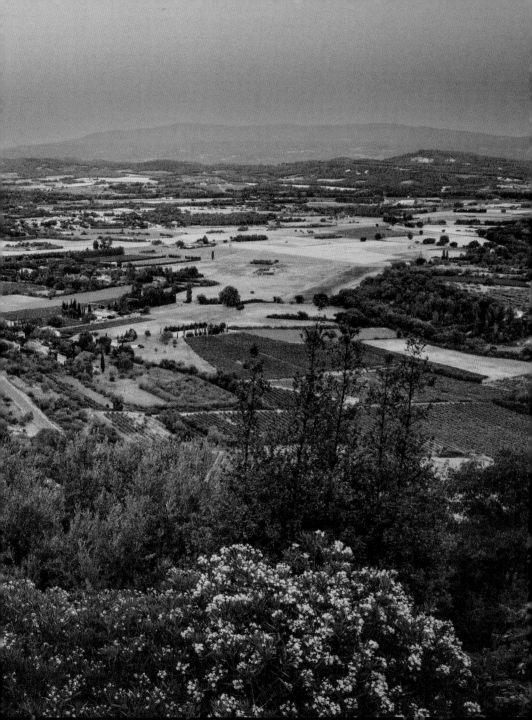

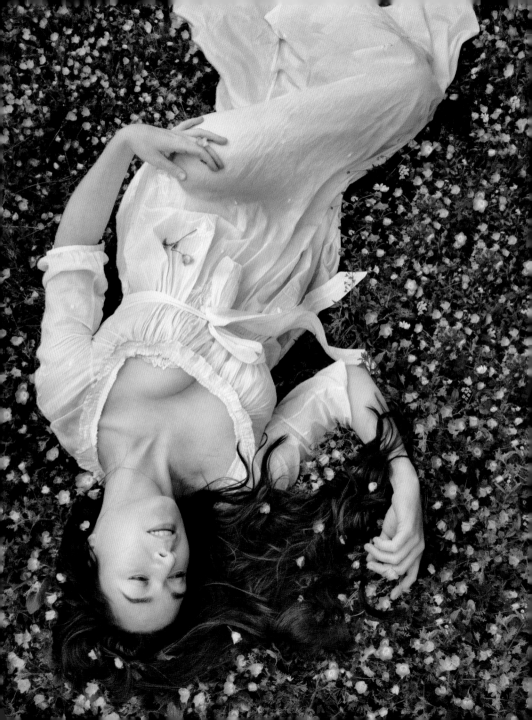

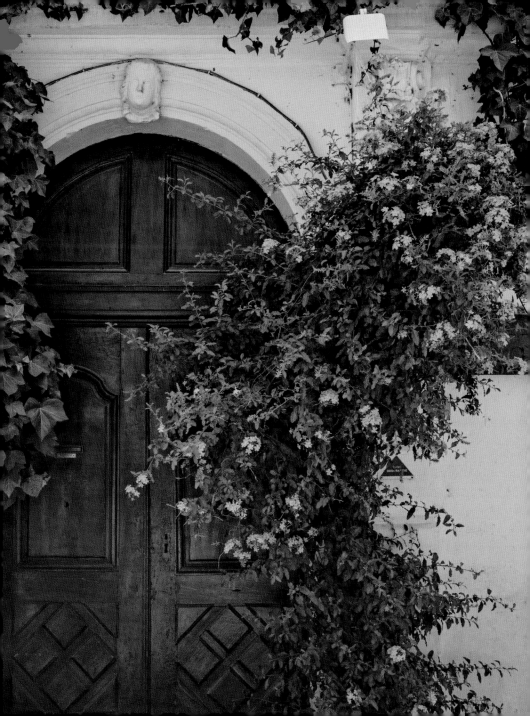

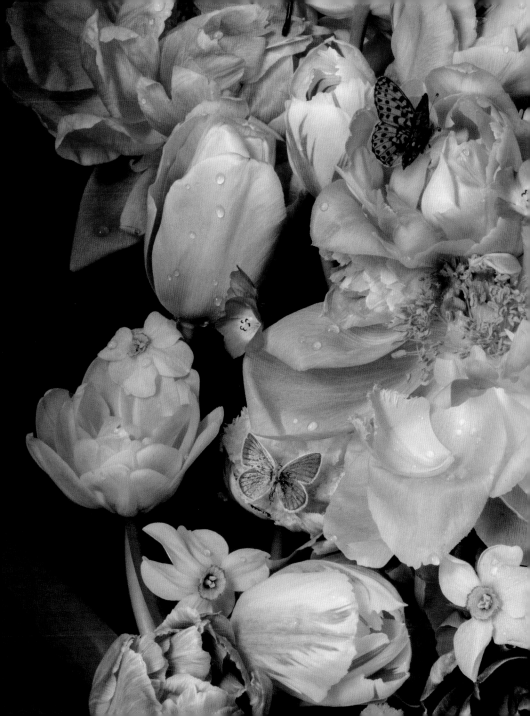

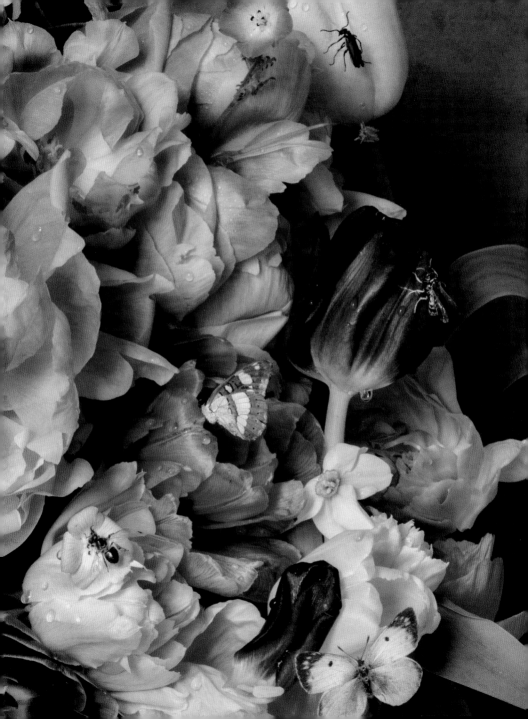

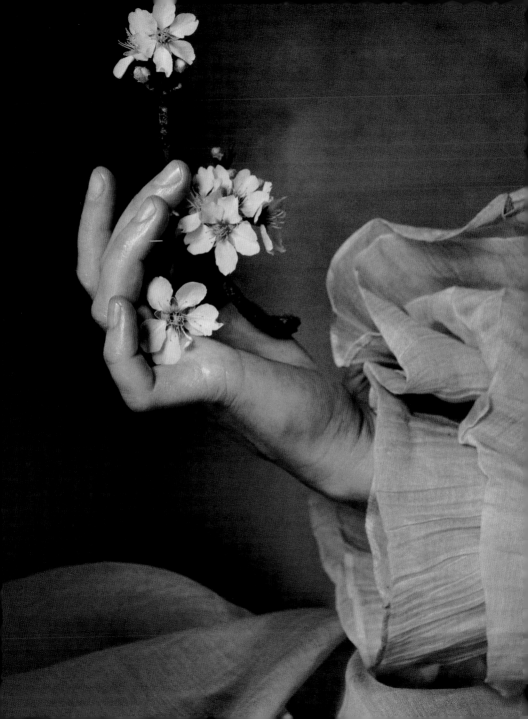

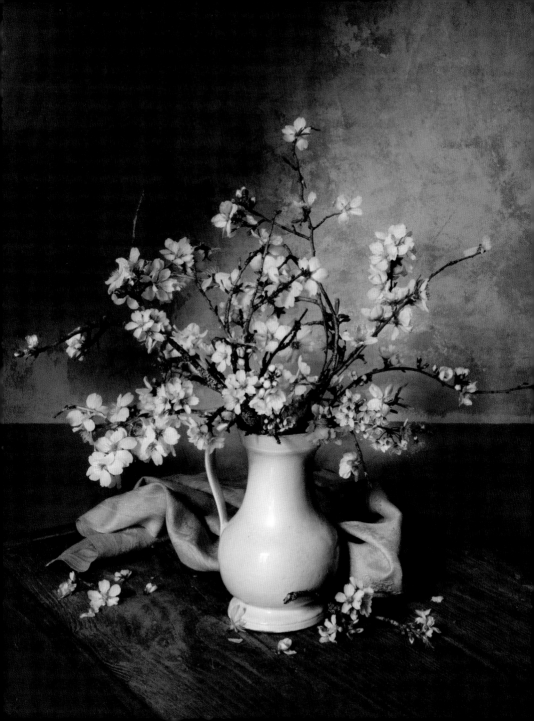

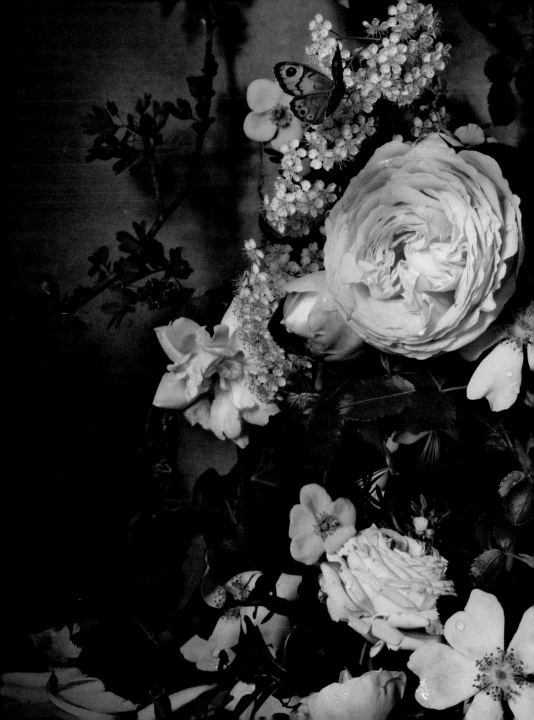

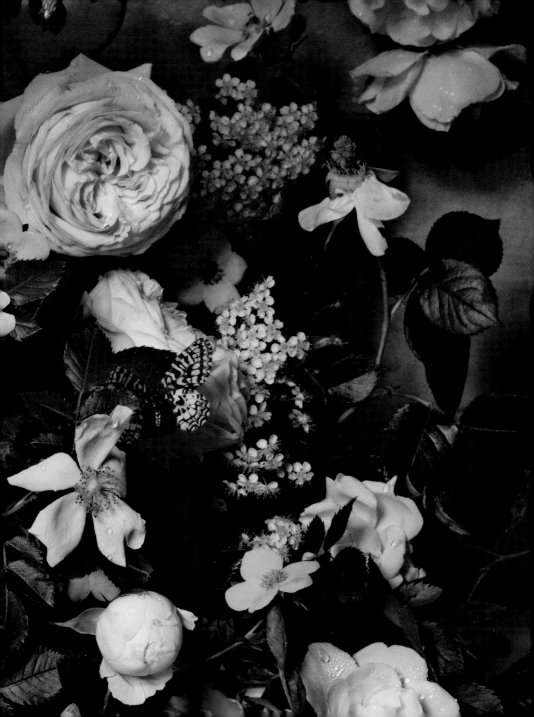

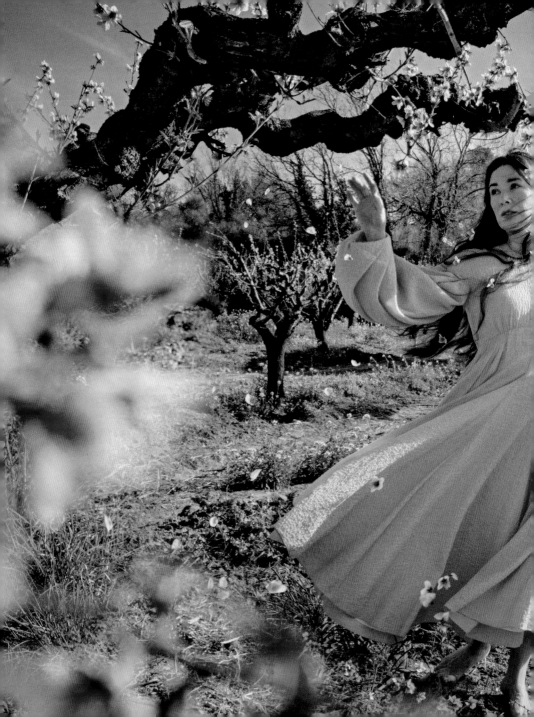

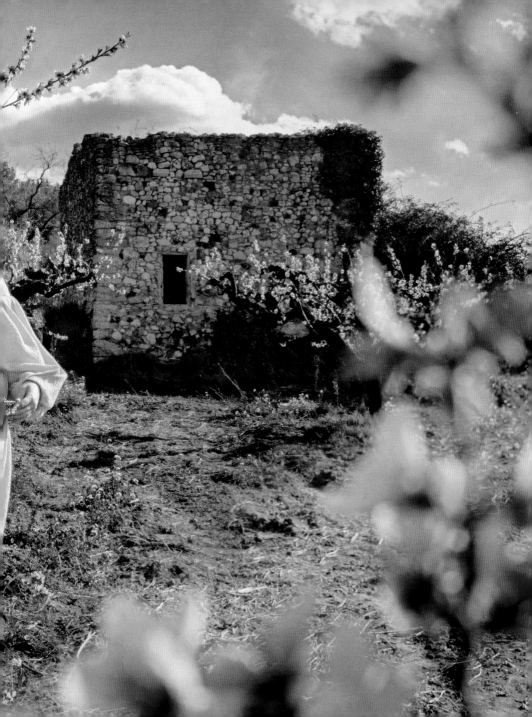

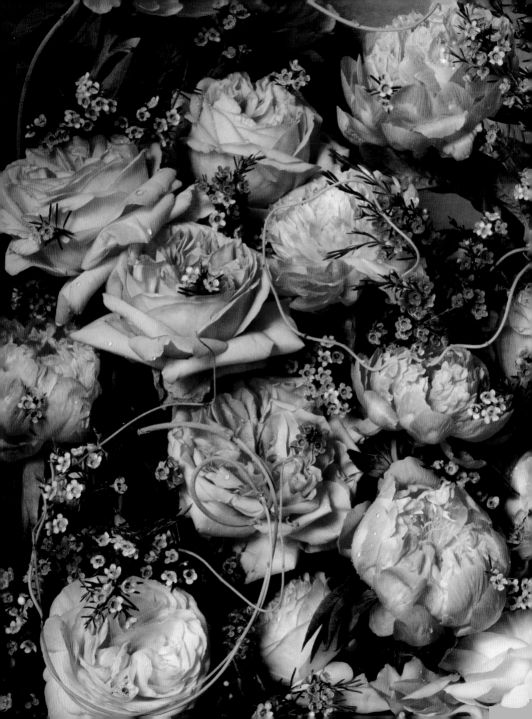

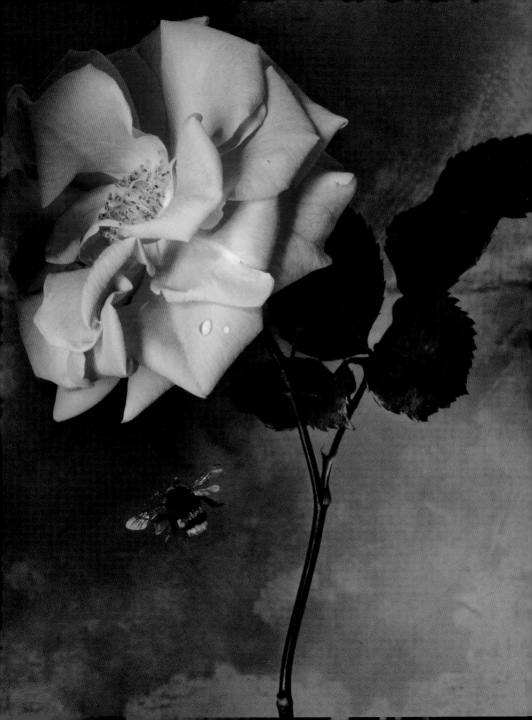

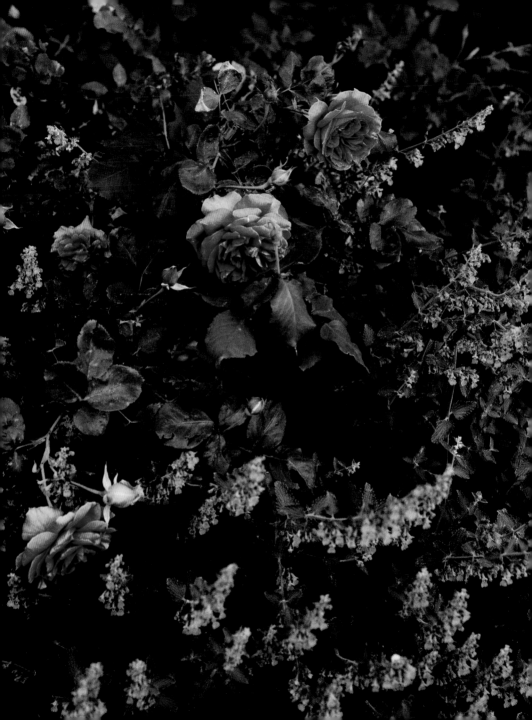

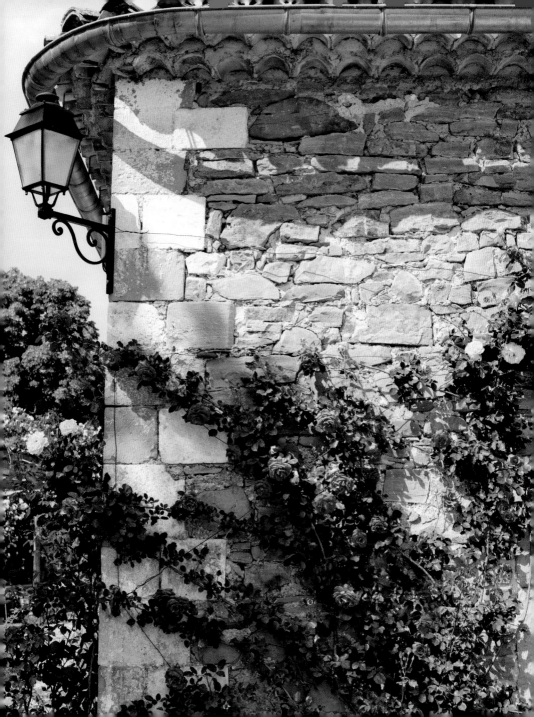

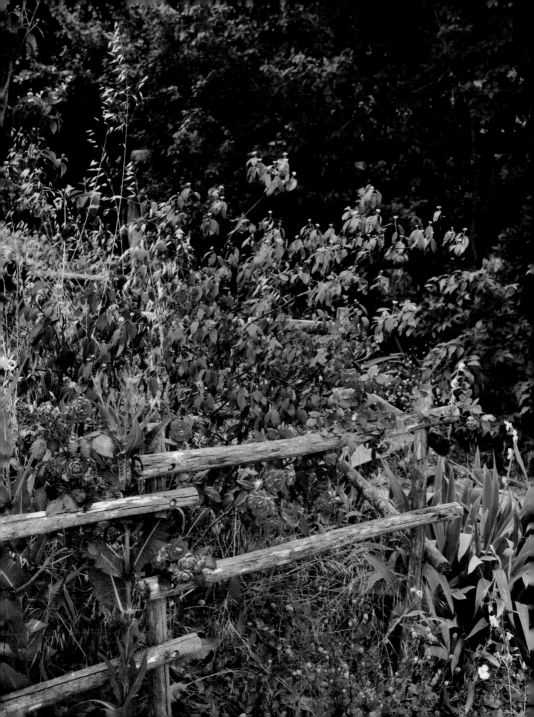

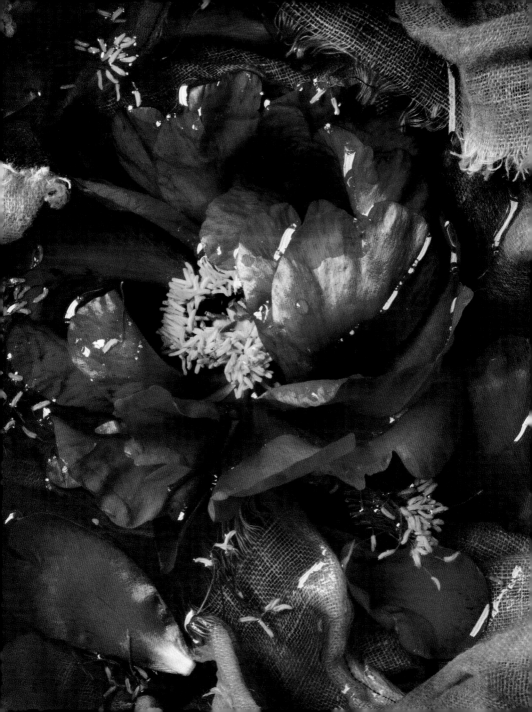

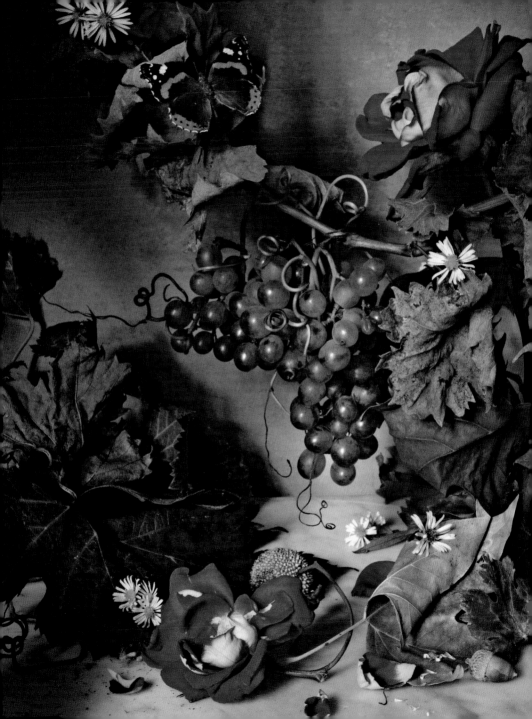

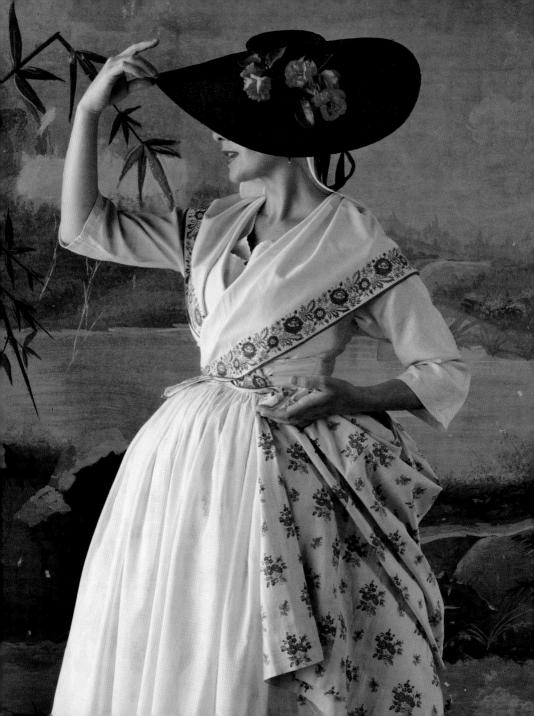

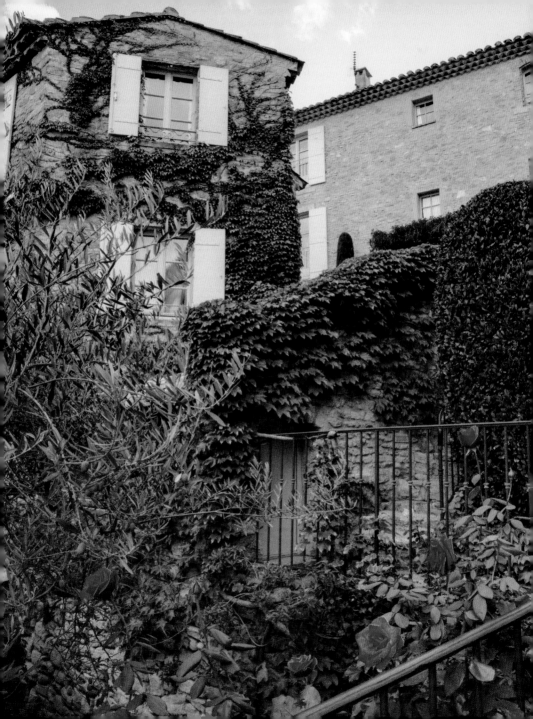

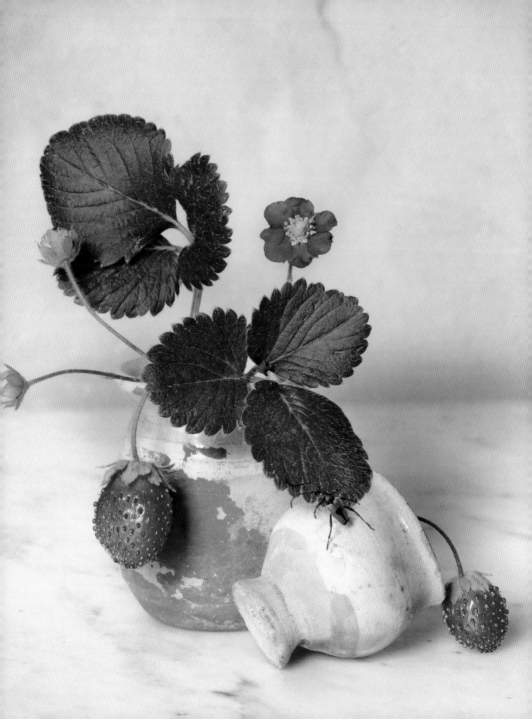

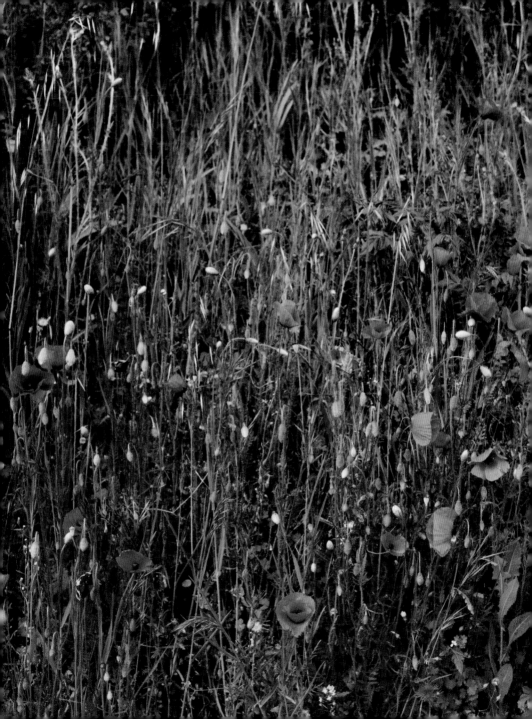

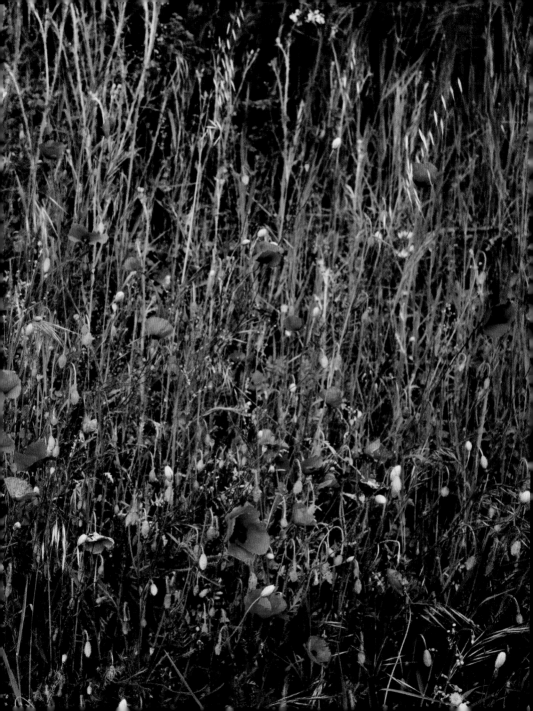

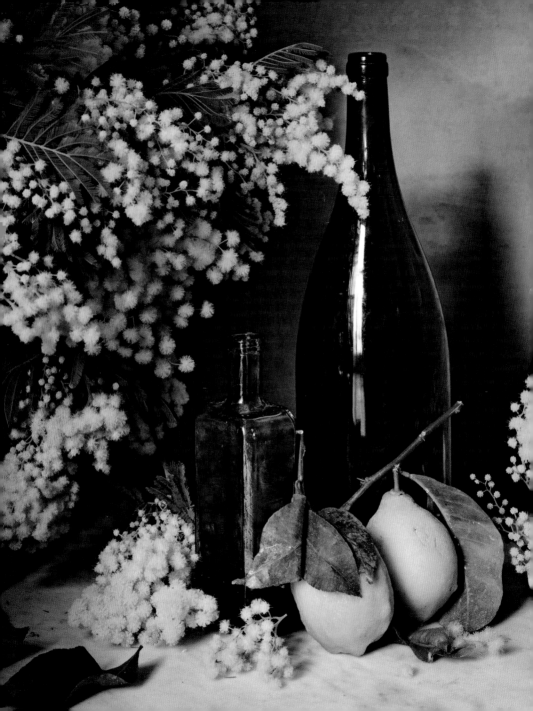

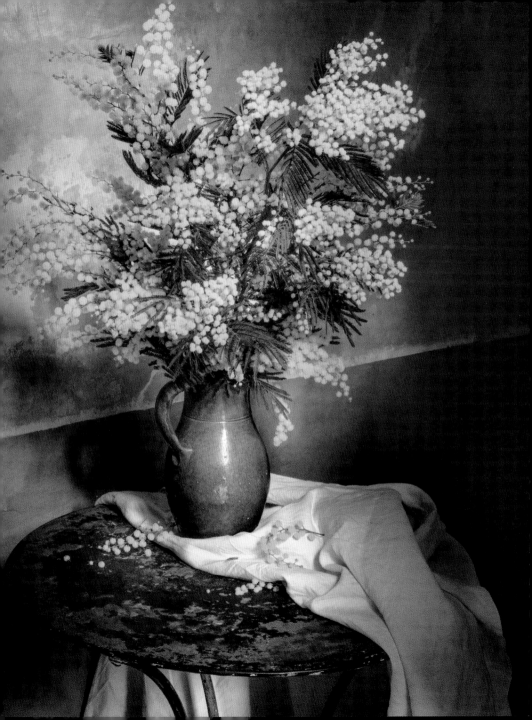

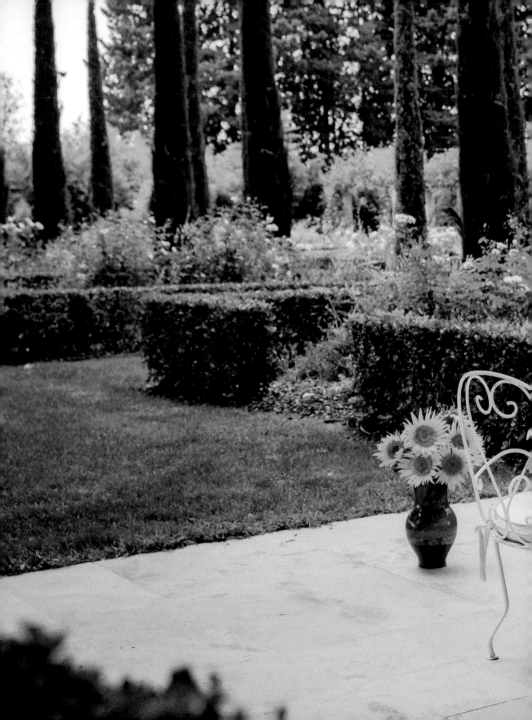

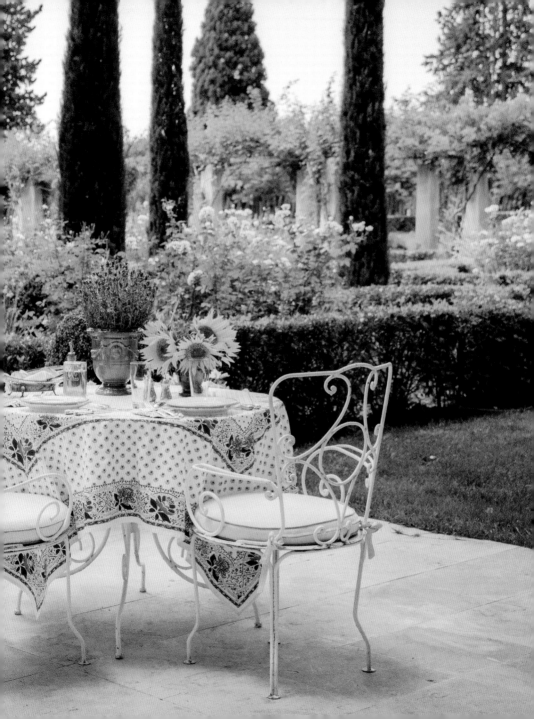

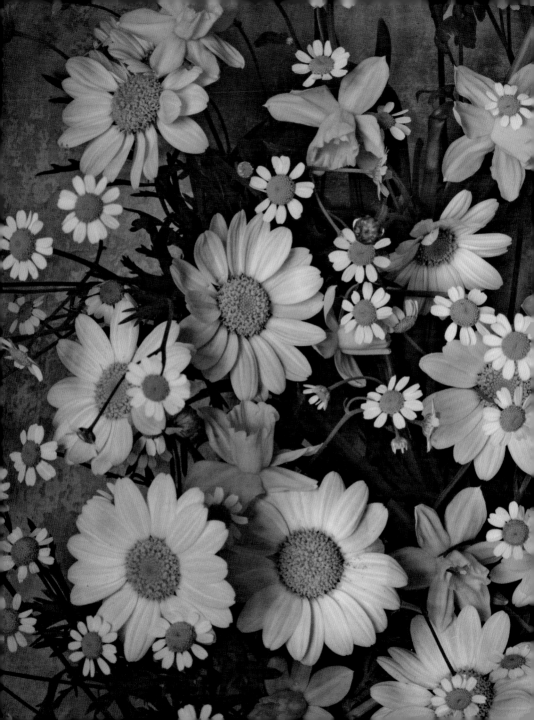

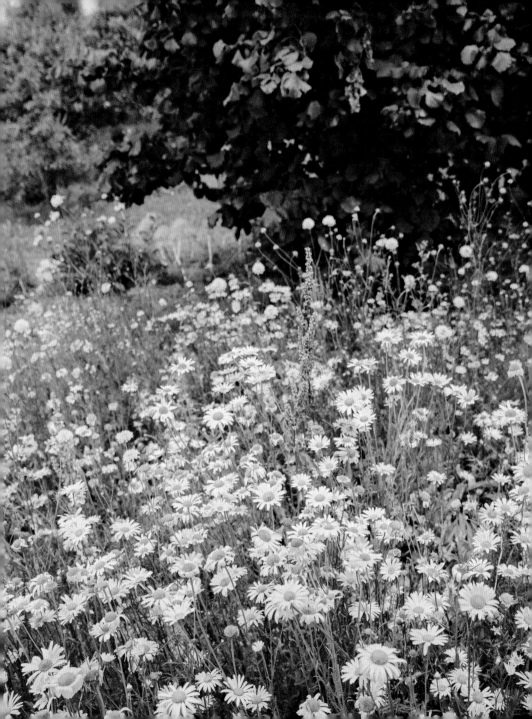

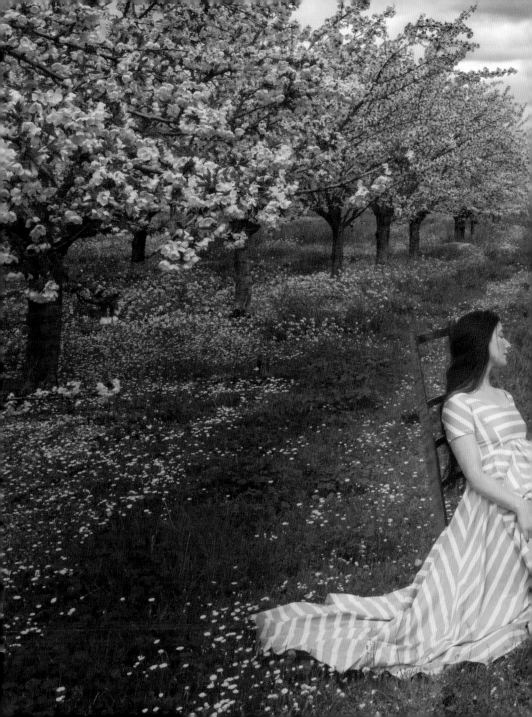

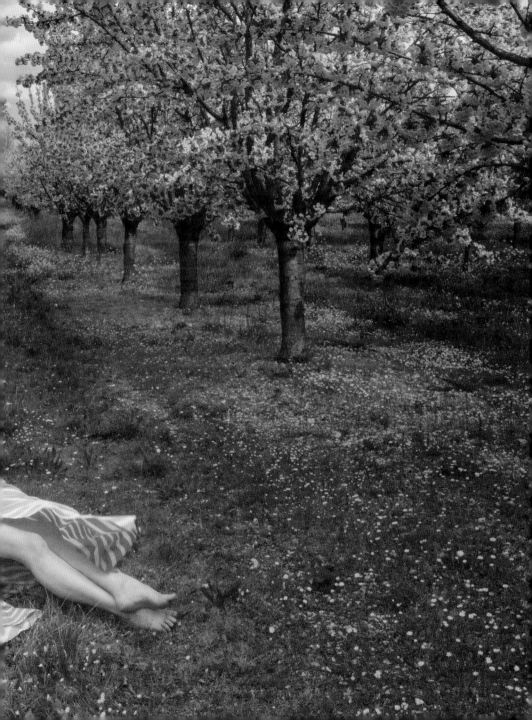

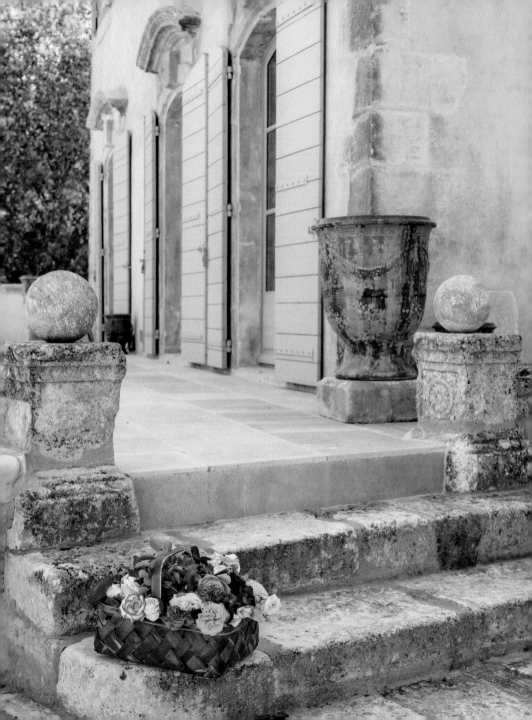

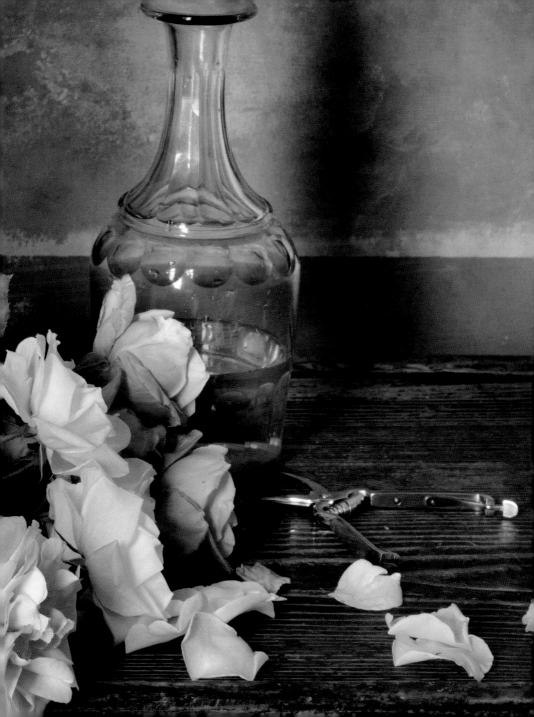

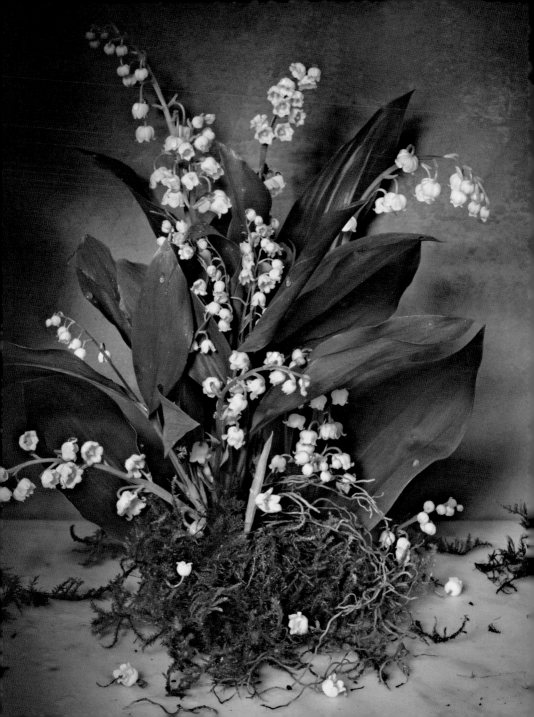

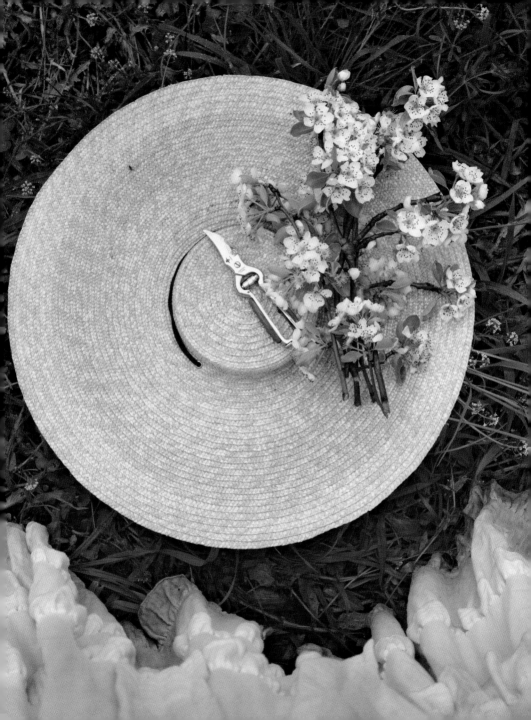

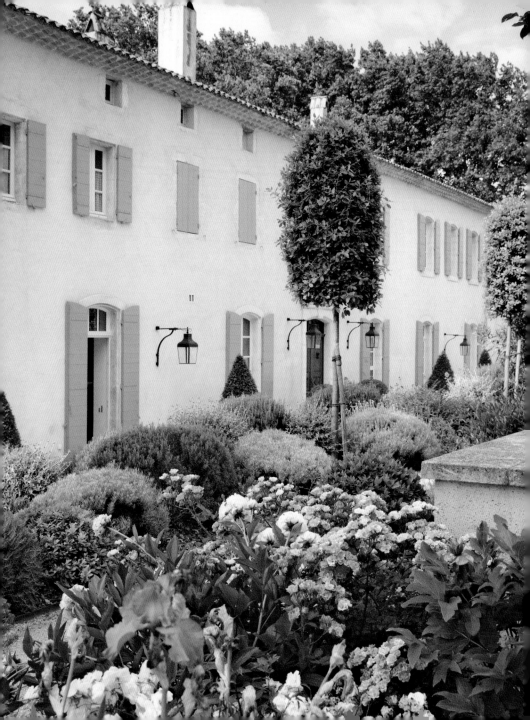

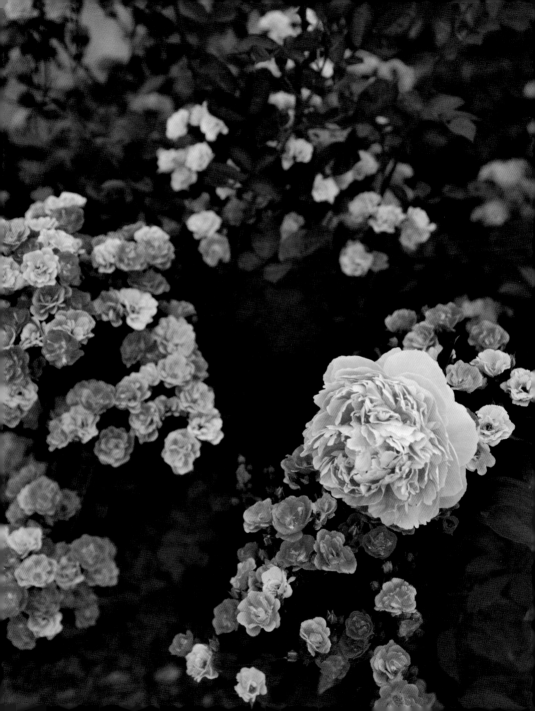

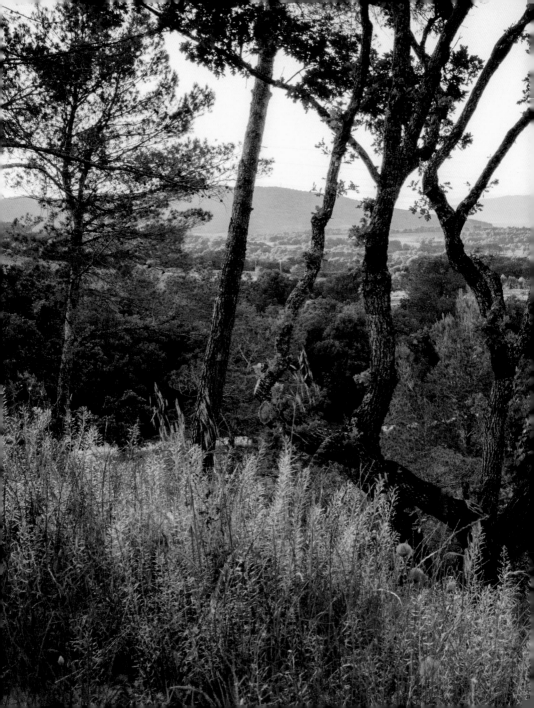

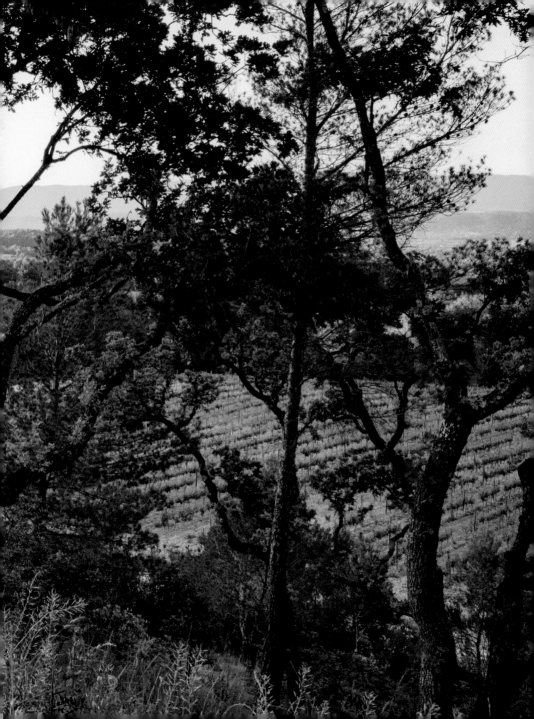

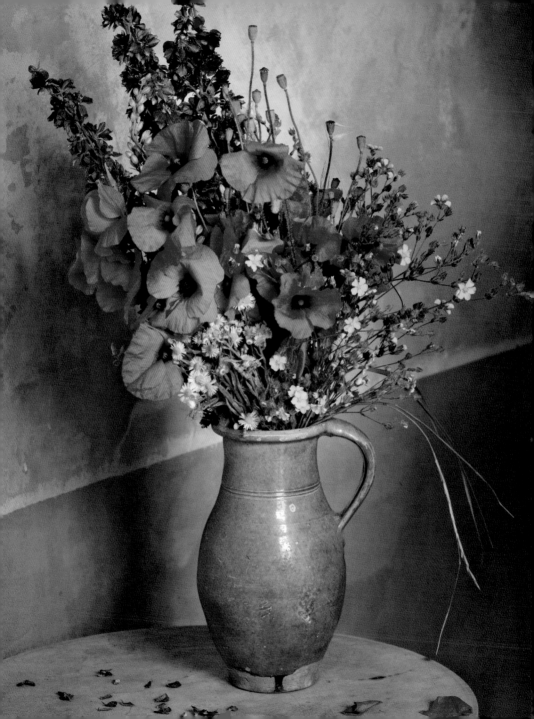

"I awoke this morning to the tolling bells of town
that dance to my window each hour through the dry
Provence air. I thought about Vincent van Gogh's
'Vase with Red Poppies.' Poppies ... poppies ... I keep thinking
about these poppies dotting the Provençal landscape.
The unnaturally crimson red pixelating the earth.
The way they so delicately flutter in the breeze,
their papier-mâché petals fanned around like the spin
of a skirt. When you stand before them you feel the fires
of life reaching back at you. I walked through town,
I had a crêpe, I bought a perfectly worn antique milk jug
showing the wear of hands that had come before my own.
I rode my bike to the market to buy a chicken for dinner,
and on the way home, I stopped at the poppies.
I filled my bag with flowers from the field,
the same flowers van Gogh walked amongst,
and I made this photograph so I could always
remember the colors of summer in Provence."

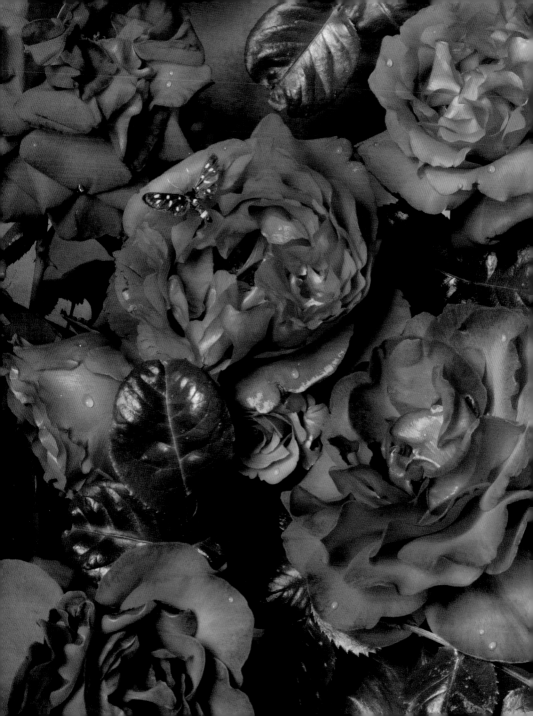

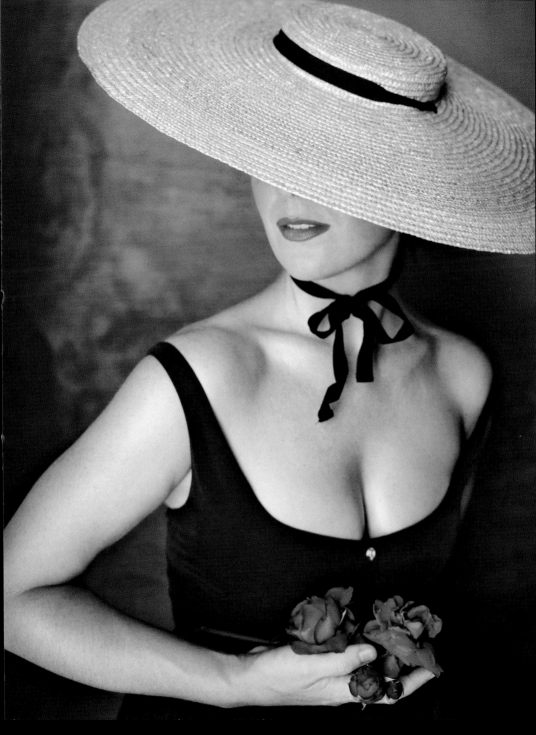

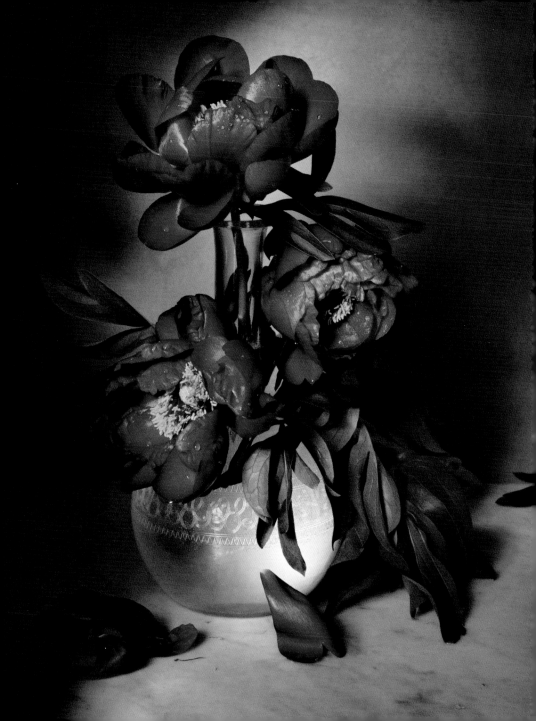

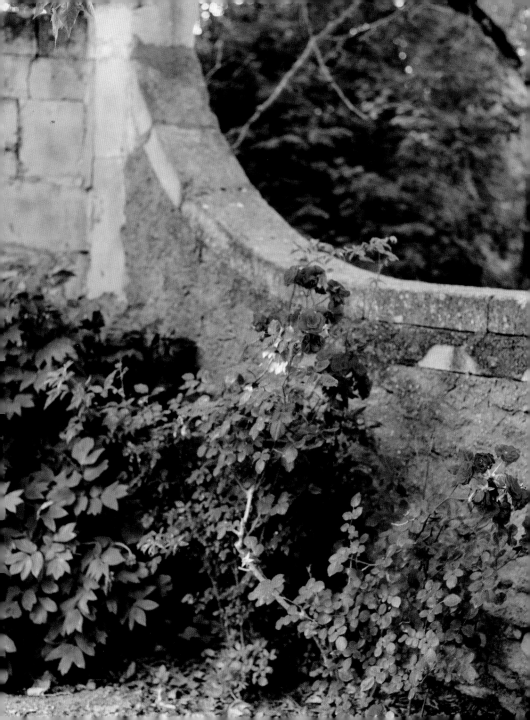

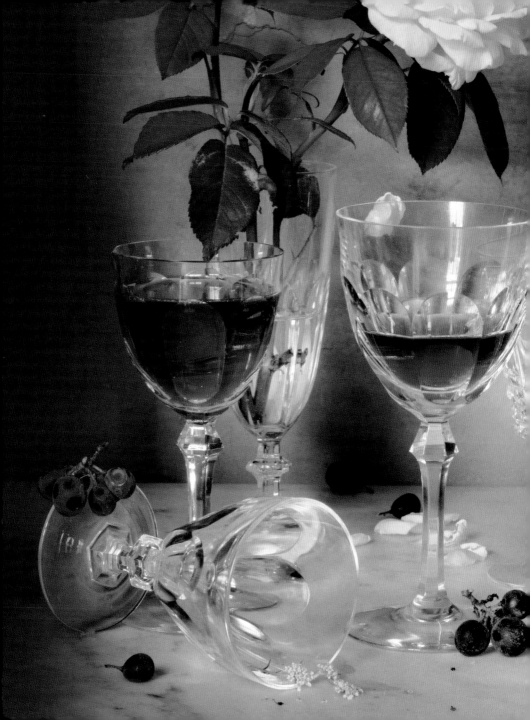

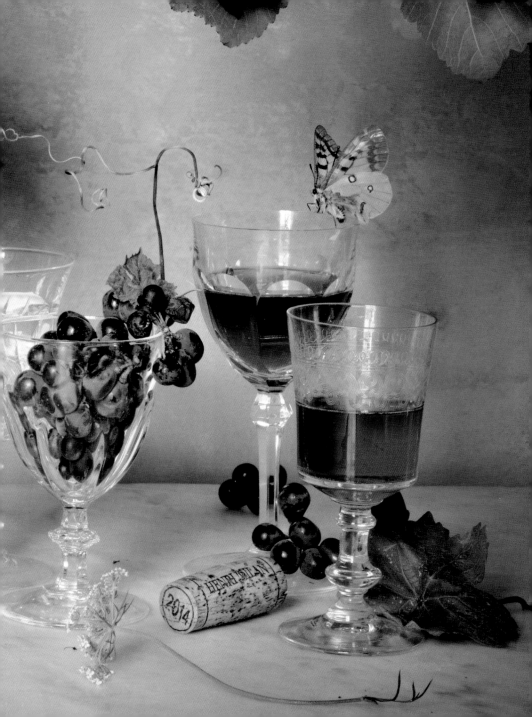

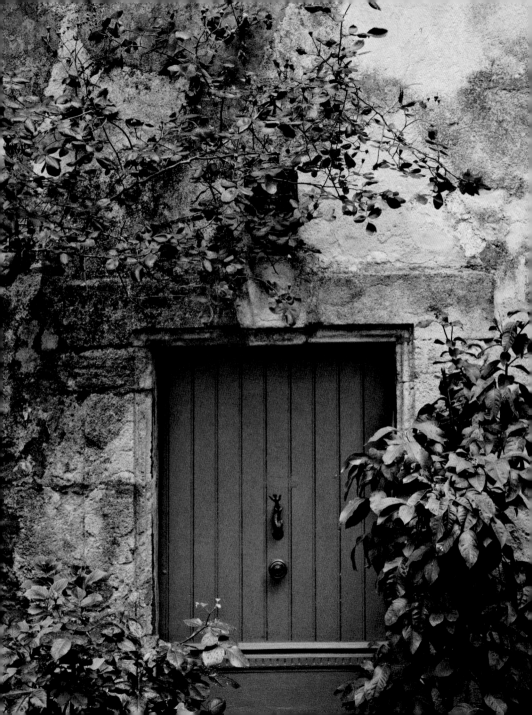

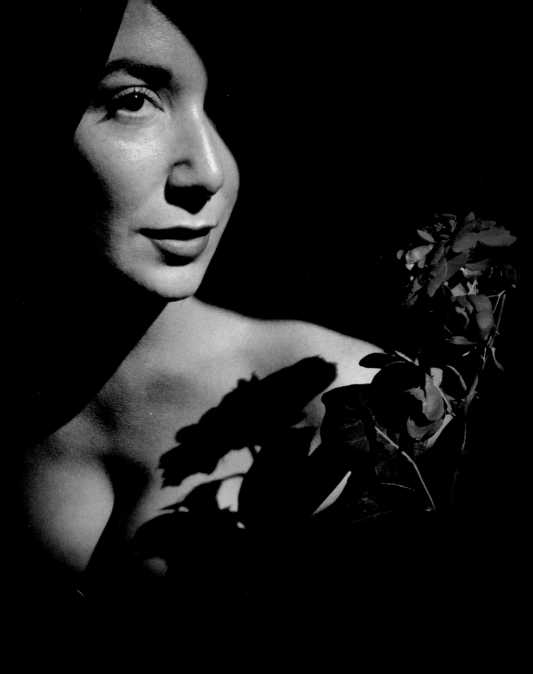

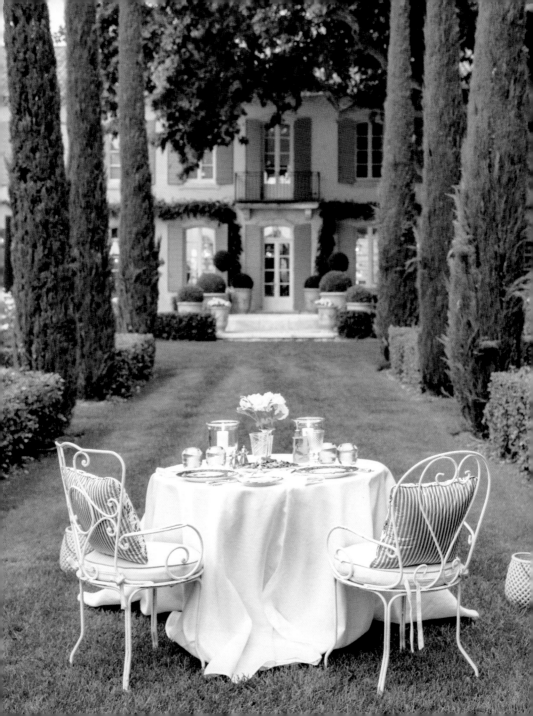

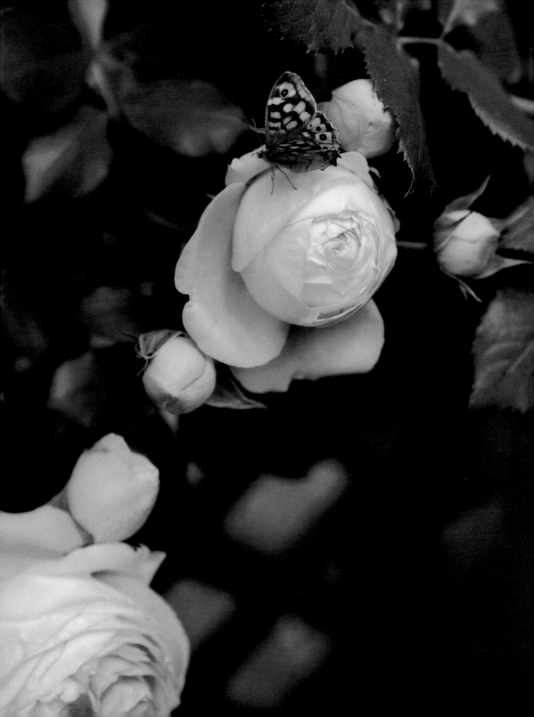

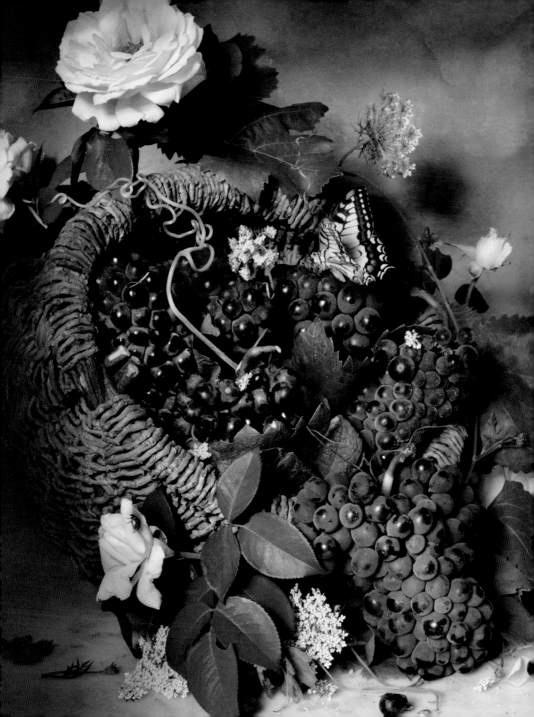

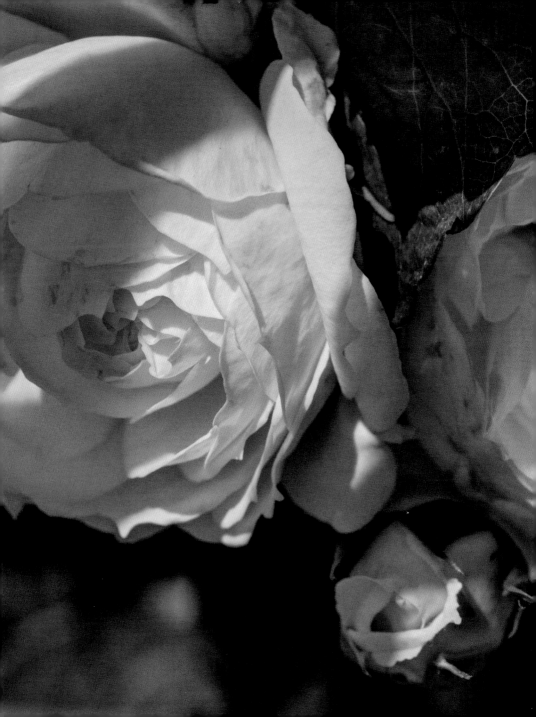

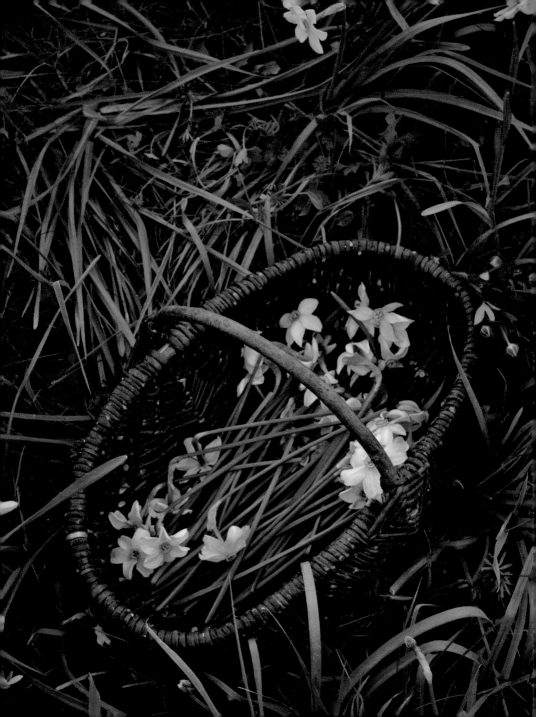

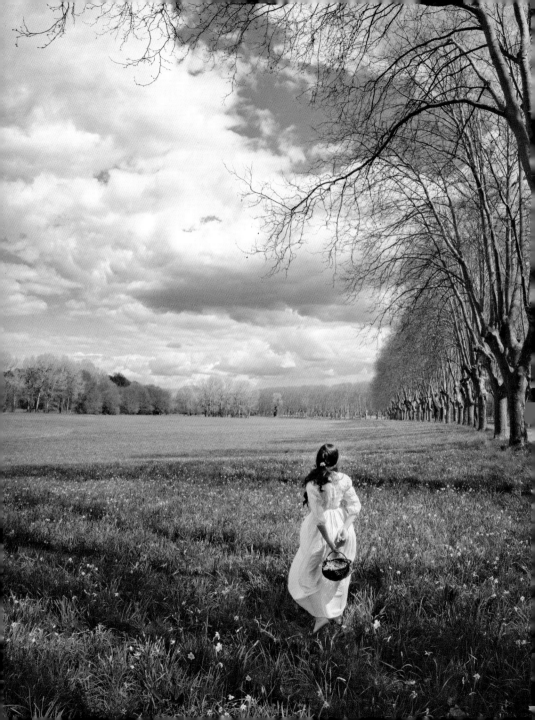

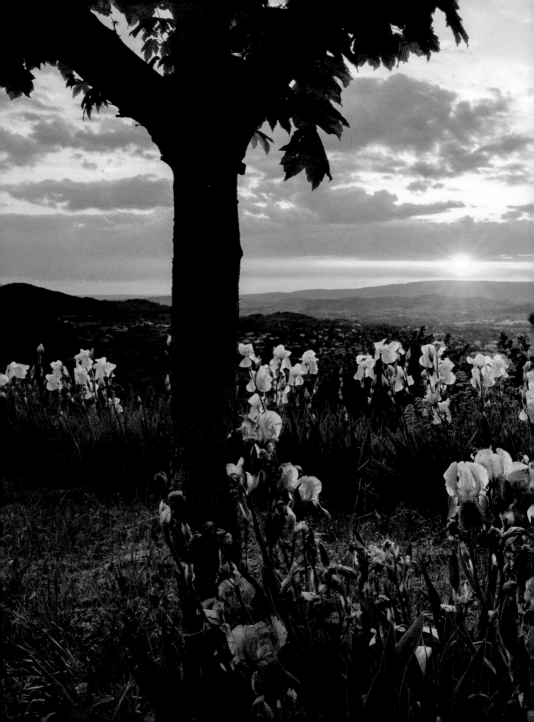

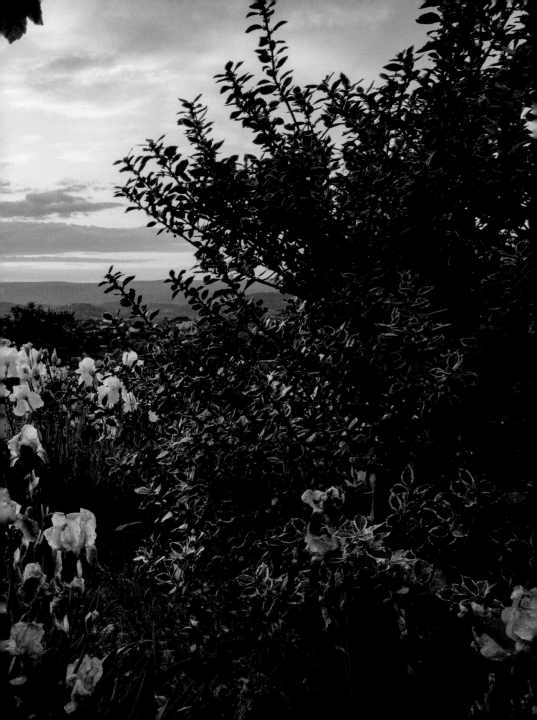

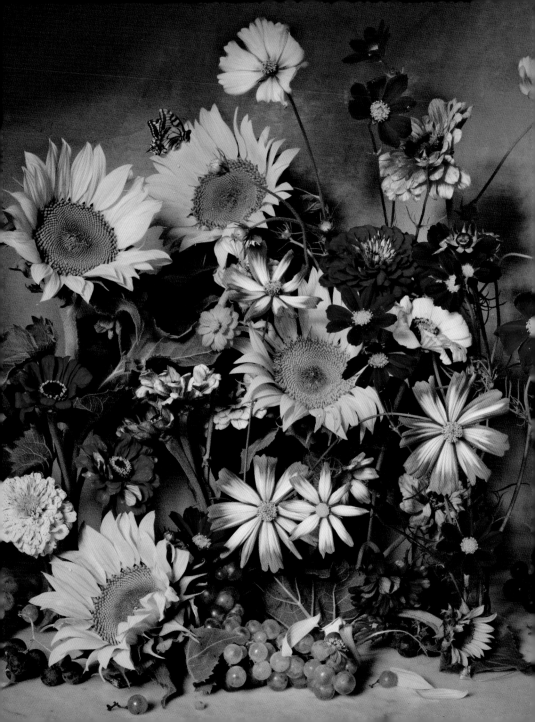

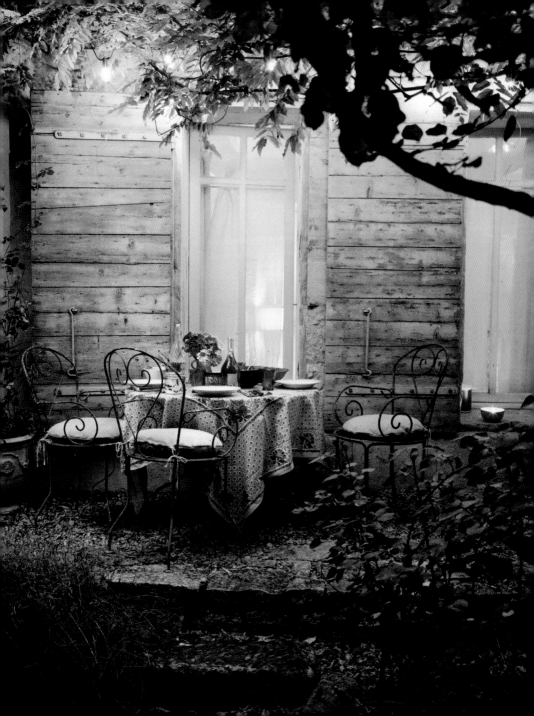

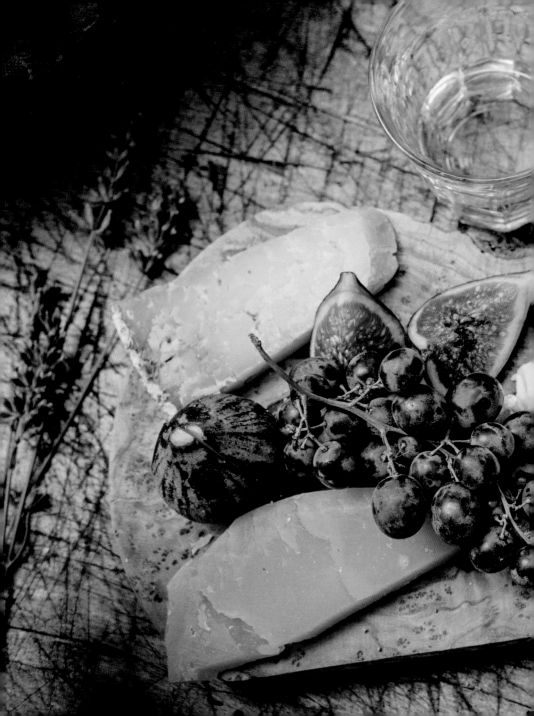

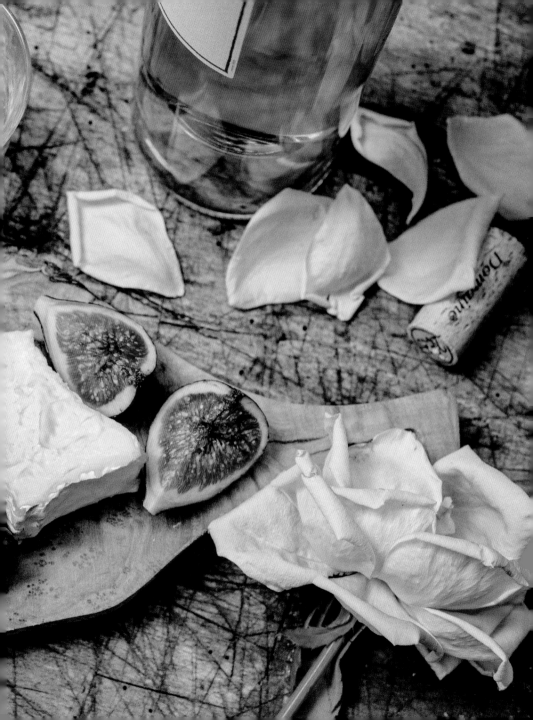

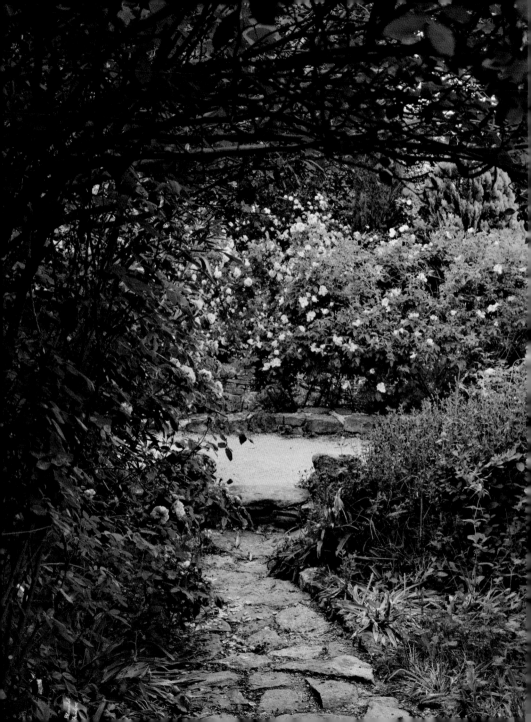

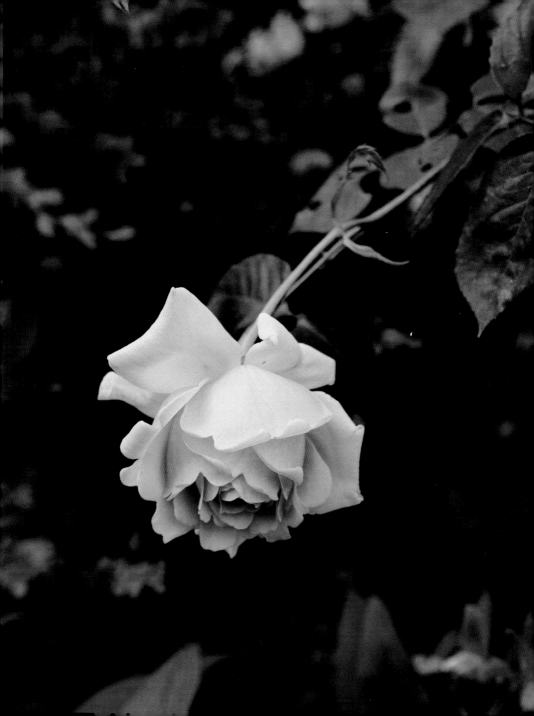

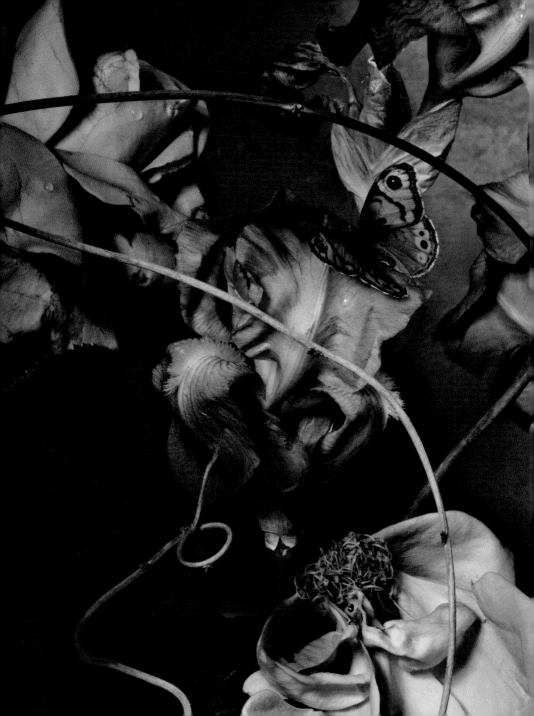

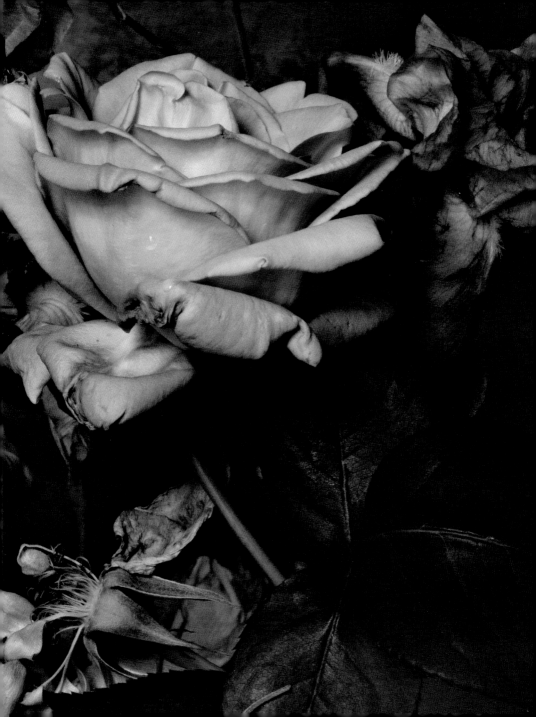

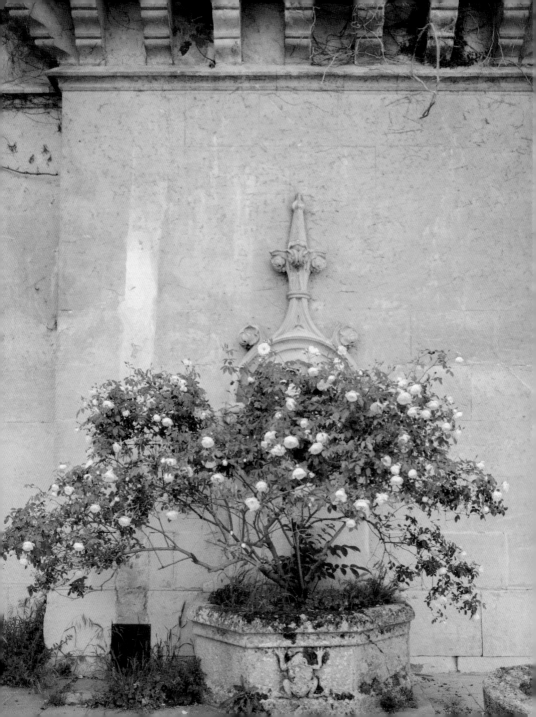

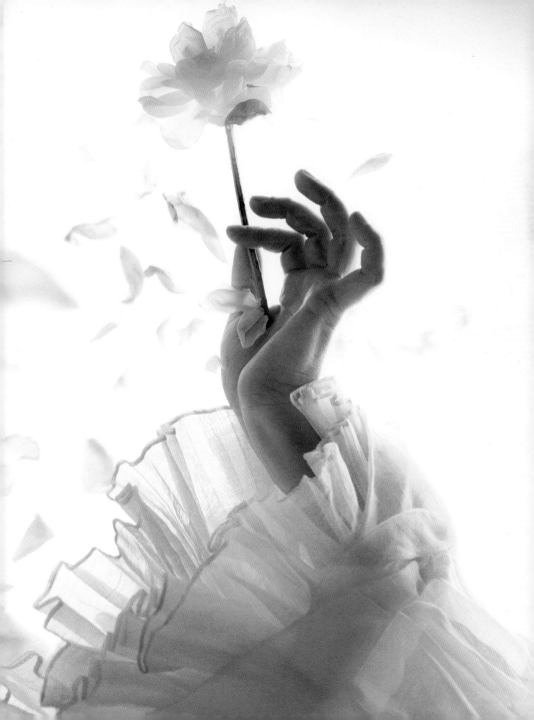

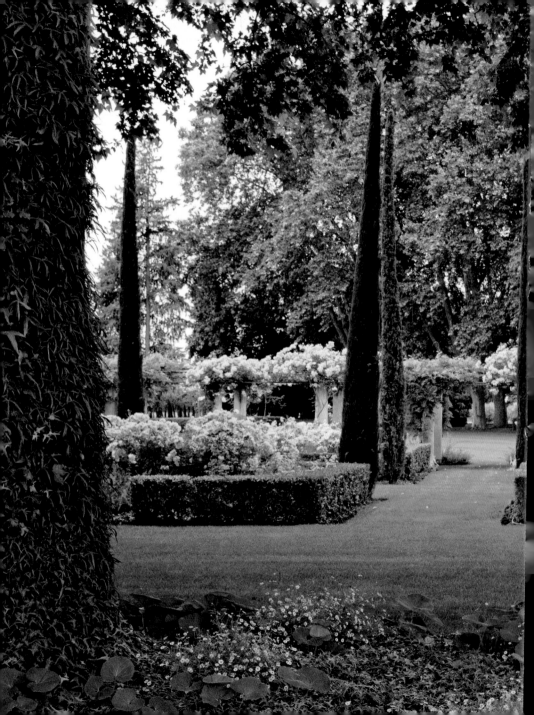

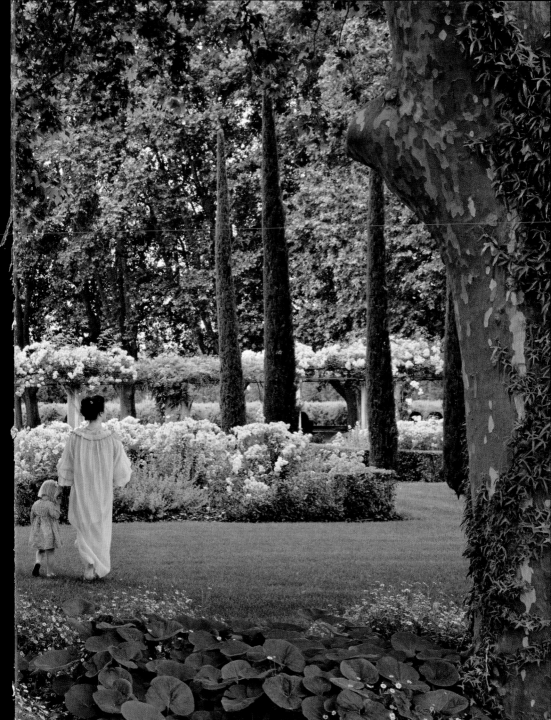

ACKNOWLEDGMENTS

Though Provence is full of flowers, this book would not be possible without the support, lessons, and collaboration of the local community I love, appreciate, and admire so deeply. I share these photographs with you.

Deepest thanks to Shauna Varvel of Le Mas Poiriers for inviting me to your inspiring garden. Thank you to Martial Florent of Luberon Horizon for your views on indigenous and artful Provence gardens. Constance Slaughter of Chateau de Mille, thank you for opening your garden to me like a second home. Thanks to Helen Puillandre for decorating my life here with beautiful creations and sharing your knowledge of flower arranging. To Cécile Girard and the Terre du Luberon family, thank you for the rainy sunrise walks through your farm and teaching me what it means to be a grower of flowers. Thank you, Florie Meyssard of Beau Repos, for taking me through your world and sharing your flower preservation lessons. To Jean Yves Meignen of Abbaye Valsaintes, your friendly rose garden bloomed into a sanctuary for all. Benoit Horchat of Roserie de Chateaubois, you are the king of roses and a magician of flowers. To Agnes, Françoise, Eric, and Clément at Fragonard, thank you for exposing me to your rich history. To all at Domaine Milan, thank you for allowing me to capture your art and nature. Thank you, Louise Pascal, beautiful muse, for posing for my flower Polaroids. David Chicoine, Rachel Baker, Paul and Sharon Mrozinski, Cedric Maros, Valerie Loubet, Marie Varenne of Fleur d'Arles, Adrienne Ryser of L'Arrosoir Paris, Marie Christine of Chateau de Moissac-Bellevue, Violette Danneyrolles, and more gave me flowers and seeds, showed me a field in extraordinary bloom, and allowed me into their homes for this book.

Heartfelt thanks to Erin Benzakein and Floret Flower for their support and the endearing and personal foreword. I have incredible teams behind the scenes. Seth Fishman and Anna Worrall of the Gernert Company, you have the magic touch. Vanessa Flaherty of DBA, thanks for always supporting my ambitions. Thank you, Sallie Lewis, for sending me language when words failed me. Thank you to Liza Battestin for your dedicated assistance on the ground for this project. Thank you once again, Natasshia Neary, for your beautiful design and illustrations. Thank you to master printer Pascal Dumas for your patience and attention to detail in test printing every photograph. To the team at Simon Element and Simon & Schuster, I am proud to be part of your publishing family. Thank you for championing my work, and for all that it takes to create books. Justin Schwartz, thank you for your trust, friendship, and creative freedom above all.

My deepest love and thanks to my husband, Kevin Burg, who wakes up every day and encourages me to go play with flowers. You are the sun to my life; without you, I could not grow. Eloise, thank you for all the walks and all the flowers you've picked for me; my darling girl, you are my favorite flower of them all. I love

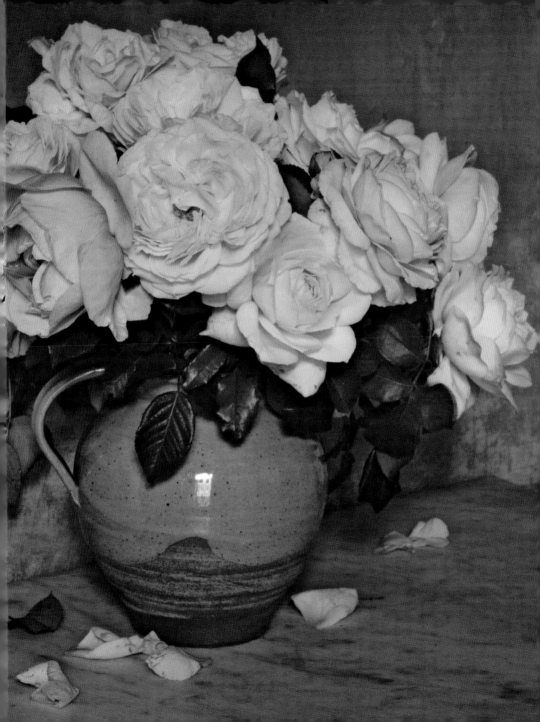

ABOUT THE AUTHOR

J amie Beck took her first photograph at the age of thirteen and soon after began earning her living as a professional photographer. She has shot campaigns and editorials for some of the world's most famous brands, including Chanel, Donna Karan, Oscar de la Renta, and Google, and her work has appeared in *Vogue* and *Harper's Bazaar*. In 2016, she took what was supposed to be a one-year sabbatical to create a personal body of work in the South of France, which changed the entire course of her life. Her career has blossomed into fine art photography; her flower photographs—including photographs from her viral #IsolationCreation series, which brought thousands of followers together in appreciation of beauty despite the pandemic—have been collected in more than eighty-three countries around the world, and she frequently collaborates with French designers to create bespoke treasures based on her work. Her first book, *An American in Provence*, an instant *New York Times* bestseller, chronicled her experiences in beautiful words and stunning photography. Jamie lives in Provence with her husband and daughter. Follow her on Instagram @JamieBeck.co.

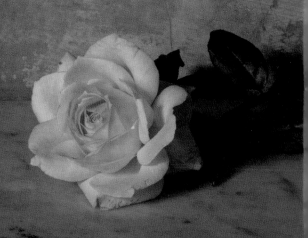